The Triumph of Japanese Style:

16th-Century Art in Japan

The Cleveland Museum of Art

Agency for Cultural Affairs, Government of Japan

The Triumph of Japanese Style:

16th-Century Art in Japan

by Michael R. Cunningham

with contributions by

Suzuki Norio, Miyajima Shin'ichi, and Saito Takamasa

Published by The Cleveland Museum of Art

in cooperation with Indiana University Press

The exhibition was organized
by the Agency for Cultural Affairs, Tokyo,
and The Cleveland Museum of Art

Exhibition dates
October 19–December 1, 1991
The Cleveland Museum of Art
Cleveland, Ohio

The exhibition, catalogue, and public programs have been made possible
by The Kelvin and Eleanor Smith Foundation

An indemnity for the exhibition has been granted by the Federal Council
on the Arts and the Humanities

Continental Airlines provided transportation

© 1991 by The Cleveland Museum of Art.
All rights reserved
Distributed by Indiana University Press,
Bloomington, Indiana 47405
Printed in the United States of America

Editor: Sally W. Goodfellow
Designer: Thomas H. Barnard III
Production Coordinator: Susan Patterson
Printed by Eastern Press, East Haven,
Connecticut 06512

Jacket: Detail of *Phoenix and Paulownia*.
One of a pair of six-fold screens; ink, color,
and gold on paper. Attributed to Tosa
Mitsuyoshi (1539-1613), Momoyama period.
The Cleveland Museum of Art, Leonard C.
Hanna, Jr., Fund, 86.2

**Library of Congress
Cataloging-in-Publication Data**
Cunningham, Michael R.
 The triumph of Japanese style : 16th-centur
art in Japan / by Michael R. Cunningham, with
contributions by Suzuki Norio, Miyajima
Shin'ichi, and Saito Takamasa.
 p. cm.
 Catalog of an exhibition held at the Cleve-
land Museum of Art, Oct. 19-Dec. 1, 1991.
 Includes bibliographical references.
 ISBN 0-940717-12-3. — ISBN 0-940717-
13-1 (pbk.)
 1. Art, Japanese—Kamakura-Momoyama
periods, 1185-1600—Exhibitions. I. Title.
N7353.4.C87 1991
709'.52'07477132—dc20 91-3364
 CIP

Contents

Lenders to the Exhibition

Agency for Cultural Affairs, Tokyo

Aichi Prefectural Ceramic Museum, Seto

The Mary and Jackson Burke Foundation, New York

Chishaku-in, Kyoto

Chozen-ji, Kofu, Yamanashi Prefecture

The Cleveland Museum of Art

Daisen-ji, Kofu, Yamanashi Prefecture

The Detroit Institute of Arts

Fujita Art Museum, Osaka

Fukuoka City Art Museum, Fukuoka Prefecture

Goto Art Museum, Tokyo

Hatakeyama Kinenkan, Tokyo

Hayashibara Art Museum, Okayama

Hyogo Prefectural Ceramic Museum, Kobe

Itsuo Art Museum, Ikeda, Osaka Prefecture

Kasuga Shrine, Nara

Kasuga Shrine, Seki, Gifu Prefecture

Kiyomizu-dera, Kyoto

Kodai-ji, Kyoto

Koen-ji, Kyoto

Kongo-ji, Kawachi-Nagano, Osaka Prefecture

Kuwanomi-dera, Azuchi, Shiga Prefecture

Kyoto National Museum

The Metropolitan Museum of Art, New York

Mitsui Bunko, Tokyo

MOA Art Museum, Atami, Shizuoka Prefecture

Myoho-in, Kyoto

Myoshin-ji, Kyoto

Nagoya Betsu-in, Aichi Prefecture

Nagoya City Museum

National Museum of Japanese History, Sakura, Chiba Prefecture

Private Collection, Ehime Prefecture

Private Collection, Hyogo Prefecture

Private Collection, Kyoto

Private Collection, Kyoto

Private Collection, Nara

Private Collection, New York City

Private Collection, Tokyo

Ryoan-ji, Kyoto

Saidai-ji, Nara

Seikado Bunko, Tokyo

Sengen Shrine, Fujinomiya, Shizuoka Prefecture

Shiga Prefectural Museum of Modern Art, Otsu

Suntory Museum of Art, Tokyo

Tamon-in, Tadotsu, Kagawa Prefecture

Tokyo National Museum

Umezawa Kinenkan, Tokyo

Virginia Museum of Fine Arts, Richmond

Greeting

It is a great delight that The Cleveland Museum of Art in its 75th-anniversary year is holding this exhibition.

In the 16th century, Japan experienced the transition from the Muromachi period (1334-1575) to the Momoyama period (1575-1600). The fall of the Muromachi shogunate accelerated the rivalry among local barons throughout Japan. It was during this warring period that Oda Nobunaga and Toyotomi Hideyoshi rose to power and began the establishment of a unified government. Soon after, Tokugawa Ieyasu defeated Toyotomi and inaugurated the Tokugawa shogunate, which was the start of the long Edo period (1600-1867).

This was one of the most dynamic political revolutions in the history of Japan, and the art world was not indifferent to the resulting social changes. Reflecting the spirit of the period, a new wave of creativity arose. Whereas during the preceding Muromachi period art forms were developed that, under the strong influence of Chinese culture, focused on spirituality, now people rediscovered and showed a decided preference for the colorful expressions traditionally associated with ancient periods. By the end of the 16th century, splendid decorative arts reflecting a fresh and innovative approach were flourishing.

This exhibition demonstrates the creative movement of Japanese art in the 16th century through a display of seventy-five paintings and decorative arts—the number selected in accord with the Cleveland Museum's 75th anniversary. The articles are of the highest quality, including a National Treasure and twenty-one Important Cultural Properties. I believe that they will help promote a deeper understanding of Japanese art.

Among the prominent museums in America, The Cleveland Museum of Art is especially known for its vigorous collection and display of Japanese art; organizing this exhibition on this occasion demonstrates this attitude. I hope the Museum will continue to play for years to come its important role in promoting cultural understanding and friendship between America and Japan through art.

I would like to express my deep thanks to the lenders of these precious articles. I am also sincerely grateful to the Director, Evan H. Turner, and his staff, who enthusiastically participated in preparing the exhibition.

Kawamura Tsuneaki
Director, Agency for Cultural Affairs
Japanese Ministry of Education

October 1991

Foreword

In 1915, even before its building was completed, The Cleveland Museum of Art appointed the Harvard University Orientalist Langdon Warner as the new Museum's Field Agent, with the intention of sending him on an expedition to pursue his researches in Chinese Turkestan. The war made such a venture an impossibility; so instead, during one trip to Europe and two to the Orient, the young scholar concentrated his studies upon the extraordinary Buddhist sculptures created around Nara in 7th-century Japan. The results of these studies, funded by five Museum Trustees, appeared in 1923 as the first volume in a projected series entitled "Publications of The Cleveland Museum of Art." *Japanese Sculpture of the Suiko Period,* containing spectacular photographs of objects then little known in the West, remains probably the most ambitious and elegant volume ever published by the Museum.

It was a significant academic contribution. Warner related the great masterpieces of sculpture associated with the temples at Horyu-ji to the spectacular cave carvings he had planned to study in Central Asia, and he discussed how the Chinese influences had been assimilated to create a distinctive Japanese statement.

Given the importance of this early study, it is perhaps fortuitous that the first major exhibition celebrating the Museum's 75th anniversary should be *The Triumph of Japanese Style.* In this exhibition Michael Cunningham, the most recent of the Museum's succession of distinguished connoisseurs of Japanese art, studies a later, fascinating period of Japanese art—about 1480-1620—during which Chinese influences were important, but simultaneously an even more unusual, bold national style emerged. As had been the case with the Suiko artists, this new style would have a great impact upon succeeding generations. Like Langdon Warner, Cunningham examines a body of material—that of 16th-century Japan—which sadly, given its remarkable originality, is still too little understood in the West.

The exhibition is the result—yet again—of a most felicitous cooperation between the Museum and the Japanese government's Agency for Cultural Affairs (the Bunka-cho). Michael Cunningham conceived the basic concept of the exhibition; then, working with Suzuki Norio, who was in charge of the exhibition for the Bunka-cho, and, as painting specialist, with Miyajima Shin'ichi, they explored the thesis in greater detail and agreed upon the works to be included. We were honored that the Japanese encouraged The Cleveland Museum of Art to include a number of our recent acquisitions that were germane to the exhibition's theme as well as six other works from American collections. The exhibition is, therefore, truly an international venture, although appropriately, for the Museum's anniversary, it is made up of seventy-five works from Japan. Because they were so important, however, it was agreed that the exhibition would only be shown once, in Cleveland. We are immensely appreciative that such fine treasures, which could never be seen in Japan at any one time, were lent for this exhibition.

With a grand generosity, the Bunka-cho has worked out all of the details in connection with the Japanese loans and has also funded the costs of gathering the material together in Japan. The Museum is greatly indebted to Kawamura Tsuneaki, Director, and his impressive staff. Our meetings with the Director of the Fine and Applied Arts Division of the Bunka-cho, Watanabe Akiyoshi, have proven as pleasant as they have been effective.

Finally, Kelvin Smith was a Cleveland industrialist who in his later years discovered the vitality of contemporary Japanese printmaking and then became fascinated by the earlier *ukiyo-e* prints and, in turn, paintings of such subjects. In 1985, the Museum received his fine collection as a spectacular gift from his wife. Given his love of Japanese art, it is a particular satisfaction that a most generous contribution from the foundation that he established should have essentially funded the costs of the exhibition and the printing of the catalogue.

Evan H. Turner
Director
The Cleveland Museum of Art

Acknowledgments

The idea for this exhibition originated years ago when as a student of Father Harrie Vanderstappen at the University of Chicago I was introduced to the beauty of Japanese painting and Buddhist sculpture. At that time the study and appreciation of Chinese art consumed nearly everyone's attention in the field of Far Eastern art. But the stimulating environment at the University helped illuminate for me the special characteristics of Japanese art, a subject that continues to fascinate, as well as elude satisfactory explanation.

Having spent some years in Kyoto exposed to the living culture—and to its well-preserved traditional culture—it became increasingly clear to me that the 16th century represented an important window on Japanese cultural history. Encouraged by the scholars Doi Tsugiyoshi and Minamoto Toyomune, I attempted to discover and then describe the special aesthetic achievements of the Momoyama period (1568-1615) in the works of two Kyoto artists. Their paintings provided glimpses beyond the contemporary interest in Chinese-influenced Japanese painting toward native themes, materials, and modes of expression. Both Doi and Minamoto-san realized that Japan's well-recognized fascination with China over many centuries had less to do with the "facts" of history than with the process of assimilation and transformation of "outside" stimuli into the living culture. This process continues unabated today, despite external appearances. I am grateful for the spirited support of Doi and Minamoto-san, and that of Kurata Bunsaku, who spurred my interest in both ancient Buddhist sculpture and contemporary art.

The exhibition that developed from these ideas brings together a fine group of ceramics, lacquerware, paintings, and textiles that illuminate 16th-century Japanese art. With the co-organizers, the Agency for Cultural Affairs (Bunka-cho), we decided on the historical breadth of the show and the material to be included. Inevitably, certain categories were excluded—calligraphy, metalwork, and sculpture—to better focus on themes particularly characteristic of the period, as well as easier to understand by an American audience.

The staffs of the Tokyo, Kyoto, and Nara National Museums have provided access to objects and paintings over the past five years, substantially advancing the progress of this exhibition. Particular thanks is due Mitsumori Masashi, Chief Curator of Nara National Museum, who sponsored a sabbatical for me at the museum's Center for the Study of Buddhist Research Materials. The Center and Museum curatorial staff could not have been more helpful during the summer of 1990.

The loans of seventy-five objects to the exhibition required extensive travel throughout Japan. My guide on these trips was Miyajima Shin'ichi, Curator in the Fine and Applied Arts Division of the Bunka-cho; he has been a staunch supporter of the project since its inception and is a contributor to the paintings section of the catalogue. In this he is joined by Watanabe Akiyoshi, Director of the Fine and Applied Arts Division and an old friend of this Museum, who first came here in 1968 as a representative of the Agency.

When approached with the idea of a special exhibition of 16th-century Japanese art to help celebrate the Museum's 75th anniversary, Watanabe-san listened sympathetically and then found a way to help organize it, despite the many demands upon his department. His appointment of Suzuki Norio, Curator in the Fine and Applied Arts Division, to assume responsibility for coordinating the project in Japan has greatly facilitated the process, and has enabled us to benefit from Suzuki-san's extensive knowledge of Japanese lacquer. His contribution of an essay on 16th-century lacquer to this catalogue and his key role in selecting an extraordinary group of ceramics, textiles, and lacquers for the exhibition provide our American audience a unique opportunity to appreciate these classical art forms from Japan—given equal status with painting by the Japanese. Suzuki-san has been ably assisted in the selection of ceramics by Saito Takamasa, Curator in the Fine and Applied Arts Division, who also contributed thoughtfully to the catalogue. Kimiko Steiner deserves credit for translating the Japanese texts provided by the contributors from the Agency for Cultural Affairs.

Special thanks go to all of the lenders—American and Japanese, individual and institutional—who made this exhibition possible.

Closer to home, the patience, diligence, and good spirits of my colleagues at this Museum have contributed immeasurably to any success this exhibition may enjoy. I thank all departments while acknowledging the particularly intense demands placed upon: William S. Talbot, Assistant Director for Administration; the Registrar, Delbert R. Gutridge; Chief Designer William E. Ward; and the talented staff of the Publications Department, through whose efforts this catalogue appears in a timely fashion. The editor, Sally W. Goodfellow, and the designer, Thomas H. Barnard III, deserve special praise for their contribution in this regard. Miki Inagaki, Oriental Bibliographer, assisted with references and translations. The Building and Grounds Department worked feverishly to construct cases and to implement William Ward's handsome installation design. The Public Information and Development Departments spent long hours in publicizing this special anniversary exhibition.

Naturally the Asian Art Department bore the brunt of the myriad tasks required to bring the exhibition, its catalogue, and international symposium to fruition. Jean K. Cassill, Nancy Grossman, and Joanne Duda all worked energetically to secure for the Museum the success of this project, and I continue to be grateful to them.

The early commitment to this exhibition by the Kelvin and Eleanor Smith Foundation cannot pass without comment. The Smith family's support of this Museum and its Japanese art collections represents an extraordinary expression of a continuing American interest in understanding Japanese culture. We are fortunate in Cleveland to have their support, and this writer takes special satisfaction in the fact that this exhibition features quintessential Japanese objects from one of Japanese history's "golden ages."

Evan H. Turner, Director, not only recognized this concept but also offered his enthusiasm, active participation, and thoughtful encouragement through all stages of the project. My thanks to him for giving me the freedom to shape the exhibition and its setting in a way that might best serve the art.

Last, but not least, my family and friends here in Cleveland, Kyoto, Tokyo, New York, and London have urged me on, with genuine interest in the ideas and objects that form this exhibition. My family has been unfailingly understanding of long absences during the past two years, yet resolved in their support of the goal. My heartfelt thanks to them, and most of all to my wife, Carin, to whom I dedicate my part in this effort. The deficiencies are mine.

Continuity and Transformation in 16th-Century Painting

Japanese cultural history has inevitably been linked to the people, the artifacts, and the ideas that have crossed the seas from the Asian continent. Events in China and Korea, the Ryukyu Islands, or other parts of Southeast Asia have also had an effect on Japanese life. Familiarity with these historical circumstances has therefore led many interpreters of Japan's cultural heritage to emphasize its derivative character. Indeed, relations with China over many centuries provide numerous examples of cultural, social, and institutional "borrowing." But there are great differences between Japanese and Chinese art.

One of these—the pleasure of integrating art with life—holds special meaning for the theme of this exhibition: the continuity and development of indigenous Japanese style and form in the 16th century. First, it will be apparent that the paintings, textiles, lacquerwares, and ceramics were all used—that is, they bear the marks of human handling through the centuries.

Secondly, they exhibit an almost bewildering range of physical, material, and stylistic appearances—most of which bear slight resemblance to Continental prototypes. For the most part, their "visual language" as well as overt subject matter (in the case of paintings) possesses a familiar, native voice. Seen together, the works may be spoken of fairly without reference to any other culture.

Finally, their placement in the continuum of the 16th century and the understanding of their usage through study of historical documents confirms what their appearance hints at: the enduring presence of a uniquely Japanese sensibiltiy.

The "triumph" of Japanese style occupies nearly the entire 16th century and spills into the first half of the next. Its origins lie 400 years earlier in the late Heian (Fujiwara) period, but its renewal and tranformation in the 16th century remains one of the most remarkable stories in East Asian cultural history, and certainly within Japan.

Intense cultural exchanges occurred among China, Korea, and Japan during the 15th and 16th centuries. At the same time, however, the country was engulfed in civil unrest, which, ironically, fostered artistic expression in the visual arts. The presence of numerous feudal estates throughout Japan encouraged varying degrees of cultural independence. Heading these estates were ambitious provincial warlords (daimyo), who not only sought recognition on the battlefield but also consciously strove to emulate the cultural sophistication evident in the aristocratic, religious, and warlord estates of the capital, Kyoto.

Figure 1. *Kasuga Mandala*. Hanging scroll; ink, color, and gold on silk. Nambokucho-Muromachi periods, 14th-15th century. The Cleveland Museum of Art, Leonard C. Hanna, Jr., Fund, 88.19

There, wooden buildings of subtle proportions and elegant architectural lines nestled amid carefully planned, tended gardens in the hillsides surrounding the city. Their settings along a stream or on a flat expanse necessitated incorporating mountain and water imagery ("landscape") into garden designs within a religious or aristocratic compound, resulting in a compressed re-creation of natural and man-made imagery. The development of rock and moss gardens and miniature landscape gardens began in the later Heian period and reached a climax during the Muromachi (1392-1568) and Momoyama periods (1568-1615).

Interest in garden art and the enjoyment of the four seasons in an ordered, private environment has its origins in Shinto, the ancient native religion. Shinto beliefs extolled the forces of nature, particularly as they manifested themselves in the changing seasons, or, for instance, in the daily passages of the sun and moon. Mountains, aged trees, and even sandbars jutting into the bays and shorelines of the islands' coasts often took on mythic significance in early Japanese society, until they became part of the established literary, and then visual, imagery of the land. The rhythms of time as measured by the seasons, or the tides, or by night and day became inextricably joined to the web of daily life and, by extension, into Japanese art.

By the 8th century countless sites throughout Japan had been identified as sacred, as the residences of *kami*, or deities. These places gained recognition first through oral tradition, then through visual emblems. Plaited grasses and small, plain wood or stone enclosures for oil lamps and offerings of *sake* (rice wine) marked these sites, until more sophisticated, architectural settings were established. Painted "maps" described some of the most important sites, such as the hanging scroll of the Kasuga Shrine in Nara (fig. 1). The comfortable melding of nature and the topography of Nara with a complex symbolic system incorporating both Buddhist and Shinto imagery is apparent.

Thus, when Buddhism, having been introduced from the Continent in the 6th century, proposed the idea of the end of spiritual life—*mappo*—in the 11th century, the two faiths were still able to co-exist—just as disparate artistic modes of expression in painting, lacquer, and ceramics thrived in similar company in Japan. The Byodo-in temple in Uji, close to Kyoto, is a sublime example of a late Heian period expression of *mappo* combined with Shinto-related imagery.[1] The wooden doors enclosing the large, seated Amida Buddha and his celestial attendants were painted in vivid mineral pigments with landscape scenes incorporating the four seasons. Horses roam the foothills, and rivers and streams nurture the lush, green appearance of the countryside (fig. 2). This is Japan with its round, low undulating hills—a landscape surrounded by water that is quite different from any Continental model.

By the end of the Heian period (1185) a critical phase in the evolution of Japanese art had occurred. In this regard, the painted doors at the Byodo-in mark the achievment of a mature, national "style" and genre quite different from contemporary painting in China or Korea. Termed "*yamato-e*" (Japanese style painting) by later

Figure 2. Detail of painting on a door of Hoo-do (Phoenix Hall). Color and ink on wood. Late Heian period, dated 1053. Byodo-in, Kyoto.

Figure 3. Detail of *Genji Monogatari Emaki.* Handscroll (now mounted in separate sections); ink and color on paper. Heian period, 12th century. Tokugawa Art Museum, Nagoya.

commentators, the salient characteristics include uniquely Japanese subject matter or themes; the use of vivid color rather than shaded, contouring lines to describe form; and a tendency to flatten or severely constrict space. Naturalism mingles with schematic religious imagery or with secular literary themes in a process of internal stylization establishing the framework for later developments. In contrast to its monochromatic counterpart, *kara-e* (Chinese painting), *yamato-e* sought a visual description of the world somewhat more oblique and restrained than the grand Chinese landscapes or figural visions of the Tang (AD 618-906) and Song (960-1279) dynasties.

Yamato-e came to be recognized as a distinctly Japanese mode of expression only after its genesis as a term that identified subject matter. Thus the inclusion of verdant landscapes in the four seasons with birds and animals, or figures gathering at a shrine in scenes describing rebirth in a Western Paradise are important signposts in the development of *yamato-e*. They indicate that Fujiwara society embraced both religious and secular subjects— the Byodo-in, for example, was a residence of the Fujiwara family converted to a private chapel. Furthermore, if one can interpret some of the vignettes in the Byodo-in panel paintings as showing changes in seasons, then it is reasonable to believe that early descriptions of murals and screen paintings in Kyoto residences and palace rooms are indeed accurate.

Surviving illustrations and calligraphic text from an album of the 12th-century *Tale of Genji*, Japan's most celebrated literary work, hint at the brilliant color, "flat" space, and shifting areas of compositional organization that begin to characterize *yamato-e* (fig. 3). Figures and objects are arranged in relationship to one another: above and below, to the right or the left, rather than in a Western perspectival sense. One learns to read such scenes almost as a new kind of visual language whose brevity, directness, and air of calm enhance the illusion of space and help to establish recognizable patterns that continue through the centuries.

The following excerpt from the *Genji* indicates the distinction made by educated Heian society between *kara-e* and *yamato-e*. It occurs early in the novel during a conversation among Genji's friends about women:

In the Office of Painting at the imperial court there are many good artists whose real abilities could not be easily discerned as they are chosen by their [skill in] ink drawing. Thus in the painting of [spectacular subjects such as Mount Horai which has never been beheld by a mortal eye, the raging monstrous fish in a rough sea, ferocious beasts of foreign lands, or the faces of imaginary demons, artists may paint according to their fancy, and their works, though with no likeness to the real, may merely impress people by their striking effects. On the other hand, in the painting of [peaceful scenery such as] ordinary hills and streams, familiar houses, gentle mountain slopes aloft in deep foliage, or the intimate charm of enclosed space within rustic hedges, a master would render his work with spirited effectiveness while inferior artists would be mostly lacking in the real qualities.[2]

Chinese influence had waned in Japan in the mid-9th century, but revived somewhat in the late 12th century, with a clearer sense of "borrowing," or injecting novel ideas into the existing, sophisticated cultural milieu. In particular, the leadership of the Zen monastic institutions in Kyoto and Kamakura spurred religious and cultural association with China and Korea. The merits of an education in Chinese classics and certain types of Chinese art were espoused—especially ceramics, lacquerware, and ink painting; the latter was known in Japan as *suibokuga* (water and ink painting).

This new, ebullient brush style coupled with intriguing subjects struck an immediate response with Japanese Zen clerics and collectors alike. The monochromatic ink tones and sparse compositional designs, in contrast to *yamato-e*, spoke a restrained visual language echoed by the simply glazed ceramics and black lacquerwares in the dimly lit rooms of the capital's temples.

As the centers of learning and artistic interpretation in Japan, these Zen institutions in Kamakura and Kyoto attracted the attention of the country's military elite, whose political and economic power eclipsed that of the court by the late 12th century. The patronage accorded the early Zen temples by the shogunate (military rulers) as a means of encouraging cultural activities distinct from those at court—like *yamato-e*—fostered the acceptance and then the practice of ink painting, calligraphy, the tea ceremony, and related arts.

Zen priests acted as spiritual and artistic mentors for the shogunate and its retainers, interpreting Chinese culture and, in the process, inevitably adapting it to native preferences and usage. Later, in the Muromachi period, they would become active agents for the shogunate—and then for the powerful, independent *daimyo* (warlords)—who sought to profit from commercial trade with the newly opened markets in China. By the late 14th to early

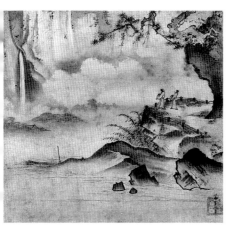

Figure 4. *Two Men Observing a Waterfall.* Hanging scroll; ink and slight color on paper. Soami, ca. 1485-1524, Muromachi period. The Cleveland Museum of Art, Purchase from the J. H. Wade Fund, 77.30

15th centuries, Chinese and Korean ink painting had become accepted, studied, and copied in the process of assimilation into Japanese artistic circles. A century later, Japanese artists—both professional and amateur—produced *suibokuga* so compelling in technical skill and visual appearance that these native products gained greater favor.

To be sure, this process was aided by the relative paucity of desirable imported paintings, and of course their cost. Chinese paintings had become highly desirable and expensive accessories to a burgeoning tea culture in Kyoto, Sakai, Nara, and Osaka. Numerous historical documents including tea journals and artist's commentaries lament the extraordinary prices of old Chinese scrolls, ceramics, and lacquers, and the cutting up of handscrolls into sections so as to gain more paintings.[3]

The interior design of Japanese residences and monastic halls included sliding door panels (*fusuma*) covered with paper on two sides, as well as fixed walls, alcoves, cabinet panels, and portable folding screens (*byobu*). For the decoration of these surfaces the Zen prelates turned to their colleagues, the monk-painters, who attempted to emulate and then re-fashion Continental brush styles. By the end of the 15th century the distinction between an amateur monk-painter and a truly professional *suibokuga* artist had blurred. Soami (ca. 1485-1524), the trusted artistic advisor to the Ashikaga shoguns, represents this new type of professional artist (fig. 4; see also cat. no. 13). He served as connoisseur, garden designer, and painter to both the Zen community and military-class patrons.

Somewhat later, Kano Motonobu (1476-1559) would consolidate the position of a new group of professionally trained artists, bearing the Kano name, whose stylistic identity grew out of the paintings of his father, Masanobu (1434-1530). The primary aim of the Kano studio centered on the increasing demand for large (and small-scale) paintings by patrons who desired to embellish their living quarters with expansive mural paintings or modest hanging scrolls for their tearoom alcoves, known as *tokonoma*.

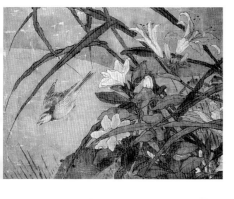

Figure 5. *Birds and Flowers.* Hanging scroll; ink and color on silk. Attributed to Sesshu Toyo, 1420-1506, Muromachi period. Mr. and Mrs. A. Dean Perry Collection, Cleveland.

The formation and development of this Kano atelier of painting was a response to the domestic need for pictorial imagery differing from the imaginary poem-paintings (*shigajiku*) favored by earlier monk-scholars. Although it is not clear how Masanobu and then Motonobu arrived at their particular formula, Motonobu was apparently inspired by Sesshu Toyo's (1420-1506) ambitious landscape and bird-and-flower compositions known so well at the time (fig. 5), and by Ming dynasty (1368-1644) bird-and-flower paintings that had been imported from China and Korea. Also, Motonobu must have known Soami as an artist and as curator of the largest collection of Chinese paintings in the country.

The success of the Kano School enterprise and of Motonobu's youthful leadership of that effort is due in large part to his innate artistic ability. His eclecticism and mastery of painting styles and methods is more impressive than any other artist of his generation—indeed perhaps of the entire 16th century. Without his presence it is difficult, if not impossible, to envision pictorial representation in this century, and especially the flowering of talent that occurred in the later decades leading, ultimately, to the revival of *yamato-e*, whose traditional practitioners were the court-appointed artists of the Tosa School.[4]

In Kyoto, at about the same time, many anonymous *machi-eshi* (town-painters)—professional fan painters and decorators—provided the capital's townspeople with inexpensive gift items and interior decorations for their homes, now that political stability and economic conditions were improving. The *machi-eshi* were largely unskilled with brush and ink (when compared to the Tosa or Kano artists), yet in a short span of two or three generations in the 16th century they succeeded in establishing a strong presence in Kyoto and other cities.

These *machi-eshi* workshops, along with the Tosa School, perpetuated the 16th-century interest in *yamato-e* subjects: famous places (*meisho*), *tsukinami-e* (monthly events celebrated each year), literary themes (especially those derived from *The Tales of Genji*), genre subjects, contemporary interests (i.e., cherry blossom viewing), and sun and moon imagery.

In the transition from late Heian (Fujiwara) to Kamakura (1185-1333) societies, the emerging military class and popular Buddhist sects, particulary the Jodo (Pure Land), had requested different subject matter in painting and promoted the use of painting styles consistent with new imagery from the Continent. The Tosa painters responded to this challenge energetically, infusing new life into *yamato-e* and mastering the handscroll format. Known in Japan as *emaki* (or *emakimono*), these illustrated narrative texts of varying length, often in multiple rolls, portray a variety of historical subjects or personages.[5]

From the 13th to the 15th centuries many *emaki* were produced by court and Tosa artists who illustrated legends about the founding of Buddhist temples and Shinto shrines, or biographies of revered Buddhist priests, which included vivid descriptions of the countrysides and towns of Japan. The artists recorded the lives of common folk as well—a far cry from the days of the *Genji* (fig. 6). These varied subjects are indicative of a shift in themes and patronage for professional painting in medieval Japan (12th-15th centuries), and an increasing interest in subject matter that reflected contemporary life.

The country's political order had metamorphosed in such a way that by the 15th century the many regional hegemons (*daimyo*) had become increasingly independent of the shogun's authority. They supported their own regional arts, away from the capital. The Ashikaga line of shoguns in Kyoto, like the court before them, thus became ineffectual both politically and culturally.

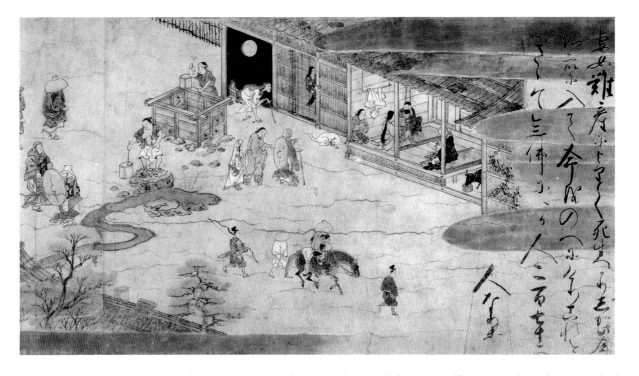

Figure 6. Detail of *Yuzu Nembutsu Engi* (Legends of the Yuzu Nembutsu Sect). Handscroll; ink, color, and gold on paper. Kamakura period, 14th century. The Cleveland Museum of Art, Mr. and Mrs. William H. Marlatt, John L. Severance, and Edward L. Whittemore Funds, 56.87

During this time, the role of the Tosa School artists changed dramatically, since their fate was linked to the court as official artists in the painting bureau (*edokoro azukari*). Tosa Mitsunobu (1434-1525), served as head of the Tosa family painters and of the *edokoro azukari* for two generations. Legend has it that about 1500, Kano Motonobu married Mitsunobu's daughter. For the Tosa, whose fortunes were declining, the customary Japanese decision to align forces through family lineage must have been particularly appealing.

Toward the end of the 15th century and into the 16th, Mitsunobu is credited with an impressive number of paintings in *byobu* (folding screen), album, and *emaki* (narrative handscroll) formats. Perhaps his most famous *emaki* is scroll four of the *Ishiyama-dera Engi* (Legends of Ishiyama-dera Temple), dated 1497, and the *Seiko-ji Engi* (Legends of Seiko-ji Temple) scrolls (fig. 7).[6] Many of Mitsunobu's other handscrolls display a wide range of subjects and styles within the *yamato-e* genre. He and his small group of Tosa artists also made less sumptuous, brief *emaki* known as *ko-e*, illustrating folk tales and related narratives in a plain, naive style. These were most likely meant for individual members of the court as well as for wealthy merchants for their personal enjoyment. The *Fukutomi Zoshi* illustrates this genre in a direct, Tosa-like painting style (fig. 8).

Figure 7. Detail of *Seiko-ji Engi*. Handscroll; ink and color on paper. Tosa Mitsunobu, 1434-1525, Muromachi period. Tokyo National Museum.

Figure 8. Detail of *Fukutomi Zoshi*. Handscroll; ink and color on paper. Muromachi period, 15th century. The Cleveland Museum of Art, John L. Severance Fund, 53.358

Aside from *emaki*, Mitsunobu executed a number of portraits that represent some of the finest characterizations of known personages in medieval Japanese portrait history.[7] It would appear that he single-handedly maintained—indeed revived—the Tosa studio painting tradition with his efforts in portraiture and *emaki*. Yet when one thinks of Kano Motonobu and Sesshu—both of whom adopted Tosa *yamato-e* elements into their work in varying degrees—one usually turns to the colorful folding screens (*byobu*) and sliding door panels (*fusuma*). As history would have it, these large-scale formats present the most challenging area in which to discern the character of interaction between the practitioners of *yamato-e* and those espousing *kara-e* (Chinese painting) formulas. Fortunately, research in this area, begun in earnest only fifteen years ago in Japan, has made substantive discoveries of information and, significantly, of many *yamato-e byobu* of the era 1500-1650.

Traditionally, Japanese art historians have thought that the introduction of strong colors and gold backgrounds in early Kano School painting was the result of the influence of the Tosa School painters—particularly Mitsunobu. Written evidence or depictions of paintings on gold ground illustrated within *emaki* are scarce. Yet the joining of Kano and Tosa studio practices is noticeable most often in surviving Kano paintings, if only because of Motonobu's skill in obtaining commissions from regional *diamyo* and even patrons overseas. The Kano style clearly captured the lion's share of early 16th-century patronage, which favored a bold brush manner in the *kara-e* mode.

Among the paintings requested by mainland clients were *byobu* and fans with subjects drawn on a background of gold leaf, a superb example of which is a single screen of pine trees in the Tokyo National Museum (fig. 9). Known as *kinbyobu* (folding screens with gold-leaf ground), these *byobu* had, by Mitsunobu's time, become a specialty of *yamato-e* production, recognized far beyond the shores of Japan for their special visual appeal and identified as quintessentially "Japanese."

As the 16th century began, Motonobu astutely recognized that the enduring *yamato-e* tradition, represented by the various anonymous studios and especially the Tosa atelier, possessed the distinctive use of themes and techniques that would once again distinguish and affirm Japanese art for future generations. Domestically, this meant that a synthesis between *yamato-e* and *kara-e* had the potential for achieving the bold new pictorial statements that Motonobu and his studio were already striving for in the 1520s. Outside Japan, it meant a lucrative source of income based upon standardized themes done in large numbers: cranes, pines, bamboo, peacock and phoenix, sun and moon, and birds and flowers. All of these subjects, ascribed to Mitsunobu and Motonobu's *kinbyobu* shipped overseas, appear in the current exhibition—some in fan format, others as folding screens. Just how the paintings were used in China and Korea, however, has not been documented, and precious few Chinese (and less Korean) paintings contain glimpses of the context in which they served as apparatus for domestic interiors.

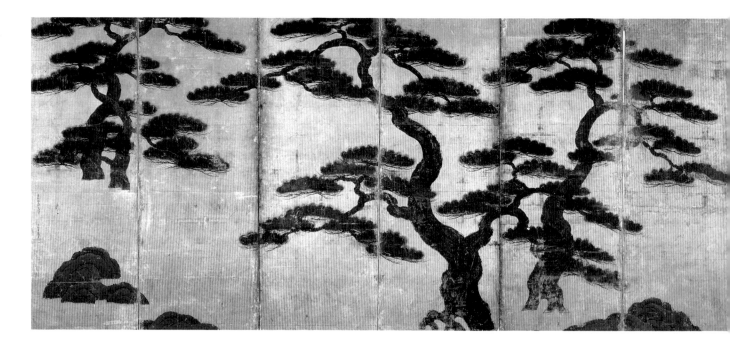

Figure 9. *Pine Trees.* Six-fold screen; ink, color, and gold on paper. Attributed to Tosa Mitsunobu, 1434-1525, Muromachi period. Tokyo National Museum.

The recent interest in Japan in the topic of *yamato-e* has stimulated discussion about the functions of these *byobu*, whose origins go back to the late Heian period and Fujiwara society. They may be broadly divided into religious and secular—dual roles assumed, for instance, by sun and moon *byobu*, an especially distinctive *yamato-e* theme—well represented in this exhibition.

Literary sources beginning in the Heian period and extending through the Muromachi, a period of four hundred years, frequently note sun and moon imagery as a subject for *byobu*.[8] Depicted alone, or sometimes combined with peacocks and paulownia, or with cranes (as in the Mitsui Bunko paintings [cat. no. 5]), such sun and moon *byobu* have traditionally been categorized as a type of seasonal landscape within *yamato-e*. But perhaps other interpretations are worth considering, as, for instance, in the Kongo-ji *byobu* (cat. no. 1).

Scattered historical references mention sun and moon imagery and associate it with Nara and Heian period interest among the aristocracy in lore about Chinese Taoist immortals and other auspicious emblems. In Nara, the Kasuga Shrine (see fig. 1) and the Sanno group of Shinto shrines (see cat. no. 1) on the western shore of Lake Biwa employed these motifs in their painted images and on ritual objects.

In Buddhist as well as Shinto theology and ritual, the sun and moon became visual symbols of the pure, radiant light emitted by the power of these respective creeds. This radiant light is depicted in Kamakura and Muromachi

period *Raigo* scenes, which describe the heavenly vision of the Amida Buddha descending to earth to greet the soul of a faithful departed. A late 15th-century pair of screens incorporates a vision of the Amida's Western Paradise, known as a *Taima Mandala*, in a landscape illustrating the Buddhist realms of reincarnation; significantly, the sun and moon also appear.[9] Thus, notwithstanding the current perception of *byobu* with gold leaf background (*kinbyobu*) or applied gold and silver washes as strictly objects of decorative function, there is good historical reason to ascribe to the Kongo-ji, Tokyo National Museum, and Mitsui Bunko sun and moon *byobu* religious meaning as well (cat. nos. 1, 2, 5).

The same holds true for their possible function at the temple. By turning again to later 15th-century records —precisely the time of Tosa Mitsunobu's activity—it seems that screens with gold backgrounds were used for a number of diverse temple occasions: flower-viewing parties, lectures by Buddhist priests, visits by the shogun, classical music (*dengaku*) recitals, poetry gatherings (for *waka* and *haiku*), funeral and memorial services, and tea ceremonies.[10] Seen broadly, these fall into familiar secular and religious functions, but the events described all take place in a monastic setting, and all are related to ritual occasions.

The versatility of *kinbyobu* surely grew out of their various functions—including serving as hanging supports for scroll paintings. *Senzui byobu* (folding screens with individually mounted silk panels), dating from at least the early 12th century, were employed at large Esoteric (especially Shingon sect) temples for ordination ceremonies. Thus, while ostensibly screens like the Kongo-ji *byobu* appear to be seasonal landscapes, perhaps it would be more appropriate to view them as fundamental apparatus, or "furniture," for certain religious ceremonies. The Kongo-ji is, in fact, a Shingon sect temple.

By the late 15th and early 16th century the Kano School artists were mastering the secrets of painting on gold leaf. At the same time, an expanding, affluent clientele of townspeople and officials in the military government (*bakafu*) began to make its presence felt in Japan's cultural life. While their tastes for *yamato-e* differed from that of the 14th- and 15th-century courts, they supported this native painting tradition under the umbrella of Kano and Tosa Schools and *machi-eshi*.

Precisely the same shift in taste and expression took place with *suibokuga* in the early 16th century: Japanese ink-painting styles and formats, having assimilated the lessons of thousands of Chinese model paintings, forged ahead into new visual terrain. The colophon on Sesshu's *haboku* (flung-ink) *Landscape* of 1495 marks this art-historical turning point, while Motonobu's career established its validity. Sesshu wrote:

After several years [in China] I returned home, only to conclude that the works of Josetsu [ca. 1386-ca. 1428] and Shubun followed their predecessors without addition or subtraction. In my opinion of Chinese and Japanese painting, having travelled in both countries, I am more and more impressed by the excellence of the artistic vision of these two men. . . ."[11]

But if fewer, talented artists chose to align themselves with the Tosa studio, whose future was uncertain, the ambitiousness and organization of the Kano enterprise, under Motonobu's leadership, offered an attractive alternative. *Kara-e* and *yamato-e* coexisted in the Kano studio, as is apparent in the Daisen-in (ca. 1520) and Reiun-in (ca. 1543) painting cycles—both done for Zen temples with the backing of the Ashikaga shogunate. At the same time, the mantle of leadership in the Tosa family painters passed to Mitsumochi (1496-1559). His efforts in the 1531 *Taima-dera Engi* (Legends of the Taima-dera Temple) and a year later in the *Kuwanomi-dera Engi* (cat. no. 33) indicate his accomplishments as well as the continuing relationship between the aristocracy and military leadership of the day.

Mitsumochi was actively engaged in producing *emaki*, fan paintings, and *byobu* at the same time that Moto-nobu and his studio were producing *yamato-e* works—as can be seen in catalogue numbers 21, 33, and 36. Historical records note two projects on which Motonobu and Mitsumochi collaborated in the 1540s: *fusuma* at the imperial palace in Kyoto, and another *fusuma* cycle for the Hongan-ji temple near Lake Biwa (unfortunately neither cycle of paintings survives). Clearly, the actual working relationship between Kano and Tosa studios at this time appears closer than is usually stated. The stylistic characteristics routinely cited in identifying each school, while apt, do not account for an art-historical reality in which Motonobu and his followers paint in a *yamato-e* style right up until his death, just past mid-century.

Although further study needs to be pursued with the Tosa painters and 16th-century *yamato-e* workshops, it seems evident that they must have tried their hand at *kara-e*. Although precious little survives to encourage, much less substantiate, such a view, the Virginia bird-and-flower and animals screens (cat. no. 17) acknowledge this crossover between subject and painting styles with powerful effect. These modest-sized works, executed in a muted palette reminiscent of Mitsunobu's *Bamboo* screens (cat. no. 8), illustrate the Tosa capacity for pro-ducing earlier Chinese and Chinese-style painting for a Japanese audience. In fact, each painting originally bore an inscription (now removed) by a Zen priest, a popular format in 15th-century monasteries. A very similar approach to "Chinese taste" Tosa bird-and-flower painting occurs in a pair of *byobu* in the Suntory Museum of Art, ascribed to the 15th-century painter Tosa Hirochika, by Tosa Mitsuoki's inscription some 200 years later.[12]

Mitsumochi; his son Mitsumoto, who died in 1569 at a young age; and then Mitsuyoshi (1539-1613) pursued *yamato-e* steadfastly, despite such ventures with *kara-e*. Either through temperament or talent, however, they were not as capable as the Kano family artists in adapting to the demands of new clientele for varied paintings on multiple *byobu* or *fusuma* in their residences or castles. Also, neither the various *yamato-e* studios or *machi-eshi* were as well organized and staffed as the Kano—another of Motonobu's several important legacies.

For these reasons the *edokoro azukari* (head of the imperial painting bureau) passed from the Tosa studio to the Kano atelier. It remained there until the mid-17th century, when Mitsuoki (1617-1691), the last of the "Three Great Brushes" of the Tosa lineage, revived the school's fortunes. But the assumption of the role of official court painters by the Kano demonstrates how well *kara-e* and *yamato-e* intermingled as subject and style from mid-century onwards. Kano-trained artists were sufficiently skilled in the repertory and techniques of *yamato-e* to fulfill numerous, extensive commissions in and outside of Kyoto. The brightest young painters came to the capital to learn the Kano method, and in virtually every instance their later oeuvre as mature artists, independent of the Kano and with their own following of students, contains extraordinary examples of *yamato-e* (see cat. nos. 31, 32).[13]

Traditionally, the success of these artists has become inextricably linked to the idea of the Momoyama period (1568-1615) representing a "golden age" in Japanese cultural history. A more accurate view embraces nearly the whole century, incorporating the contributions of the Sesshu, Kano, anonymous *machi-eshi*, and *yamato-e* studio painters together with the Tosa School artists. Ultimately, the Tosa languished, but *yamato-e* per se did not under the aegis of Mitsuyoshi, the Kano, Kaiho Yusho, or Hasegawa Tohaku. Indeed, the persistence of *yamato-e* throughout the century represents a cornerstone of the on-going, inevitable process of transformation occurring within all art forms in 16th-century Japan. The appearance of Kodai-ji *maki-e* lacquerwares at the end of the century and the encouragement of specific ceramic forms and surface decoration without reference to Continental prototypes or canons of taste reflect the continued development of indigenous ideas and visual preferences born decades before the Momoyama historical identity was recognized.

Michael R. Cunningham
Chief Curator of Asian Art

1. See Fukuyama Toshio, *Heian Temples: Byodo-in and Chuson-ji*, vol. 9 of the *Heibonsha Survey of Japanese Art* (New York and Tokyo: Weatherhill/Heibonsha, 1976).

2. This translation comes from Kenji Toda, "Screens Paintings of the Ninth and Tenth Centuries," *Ars Orientalis* 3 (1959): 159. For a recent, complete translation see Edward G. Seidensticker, trans., *The Tale of Genji*, 2 vols. (New York: Alfred A. Knopf, 1976).

3. See, for example, comments of the prominent, independent late 16th-century painter Hasegawa Tohaku recorded in the *Tohaku Gasetsu*. This is translated and annotated in Michael R. Cunningham, "Unkoku Togan's (1547-1618) Painting and Its Historical Setting" (Ph.D. diss., University of Chicago, 1978), pt. 2, pp. 170-281.

4. The most comprehensive study of Motonobu is found in Tsuji Nobuo, "Kano Motonobu," pt. 1-5 in *Bijutsu Kenkyu* nos. 246 and 249 (1966), and nos. 270-272 (1970).

5. See *Emaki: Narrative Scrolls from Japan*, exh. cat. (New York: Asia Society, 1983), particularly the introductory essay by Professor Miyeko Murase.

6. Consult Yoshida Yuji, *Tosa Mitsunobu*, vol. 5 of *Nihon Bijutsu Kaiga Zenshu* (Collection of Japanese Painting) (Tokyo: Shueisha, 1979), pls. 1-5, 30, and fig. 6.

7. Kyoto University of the Arts, *Tosa-ha Kaiga Shiryo Mokuroku: Shozo Fumpon* (Catalogue of Tosa School Painting Records: the Portrait Sketches) (Kyoto: Shiigu Press, 1990); and Motonobu's *yamato-e* portrait *The Poet Sogi on Horseback* in Sherman E. Lee, *Reflections of Reality in Japanese Art*, exh. cat. (Cleveland: Cleveland Museum of Art, 1983), no. 75.

8. This subject has been discussed with considerable insight by Kenji Toda, "Screen Paintings of the Ninth and Tenth Centuries," *Ars Orientalis* 3 (1959): 153-66; by Yoshida Yuji in *Mitsunobu*, vol. 7 of *Nihon Bijutsu Kaiga Zenshu* (Collection of Japanese Painting) (Tokyo: Shueisha, 1979); and Adachi Keiko in "Muromachi Jidai Yamato-e Byobu-e ko" (Thoughts on Muromachi Period *Yamato-e Byobu* Painting) in *Muromachi Bijutsu to Sengoku Gadan* (Art of the Muromachi and Sengoku Periods), exh. cat. (Tokyo: Tokyo Teien Art Museum, 1986), pp. 119-24.

9. See *Muromachi Jidai no Byobu-e* (Screen Paintings of the Muromachi Period), exh. cat. (Tokyo: Tokyo National Museum, 1989), no. 6. These little seen or studied *byobu* are one of the most complex compositions among *yamato-e*; their dating and interpretation presents many challenges.

10. In addition to these functions noted by Yoshida, see those mentioned by Bettina Klein in "Japanese *Kinbyobu:* The Gold-leafed Folding Screens of the Muromachi Period (1333-1573)," *Artibus Asiae* XLV, no. 1 (1984): 5-33, and nos. 2/3: 101-73.

11. Adapted from that in Jon Carter Covell's *Under the Seal of Sesshu* (New York: De Pamphilis Press, 1941), p. 33.

12. See *Muromachi Jidai no Byobu-e* (Screen Paintings of the Muromachi Period), exh. cat. (Tokyo: Tokyo National Museum, 1989), no. 9.

13. See, for example, Kawai Masatomo, *Yusho/Togan (Kaiho Yusho/Unkoku Togan)*, vol. 11 of *Nihon Bijutsu Kaiga Zenshu* (Collection of Japanese Painting) (Tokyo: Shueisha, 1979), pls. 16, 40, 41; also *16 Seiki no Bijutsu* (Art in the 16th Century), exh. cat. (Osaka: Osaka Municipal Municipal, 1988).

Chronology

Periods referred to in the catalogue

Kofun period	AD 300-645
Nara period	645-794
Heian period	794-1185
Kamakura period	1185-1333
Nambokucho period	1333-1392
Muromachi period	1392-1568
Momoyama period	1568-1615
Edo period	1615-1868

Contributors to the Catalogue

Suzuki Norio	SN
Miyajima Shin'ichi	MS
Saito Takamasa	ST

Entries without initials were written by Michael R. Cunningham

The translated material provided by the Japanese authors has, in some instances, been adapted or expanded to assist Western readers.

Explanatory Notes

All endnotes and figure captions for individual catalogue entries appear in the back of the book (pp. 143-162).

Romanized Japanese names, places, and terms appear without the usual diacritical marks.

Japanese personal names appear in the traditional style: family name first, followed by given name.

Numbers in brackets in the text material refer to catalogue numbers of works in the exhibition.

Height precedes width (or length) in dimensions.

Since all of the ceramics in the exhibition are stoneware, only specific ceramic types are designated.

To identify those works of art considered important to Japan's cultural heritage, the Agency for Cultural Affairs (Bunka-cho) supervises a registration system for protecting designated works. The classifications are: National Treasure, Important Cultural Property, and Important Art Object.

All of the following endings mean "temple":

-dera

-ji

-in

Catalogue

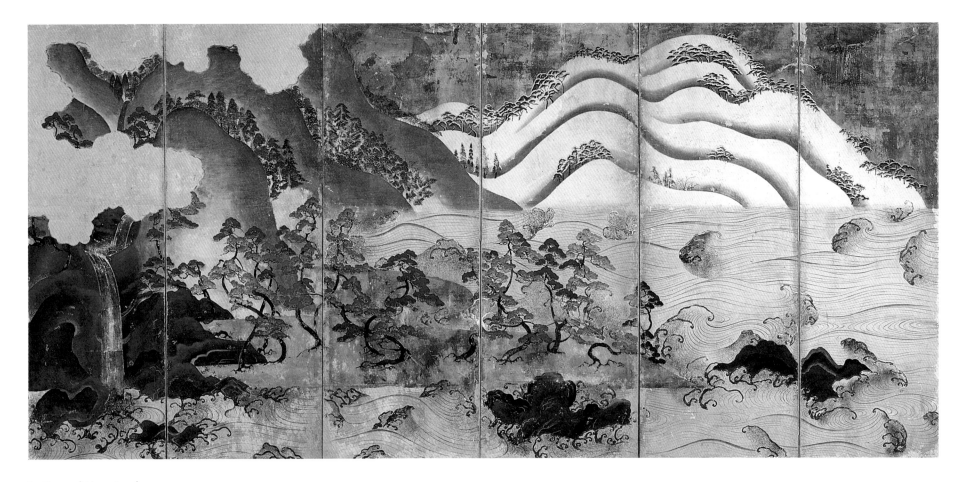

1 Sun and Moon Landscape
Pair of six-fold screens; ink, color, and gold on
paper with applied cut silver and gold
Each 147 x 313.5 cm
Muromachi period, 15th-16th century
Kongo-ji, Kawachi-Nagano, Osaka Prefecture
Important Cultural Property

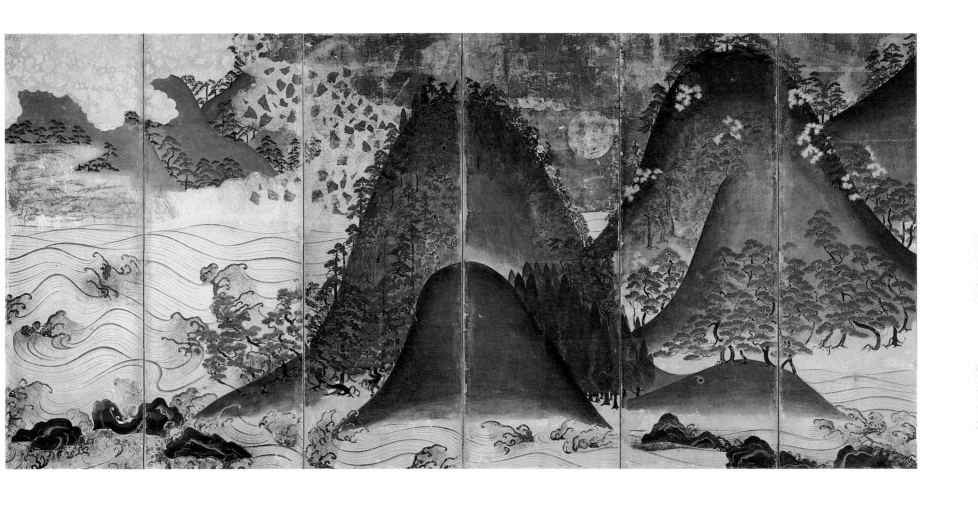

Yamato-e is the peculiarly Japanese style of painting characterized by details rendered in opaque colors and conceptualized forms. The Tokyo National Museum screens [2] are important to the study of 16th-century *yamato-e* because they exemplify so well the style, material, and composition around which other, similar paintings can be grouped. Foremost among these paintings is this pair of *Sun and Moon* screens from the Kongo-ji temple collection.[1] They depict one of the most attractive and powerful vistas in all Japanese art. Beginning on the right, a sunlit landscape of lush, deep green, and gently rounded mountains rises from a frothing sea. Waves rise and curl as they pass the shore or crash among the rocks. In some places the crests of the waves mimic the shapes of pine trees silhouetted against the water.

In pronounced contrast to the dynamic seascape, the mountainsides and valleys appear calm. The shapes of the mountains, their color, the varied groves of trees—particularly the pines ascending the slopes of the mountains —identify this place as *yamato,* the ancient appellation for Japan. Not only does the vast seascape itself confirm this, but one sees how different its characteristics are from depictions of lakes or rivers [19, 34] by *yamato-e* artists.

The splotches of white on the mountainsides in the right two panels identify spring, whereas the two panels to their left—all green—signify summer. Here, the vivacity of the drawing, and the design and materials so characteristic of these *byobu* (folding screens) propel the meaning of the temporal sequence, convey a sense of summer's hot sun, and link this screen to its mate.

The backgound has changed through the centuries: the silver has oxidized to a darker tone—originally it would have produced a more reflective surface in concert with the gold. In both instances these colors are produced by a combination of painted and applied techniques (*kirihaku* and *sunago*) akin to those used in lacquerware [43, 60]. The variety of cut, torn, sprinkled, and twisted shapes of the gold and silver foil papers lends an especially opulent appearance to the surface design, which enhances the interlocking of sea, cloud, mountain, and cloud forms. Clearly the artist was familiar with or employed an artisan trained in such applications, the tradition of which goes back to the late Heian period of papermaking and lacquer art.

The extraordinary 12th-century illustrated *Lotus Sutra* known as the *Heike Nokyo,* still owned by Itsukushima Shrine near Hiroshima, possesses sun and moon imagery amid a cut gold-and-silver field similar to that in this Kongo-ji *byobu*.[2] Wave patterns highlighted with windswept curls are also incorporated into the landscape imagery. Like their 12th-century predecessors, 16th-century artists —especially *yamato-e* painters—referred to water patterns and water imagery with considerable frequency, as is apparent, for instance, in the background of the Koen-ji temple fan screen [21].

The left screen of this pair continues that imagery, ending in the distance at the bottom of layered, snow-clad mountains. At the end panels the waves break on a beach, not unlike those at Hamamatsu [3], from which foothills and then peaks rise abruptly. A waterfall courses down from distant mountains, gaining size and strength until it passes through gold clouds and plummets into the ocean at the far left panel. This same imagery occurs in the right-most panel of the Tokyo National Museum *Sun and Moon Landscape* screens [2], indicating both its acceptance as a framing compositional motif and its evocation of the universality and variety of the "water" metaphor in Japanese life and art.

The order and the variety of plant life, the patterns of the fresh water, and the rock forms and landscape configurations all raise these screens to a higher level of sophistication in the portrayal of *yamato-e* landscape. The addition of metal foil for the sun and moon as well as the elaborately applied foil-wrapped papers (*kirihaku*) and sand-like particles of silver (*sunago*) supports this assessment. Historically, the melding of comparable imagery with lavish materials is more common to religious paintings, especially mandalas and illustrated sutras

Numerous Kamakura and Muromachi period Shinto mandalas prominently feature a sun and/or moon disk and seasonal mountainscape (including a waterfall) with richly painted religious imagery. Indeed the lacquer panel paintings on the 7th-century Tamamushi Shrine at the Horyu-ji temple in Nara possess sun and moon depictions as part of the Buddhist narrative. The mountainsides and waterways in this compact island country, considered the abodes of the native gods (*kami*), highlight these symbols of time's passage as well as the intimate relationship between "heaven" and "earth."

The particular configurations of the mountains in these *byobu* clearly relate to a Shinto mandala such as the Nara National Museum's *Sanno Mandala* (fig. 1, and see [20]). A 15th-century hanging scroll whose materials include gold (paint) and whose imagery embraces the four seasons, the mandala provides a model for considering later sun and moon paintings.

While the artist of the *Sanno* mandala must have been a professional employed by a temple to produce religious icons (*e-busshi*), the Kongo-ji artist may well have been unattached to a religious institution in the late 15th or early 16th century. But he was certainly a professional, with access to the finest materials of the time. Some of the forms and compositional elements, while reminiscent of [2] or of the sheer material exquisiteness of [3], ultimately remind the viewer that this anonymous artist's legacy survives only in these incomparable *byobu* from the Kongo-ji.

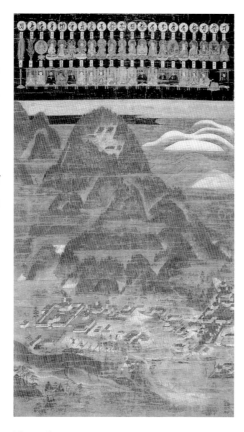

Figure 1.

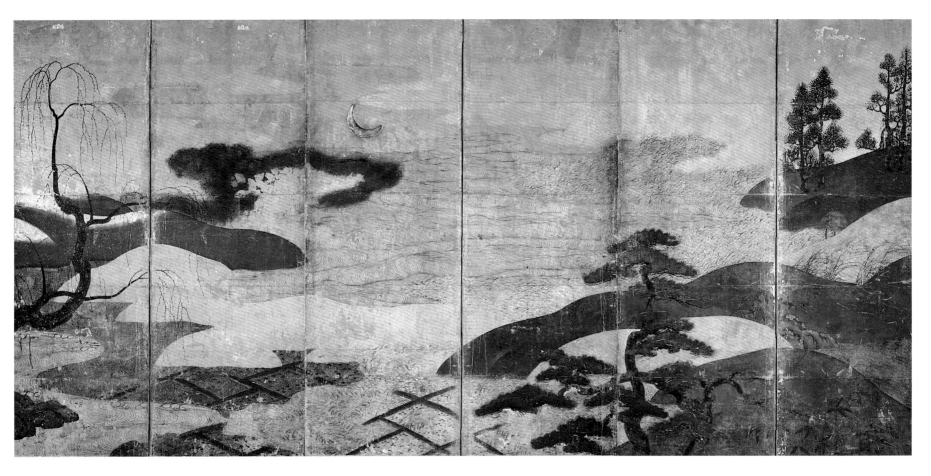

2 Sun and Moon Landscape

Pair of six-fold screens; ink, color, and gold on
paper with applied cut silver and gold
148 x 310 cm (right); 148.5 x 312 cm (left)
Muromachi period, 15th-16th century
Tokyo National Museum

Although these two screens have only been
joined together in modern times, they form a
compelling *yamato-e* image. Said to have
once been parts of separate painting cycles at
the Imperial Palace in Kyoto, they neverthe-
less are sufficiently close in dimensions,
theme, and technique to justify their transfor-
mation into *byobu* mates.[1] Despite some
apparent differences, a particular *yamato-e*

sensibility can be discerned that links them
together, while allowing for their individuality.
What is more, their separate survivals estab-
lish the existence in the late 15th or early 16th
century of yet another pair of sun and moon
screens, which historical records confirm.[2]

The design of the right screen is quite in-
tense, a match for its challenging subject. The
left-most panels reveal a budding willow tree,
behind which a golden bridge spans a river
torrent as it juts diagonally upward, off the
screen. The continuation of this motif, which
appears only in *yamato-e*, would have pro-
vided the link to adjoining left panels, now
lost. Arching bridges like this one appear as
the central motif in *yanagi-bashi* (willow
bridge) screens, a staple *yamato-e* subject.

Traditionally these *byobu* (folding screens)
are thought to represent the bridge spanning
the Uji River, near Kyoto, which has been
immortalized in classical Japanese literature.

Billowing clouds of white pigment, ink, and
oxidized silver conceal the bridge span and
distant mountains. These clouds also provide
the unifying element of the entire composition,
whose primary features are a spectacular
cherry tree in full bloom, a waterfall, and a
torrential stream bordered by massive green
boulders. None of these elements of nature—
the season being spring—are viewed in their
entirety. The cherry tree probably alludes to
the Yoshino area, south of Nara, famous for its
wild cherry trees.

This lack of wholeness in the midst of such
a richly varied, dynamic expanse plied with
multiple layers of mineral pigments and ap-
plied metallic surfaces (including the solar and
lunar shapes) helps characterize this vision of
a *yamato-e* landscape. It not only establishes
the contrasting note through which the distant
sun appears, but also provides the binder that
links it to its more pacific mate, the moon
landscape. There, too, the world is as richly
endorsed with gold and opulent silver material
as it is fractured and layered.

Autumn grasses and rice fields in the right
and central panels ultimately give way to
snowy hillocks. The interlocking patterns of
reeds, water, rice fields, grassy or golden hills
intermingling with silver-gold clouds and sky

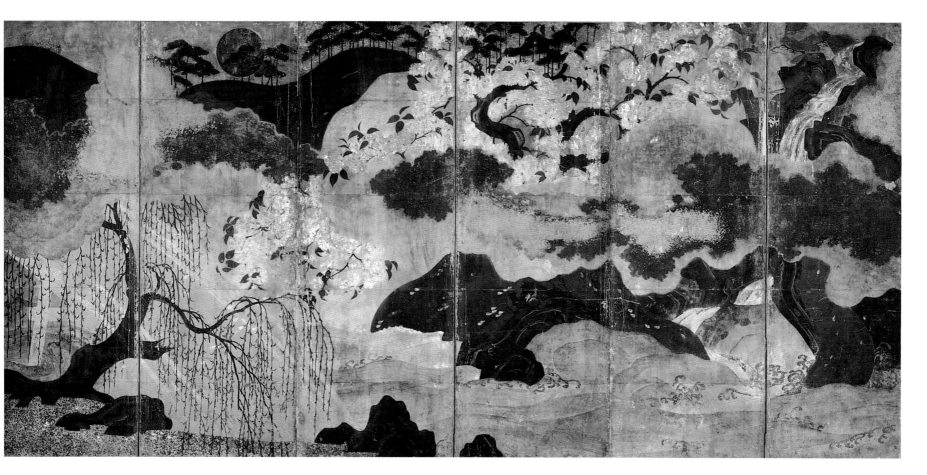

almost defy logical interpretation. Yet references to the seasons, to time, and to man's presence—the lone fisherman's hut raised on stilts in the right panel—assure the viewer that this aspect of the world, however fragmented, exists. But what these two landscapes *mean* presents more formidable obstacles, at least for the curious Western viewer, as noted earlier (in the essay).

The fact that they were brought together indicates that differences or incongruities in authorship, style, and expressive content were—and continue to be—secondary to completing a seasonal sun and moon image. Even differences in dating proposed by various scholars have not undermined the pairing. In part, this is due to their obvious visual appeal as a unit.

But an aspect of this appeal, which has little to do with the sense of the "decorative" so associated with colorful Japanese painting by Westerners, is the joining of two strongly contrasting, expressive components into one statement. Each screen contains a series of fragmented but interrelated painted elements whose sum total presents a new, poetic vision of a dynamic landscape. Time is specific both to season and time of day. And human presence is inferred, without the depiction of an actual figure.

Otherwise, the scenes depicted and the moods they evoke differ considerably. It is this interplay between commonality and divergence that ultimately explains their successful resolution together, within the sun and moon glare of *yamato-e*.

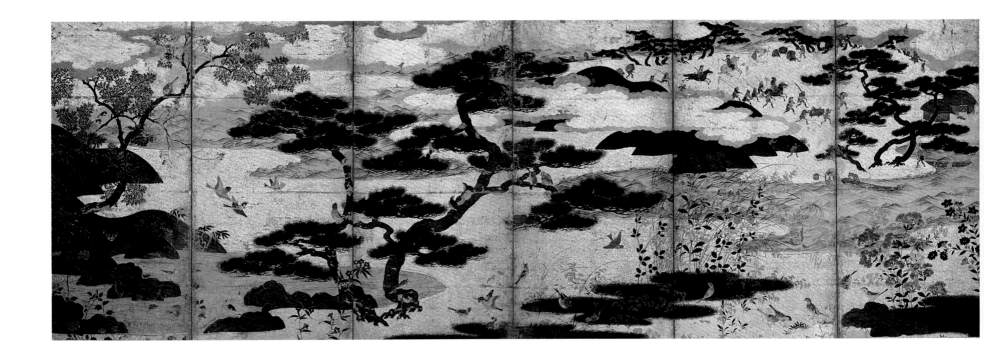

3　Hamamatsu Bay
Pair of six-fold screens; ink, color, and gold on paper with applied cut silver and gold
Each 106 x 312.5 cm
Muromachi period, 15th-16th century
Tokyo National Museum
Important Cultural Property

The compositional arrangement of these screens by an anonymous Tosa School painter represents a novel event in *yamato-e* of the period. On the one hand, the larger and most attractive visual elements are components of a seasonal landscape: budding willow tree with spring flowers (right) and two pines with autumn grasses (left). In the background are reduced genre scenes focusing on the themes of traveling, fishing, salt-making (right), and military pursuits (left).

The screens are somewhat smaller than the standard screen size, rather like the Suntory *Hie-Sanno and Gion Festivals byobu* [20], so that the viewer's initial attention is naturally drawn to the varied, meticulously rendered foreground elements. The number of birds (more than sixty) nearly rivals that of the flowering plants and grasses. Shown in gatherings rather than by paired species—as usually portrayed in 16th-century ink paintings (*suibo-kuga*)—they display a sense of playfulness and harmony with the landscape. There are no predators here (as in [29]).[1]

The foreground world appears quite self-contained in these *byobu*. Extensive areas of gold-flecked land and beach interlock with watery lagoons on small bays to provide a ground line and backdrop. Silver-outlined gold clouds roam through the sky at mid-distance, defining the upper limits of the aviary scenes. The large scale of the end-panel trees together with the features mentioned above effectively frame the scene, lending it the air of a timeless, studied—almost zoological—showcase (see also [4]).[2]

The prominence of the water theme once again in *yamato-e* provides both the "glue that binds" and the attractive ground that highlights transitional areas in the painting—whether from seasonal to genre subjects, fore- to background, or from a natural landscape to one inhabited by man. The water areas propel attention toward the center of the combined *byobu* in which six panels—half of the entire composition—depict the toil of men fishing, transporting (on water and land), making salt, hunting, and serving those of a higher social class (the *samurai*, on horses). Indeed, the inclusion of the *samurai* may provide a clue to the patronage or clientele for such a screen, in much the same manner that the original owner of a scene from *The Tale of Genji* [25] approved the rice-planting scene in his otherwise courtly *byobu*.

This represents an ongoing custom in Japanese painting since the Heian period to record the seemingly mundane with the religious, using the most refined materials and talented craftsmen. The meeting, as it were, of high and low, sacred and profane arises from the deeply held Buddhist tenet that there are, finally, no differences, only shared characteristics.

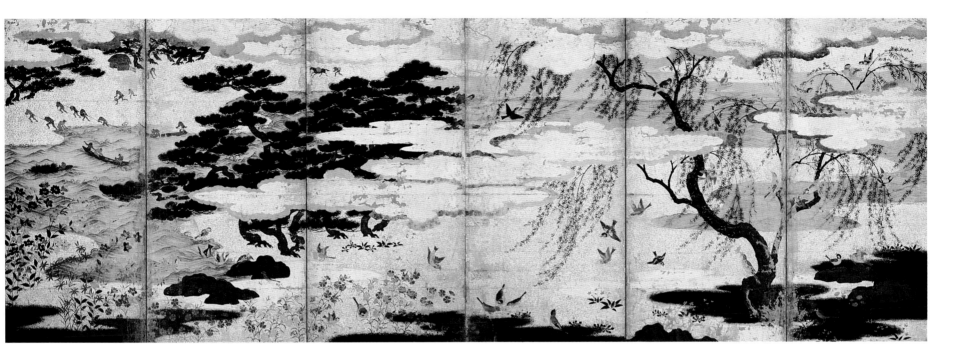

In these screens the predominant secular theme is fishing and the related activity of salt-making, for preserving fish and other perishable foodstuffs. The very same theme is found in the famous Shitenno-ji illustrated sutra of the 12th century.[3] Along with the culture of sake [36], the cultivation of rice, and the passage of time expressed through the seasons, these are some of the preeminent genres in the native arts of Japan. Underlying them are deeply religious notions—both Shinto and Buddhist—of cleanliness, salvation, and paradise. One contribution of 15th- and 16th-century *yamato-e* lies in its elevation of the status of everyday existence to a level commensurate with spiritual concerns. The popular Buddhism of the 14th century, which was

expressed visually in realistic sculpture and illustrated handscrolls, formed new meaning and expression in 16th-century *yamato-e*.

Thus the same energy and freedom with which the birds tumble and the winds blow in the foreground of these *Hamamatsu byobu* motivates the men in the distance going about their daily chores. Indeed, the artist has established a kind of equivalence in scale between birds and humans by foregoing any serious attempt at Western perspective. The assortment of activities within this gracefully layered, two-tiered format can be regarded as a kind of cataloguing, which inherently conveys a sense of separateness. This becomes evident by comparison with the *Rakuchu-Rakugai* [18] or *Famous Views of Lake Biwa* [19] in which a more fully developed, single-plane tableau

binds people or groups together, visually and emotionally. Clearly these *Hamamatsu* paintings are true pastorales, seldom seen in *yamato-e*.

In part, this feature helps explain the mesmerizing power of the Kongo-ji *Sun and Moon* screens [1], which benefit, ultimately, from the lack of any genre motifs or human or animal presence. To a lesser degree, the same may apply to the Suntory *Fall and Winter Landscape* [4]. But precisely because of man's inclusion in these idyllic bird-and-flower landscapes, these screens suggest more elaborate levels of interpretation.

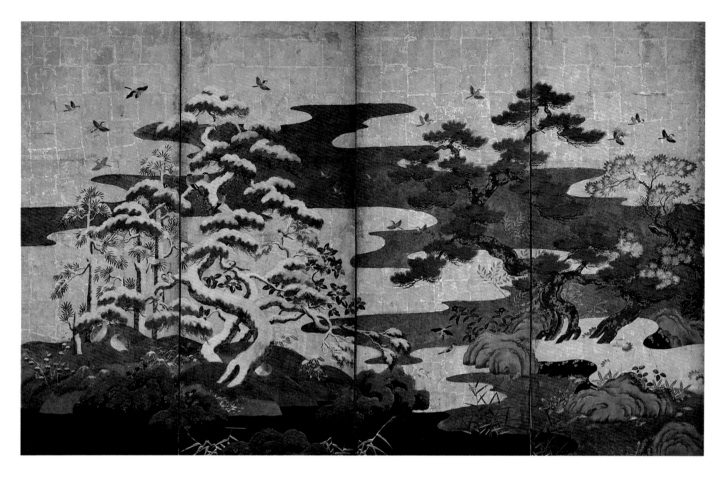

4 Flowers and Birds of Autumn and Winter
Pair of four-fold screens; ink, color, and gold
on paper
181.4 x 291.4 cm
Muromachi/Momoyama periods, 16th century
Suntory Museum of Art, Tokyo

These screens represent a departure from the
other *byobu* (folding screens) in the exhibition
in two significant ways. First, their present
condition indicates that they were joined to-
gether originally so as to form a single, eight-
panel screen—an unusual, although not un-
heard of, format in 16th-century painting.
Eight-fold (and ten-fold) single screens, how-
ever, appear regularly in Korean painting and
certainly were known in Japan then. Most
likely this screen was divided in half to form a

pair of seasonal landscapes rather than one
continuous scene when its mate, also eight-
fold, was lost.[1] Physical as well as visual evi-
dence confirms this. The brilliant red leafage of
the central maple tree—symbolizing autumn
—has been split down the middle. Originally
the pairing of this colorful maple with the pine
on an embankment sheathed in gold foil
marked the focal point of the composition.

Secondly, two seasonal representations are
missing: spring and summer. The large finger-
shaped banks of ground located at the mid-
point of the composition of the right-most
panel indicates where the linking motif for the
original pairing occurred. All the bird group-

ings and floral elements also cease well before
this panel's border, unlike any other margin
areas in this *byobu*. Then, too the direction of
flight of the various groups of birds overhead
indicates one side of a pattern that would have
required a balancing member to the right, now
unfortunately lacking.

Nevertheless, as is apparent in the Tokyo
National Museum *Sun and Moon byobu* [2],
unforseen—even odd—pairings in large-for-
mat paintings of the period often provide quite
satisfactory results. A long and venerable tra-
dition exists in Japanese cultural history of
creative "mismatching," especially in the
decorative arts. The continued vigor of the tea
ceremony through the centuries has in large
part benefitted from this openness to "rear-
rangement,"[2] or change in original intention.

In their present configuration these *byobu*
provide a resplendent, quite individualized ap-
proach to *kinbyobu* (gold-leaf folding screens).
The scene depicted includes a bewildering
assortment of meticulously described birds
(usually paired) and flora. Flowering plants
and grasses issue from behind almost every
rock or cranny, heralding the seasons. They
provide a web of line and color connecting the
three major land groups as well as enlivening
the internal visual cohesiveness of each land
unit. These features demonstrate an unmis-
takably similar lineage with [3], dating nearly
a century earlier.

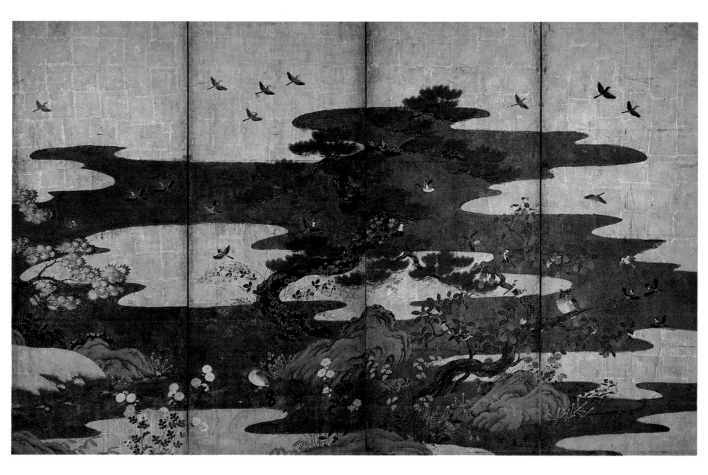

There is no middle ground in these Suntory *byobu*, and the landscape features occur in the foreground. Identifying actual "ground" as one views the screens from right to left proves elusive, except for the rock formations. The dark purple-brown tone that appears across the compositional surface plays a dynamic, chameleon-like role in suggesting here, water, there a cloud, and "ground" as well. Formed of an unusual combination of *sumi* ink and silver paint (*ginde*), which has darkened through oxidation over the decades, it provides the principal visual binder in the *byobu*.

While the dark blue-black stream in the left *byobu* makes it clear where water actually flows, the purplish-brown cloud bands defy clear interpretation as either water, ground, or clouds, as they provide an abrupt backdrop, with the gold foil, to the composition. Although similar in some respects (including date) to the *Birds and Flowers* screens [28], the extraordinary stylization and interplay of forms in such a severely delimited space points to a talent free of the Tosa-Kano School practices. While individual elements, motifs, or compositional devices are familiar, none appears wholly characteristic of another identifiable hand or school. In the aggregate, however, this perception becomes even clearer.[3]

The strength of refined visual characterization, of form and color, and the degree to which they coalesce effortlessly in these *byobu* is like no other example in the exhibition, perhaps indeed in 16th-century *yamato-e*. The origins of Rimpa (decorative style) School painting are anticipated so clearly here, in the later 16th century, 100 years before Korin (1658-1716).

One further note illustrates the novelty and creative spirit of this *byobu* pair. The far right panels of the right screen include an owl perched in a pear tree, gazing toward the edge of the *byobu*—presumably toward the left-most panels of the lost screen. Owls seldom appear in Japanese painting, so this may be one of the earliest 16th-century examples.[4] Indeed, many of the birds in the screen fly toward the owl, perhaps in recognition of its unusualness even among a varied assemblage of birds such as the artist has set forth in these *byobu*. The delineation of the owl's features is animated and deft, unlike the other birds, such as the quail. In particular, the golden eyes are encircled with green—a touch reminiscent of the occasional gold and silver lines used to enhance rock contours or tree-trunk forms elsewhere in the composition.

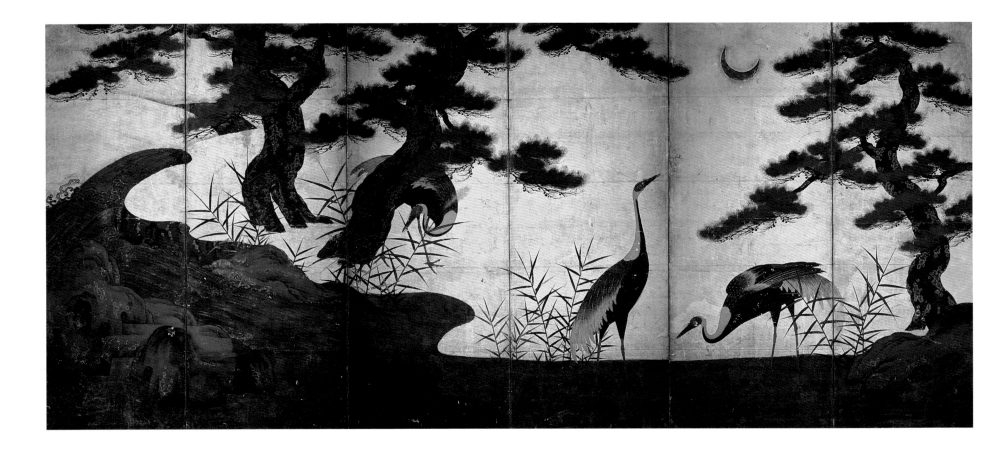

5 Sun and Moon with Cranes and Pine
Pair of six-fold screens; ink, color, and gold
on paper
157 x 352.4 cm (right); 157 x 366.8 cm (left)
Muromachi period, 16th century
Mitsui Bunko, Tokyo

Among the *yamato-e* screens with gold back-
grounds (*kinbyobu*) that have been redis-
covered in recent years, this pair is especially
distinctive. It depicts evenly matched groups
of cranes foraging along the banks of a stream
in a pine grove. *Sasa* and pampas grasses,
reeds, flowering azaleas, and little else other
than rock clusters comprise the setting. This is
a particularly quiet, even intimate scene, high-
lighted by the rich backdrop that extends from
streambank to treetops without the interruption

of clouds, blue sky, or distant landscape refer-
ences, as is commonly seen in *byobu* of the
period.[1]

This type of *yamato-e*, known only in a
handful of surviving examples—two of which
are in this exhibition ([5] and [6])—is rare. The
few depicted in *emaki* (illustrated handscrolls)
of the 15th and 16th centuries attest to the
infrequency with which such *byobu* appeared
in monastic or domestic interiors. However,
the Tokyo National Museum has a single
byobu of a splendid grove of pine trees set
against a simple gold background that belongs
in this select group of survivors.

Alterations in the condition of these *Sun
and Moon* screens make clear that at one time
they were used as sliding door panels (*fusuma*)
and therefore were integrated into a larger

painting cycle for an interior room. While nor-
mally this would mean that the paintings as
presently constituted were originally more
extensive—certainly a possibility—it also al-
lows for a room whose decor included an as-
semblage of subjects done in different stylistic
modes. Illustrated handscrolls confirm this
arrangement.

In any case, their present state adequately
demonstrates the visual impact of such an en-
larged, close-up view of these stately pines
and birds. Lacking any substantial reference to
deep space, the gold background provides an
effective field for further enhancing the mas-
sive, thickly colored pines and rock ledges.
The brush manner as well as the detailing in
tree forms is very similar to that of the Tokyo
National Museum single *Pines* screen.

If one considers broadly the visual "geome-
try" of these *Sun and Moon* screens—their un-
dulating contour lines, patterns of overlapping
forms, and the spacious, curvilinear intervals
distinguishing one natural element from
another—then it becomes possible to place
these screens in a more precise 16th-century
milieu. Other works to consider in such a
group would be the Tokyo National Museum
Pines screen (attributed to Tosa Mitsunobu),
and their *Horses and Grooms in a Stable* [22];
the Idemitsu Museum of Art's *Uji Bridge* and
Flowering Plants of the Four Seasons; and the
Cleveland Museum's *Phoenix and Paulownia*
screens (attributed to Tosa Mitsuyoshi [6]).[1]
Although the *Sun and Moon byobu* are surely

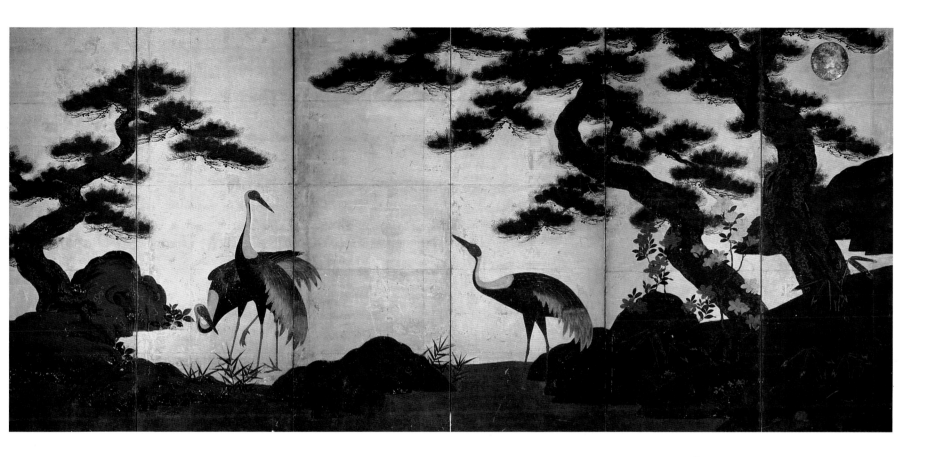

the work of a Tosa School artist during the first half of the 16th century, further study is required to determine whether, for example, Mitsuyoshi and his atelier should be assigned their authorship.

The lack of signature or seals on such large-scale *yamato-e* paintings as well as a dearth of historical records that might indicate patronage or siting complicate the research task. Mitsunobu and Mitsuyoshi's only substantiated paintings are small-scale works, albums, and *emaki*, which include calligraphic passages to describe the subject or narrative, and sometimes record the artist's identity. It would seem that these were more highly prized, at least as personal statements, deserving of the most refined materials and skill. Certainly they found special favor with patrons.

The distinctive, absorbent quality of the gold background in these *Sun and Moon* screens suggests equivalent attention to painting material in order to achieve a desired visual effect. A combination of *kinde* (painted gold) and *kinpaku* (applied gold foil) has been layered upon the surface to soften and diffuse the reflective capacity of the gold foil. Comparison with most of the other *yamato-e* or Chinese-style *byobu* painted on gold foil backgrounds in the exhibition reveals the difference in reflective light quality and strength.

The ambient gold tones in the *Sun and Moon* screens suggest a source of light from within (or better, *from behind*). In this way the dark, impasto-like blues, greens, and ochres of the main landscape elements gain both clarity and gravity. Considered from this point of view, these *Sun and Moon* screens illustrate a powerful new style, fully developed by mid-century. Today one can only imagine the added effect of seeing a richer band of blue water through which lines of silver wave patterns coursed—an effect now lost to oxidation of the materials over the centuries.

Comparison of the *Sun and Moon* screens with the subject, composition, and materials of the Cleveland Museum *byobu* [6] is informative.[2] Both pairs of screens possess compositions with crucial, weighted elements at their far ends; and they are joined by a continuous landscape feature that is centrally placed. Middle and far distance is all but eliminated.

Soaring trees and bamboo, or mounded rock groupings are summarily lopped off, top and bottom. Added to these devices for increasing visual dramatic appeal is the monumentality given the heraldic birds.

Indeed, the visual bravura of these two *byobu* resembles the pair attributed to Sesshu [11] rather than contemporary Kano painting. Both the palette and the elegant, compact design of these Mitsui Bunko screens underscore the diversity and sophistication of early 16th-century *yamato-e*. By 1500, Tosa School artists had mastered large-scale painting compositions with gold backgrounds, a fact certainly not lost on the emerging Kano School painters.

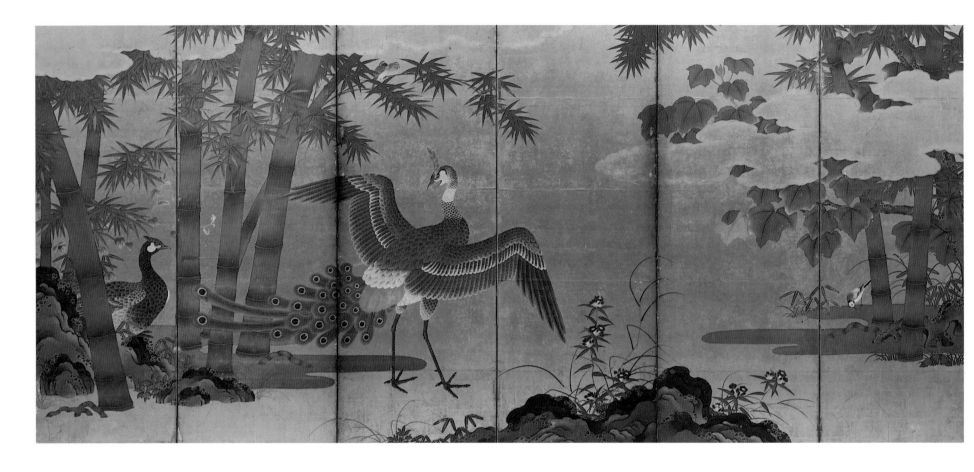

6 Phoenix and Paulownia, Peacock and Bamboo

Pair of six-fold screens; ink, color, and gold on paper
Each 160.5 x 362 cm
Attributed to Tosa Mitsuyoshi (1539-1613)
Momoyama period
The Cleveland Musuem of Art, Leonard C. Hanna, Jr., Fund, 86.2-3

Unlike the *yamato-e* paintings discussed so far, the seasonal theme appears here in a more cloaked manner. The common element of the massive bamboo stalks concentrated in three "islands" of landscape lends both an organizational schema and a focused temporal identity to the whole.

The identification of the seasons is indicated by the flowering paulownia of spring and early summer (right), followed by autumn's browning leaves (center) and, finally, a burst of red, signifying the arrival of winter. This sequence is unusual, but no more so than the joining of the two pairs of majestic birds. The mythical phoenix, traditionally an auspicious symbol in East Asian imagery, appears frequently in painting and Japanese lacquer decoration as well as literature from the Heian period. Its association with imperial authority in China seems to have been adopted in Japan in part because of its exotic form and decorative feather patterning. Its potential, therefore, for stylization and freedom of representation was great indeed.[1]

The paulownia tree, in which this mythical bird is said to have nested, is found in Japan, where its leaves and purple flowers are appreciated. In paintings and in lacquer designs, paulownia features appear either as separate design motifs or as components of a well-developed landscape, as here. The lacquer panels in the Kodai-ji temple, and the writing set and pair of screens by Kano Tanyu (1602-1674) in the Suntory Museum of Art are all superb examples of these approaches.[2]

The Cleveland screens, as well as others in the exhibition, present only portions of the principal trees and bamboo on a highly stylized ground puntuated by rocks, small flowering plants, and an occasional bird. Placed within a relatively narrow foreground space, these "islands" have extended, finger-like protrusions. Two of the preceding screens [3, 4] contain the same kind of islands, although in the latter they are more complex. These paintings, in addition, share similar palettes and patterns of flower arrangement.

Bamboo stalks, and rocks covered with lichen provide the fundamental design elements, anchoring the compositional ground and framing the birds. The placement and the depiction of the rocks is reminiscent of the Tokyo National Museum *Sun and Moon* screens (left side) [2]. The *Phoenix* and *Peacock* screens should also be viewed as sharing clear affinities in palette and in delineation of forms with the Mitsui Bunko *Sun and Moon*

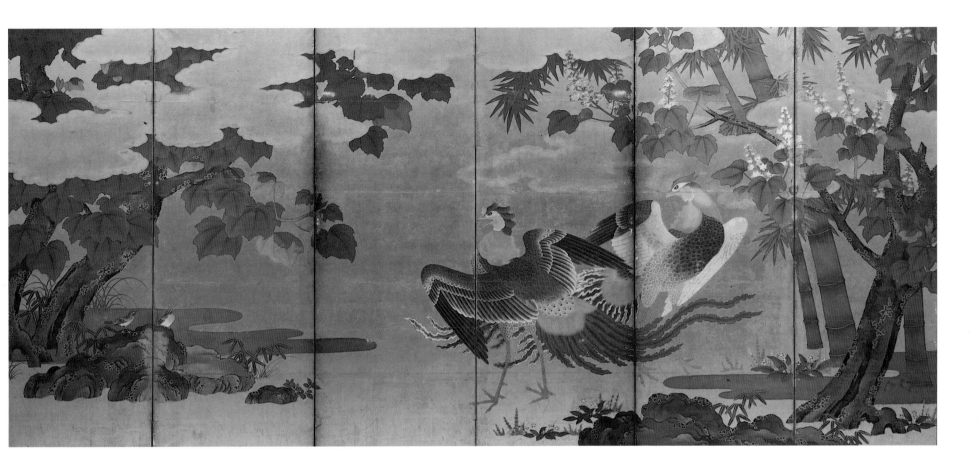

byobu [5]. These two pairs of screens are strong representatives of a small group of 16th-century paintings that not only have large areas of painted or applied gold surfaces but also make scant reference to middle or far distance.

Phoenix and Paulownia, Peacock and Bamboo provide useful, anecdotal pictorial elements that elucidate other works, such as, Kaiho Yusho's *Bamboo and Morning Glories, Pine and Camellia* [31], in which blue morning glories loop through the bamboo grove in the left screen, and the Metropolitan Museum *Bamboo in Four Seasons* screens [7], where the red ivy also mingles with the bamboo.

These *Phoenix* and *Peacock* screens, then, fit comfortably into a group of large-scale *yamato-e* generally assigned to a mid-century date.[3] By virtue of their subject, they appear to be special commissions made to inspire sentiments of authority cloaked in a decorative seasonal schema. No one would mistake these *byobu* as mates to Sesshu's Chinese-style screens of *Flowers and Birds in Four Seasons* [11], painted decades earlier.

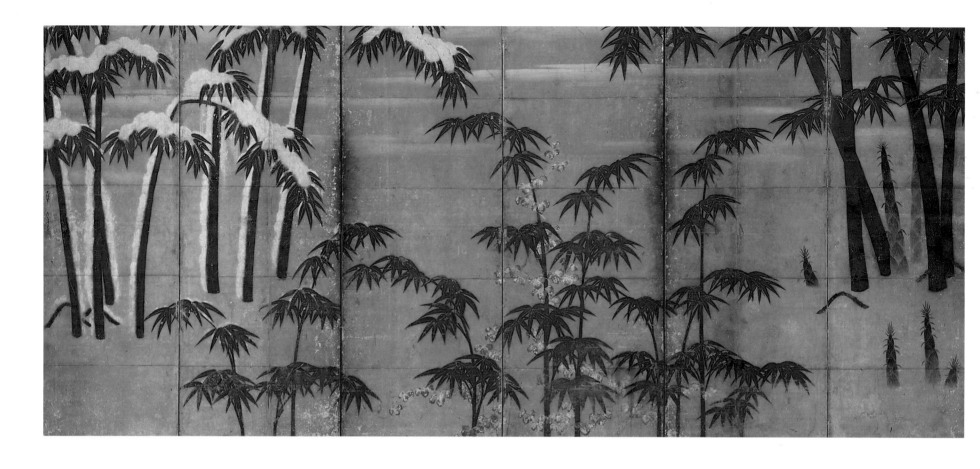

7 Bamboo in Four Seasons
Pair of six-fold screens; ink, color, and gold on paper
Each 174.4 x 381.7 cm
Attributed to Tosa Mitsunobu (1434-1525)
Muromachi period
The Metropolitan Museum of Art: The Harry G. C. Packard Collection of Asian Art, Gift of Harry G. C. Packard and Purchase, Fletcher, Rogers, Harris Brisbane Dick and Louis V. Bell Funds, Joseph Pulitzer Bequest and The Annenberg Fund, Inc. Gift, 1975 (1975.268.44-45)

While the Kyoto National Museum and Kuboso Museum *Genji* albums by Tosa Mitsuyoshi (1539-1613) provide documented examples of the artist's technique, materials, figural style, and design "sense," there exists scant comparable material for his father, Mitsunobu, among *yamato-e*—save portraiture and *emaki* (handscrolls).[1]

Despite this, numerous *byobu* have been attributed to him, at least two of which are in American museum collections and provide divergent views of his large-scale oeuvre: the Virginia Museum of Fine Arts *Birds, Animals, and Flowers* [17] and these *Bamboo in Four Seasons*. The linked, continuous vista of a bamboo grove seen through its stages of growth and the seasons is one of the most satisfying—and rarest—in all *yamato-e*. The subject is known through depictions in *emaki*, both prior to and contemporary with Mitsunobu's life.[2] But this pair of screens and the single screen of the same subject [8] appear to be among the most faithful of Mitsunobu's non-figurative *yamato-e* painting that survive.

The Metropolitan *byobu* describe a tranquil scene, utterly suspended in time but for the seasonal references passing from right to left across both screens: spring-summer-autumn-winter. Only small violets, *sugine* plants, and arched bamboo runners appear in the "landscape." Not a single mature bamboo plant —the ostensible subject of these screens— appears in its entirety. All are cropped above or below in a typical *yamato-e* convention meant to intensify visual contact in the picture plane and with the viewer. To this end, the stalks and the branches are "cleaned up," their forms are summarily delineated, and tonal variation is minimal.

The placement of bamboo stalks into evenly spaced groups across the *byobu* surfaces (clearly serving as brackets at the end panels) suggests again a common approach to *yamato-e* screen design in the late 15th-early 16th centuries. This evenness of form within a muted tonal palette also appears in the Cleveland *Pampas Grasses* [10] and *Stable* screens [23].

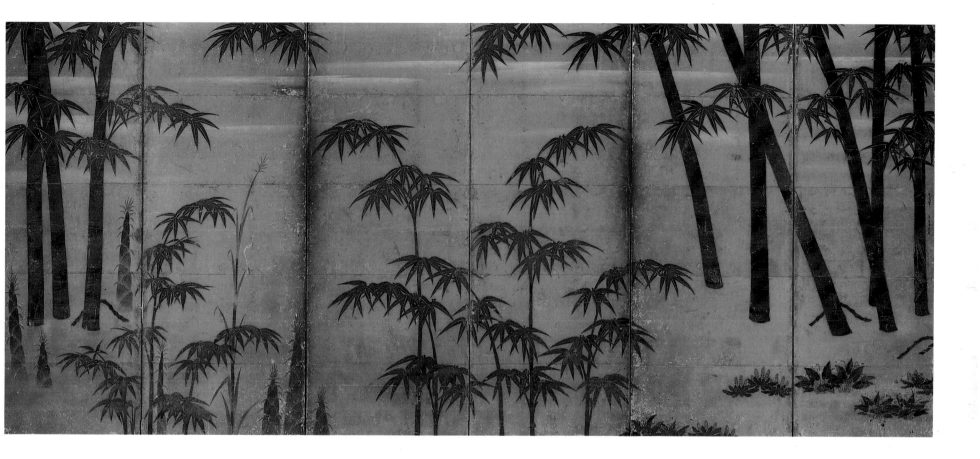

The spatial setting remains narrowly defined. The foreground is dramatically established by the cut-off plants. Far distance is suggested by the gold paint (*kinde*) applied as thin, faint clouds. The scene in fact occupies a narrow corridor quite similar to that in Sesshu's *Flowers and Birds* [11]. Judging from the *yamato-e* paintings illustrated in Mitsunobu's narrative *emaki* scenes, this lack of spatial recession is in keeping with the artist's other work. Spatial depth, at least in the Western or Chinese sense of progressive recession into "middle" and "far" distance, held minimal interest for Japanese *yamato-e* artists. In these screens, Mitsonubu took considerable license

with reality by presenting three seasons in one screen (left), omitting summer. Was the omission purposeful? a conscious decision to compel viewers to imagine the season on their own? Whatever the case, while the subject itself may be called into question, the presence of the bamboo theme and composition in the other, slightly later screen [8] affirms what is recorded in illustrated handscrolls: the subject was a staple of the *yamato-e* repertory, much like grasses, reeds, festival and genre scenes, and *Genji* episodes.

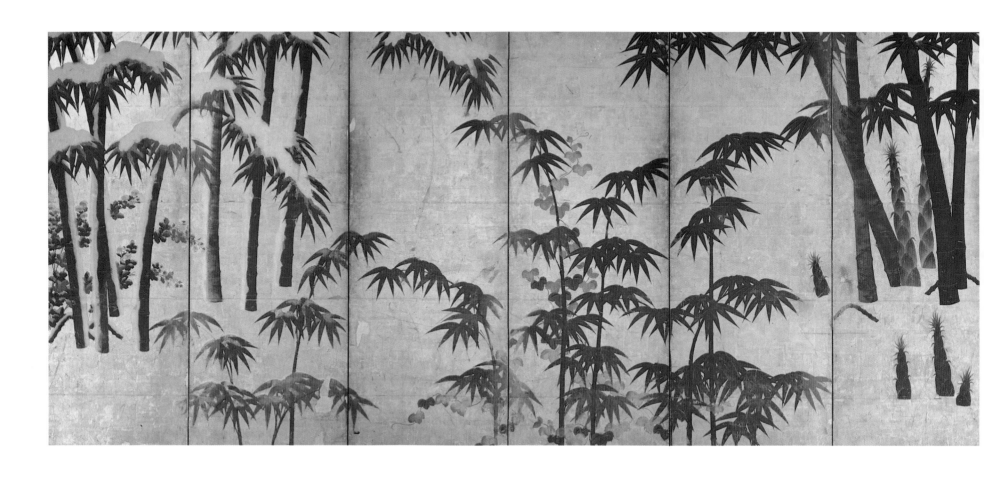

PAINTINGS

8 Bamboo in Four Seasons

Six-fold screen; ink, color, and gold on paper
Each 153.3 x 350.2 cm
Momoyama period, 16th century
Private Collection, Tokyo

While this single *byobu* of *Bamboo in Four Seasons* adheres closely in composition to the Metropolitan pair [7], it imparts a new, more strident tone. Its anonymous author (obviously inspired by the pair) chose instead a gold foil background to further delimit spatial depth and added chrysanthemums among the wintering bamboo. The palette is thicker and richer, the bamboo shapes more firmly and independently outlined. A comparison of the rendering of the snow in each of the paintings reveals these features, which are even more heightened by the gold background. The naturalism of the earlier Metropolitan screens, in which the viewer could imagine hearing the sound of snow falling to the ground from the heavy bamboo stalks, has become exquisitely fixed in this later screen.

The composition and the execution of this screen mark not only a departure from Tosa School *yamato-e* painting in the first half of the 16th-century but also a thoughtful, determined entrance into Momoyama-era painting and beyond. The willful alteration of natural forms, palette, and setting to achieve a new vision marks later 16th-century aesthetics— as witnessed in Kodai-ji lacquer [55], Yellow Seto ceramics [76, 77], or the Chishaku-in paintings of 1592 [32]. Indeed, the early Rimpa School artists Sotatsu (active ca. 1600-1640) and Sosetsu (active mid-17th century) took these pictorial elements to increasingly artificial, decorative levels following the turn of the century.[1] In doing so, they formed the latest link in a chain of *yamato-e* pictorial sensibility and subject matter extending back to Heian-period illuminated manuscripts.

Bamboo imagery in the later 16th century occurs in Tosa, Hasegawa, and Kano School painting, and continues thereafter, particularly in extensive *fusuma* (sliding-door panels) cycles that incorporate tigers as part of an image[2] favored by large temples or for audience rooms in castles. But the *yamato-e* preference was for bamboo alone, and was sometimes rendered as a fan painting (fig. 1; part of the same album of fan paintings in this exhibition [37]). Here again the theme of time's relentless march, as expressed by the winter season, is buoyed by the presence of young bamboo stalks arching across the fan's surface with considerable resilience. As if to emphasize this optimistic note (as well as to create a strong pictorial image), all of the mature bamboo stalks have been cut off.

This compressed "framing" of *yamato-e* subjects, some of which are actually quite expansive in scope (such as landscapes depicting famous sites in Japan), is discernible from the later Heian period (10th-12th centuries), as previously mentioned. It sometimes occurs in ceramics, lacquerware, and even metalwork designs as well. Indeed, a series of ink sketches for designs on Ashiya style iron kettles ascribed to Tosa Mitsunobu illustrate bamboo in four seasons.[3] Not only does this affirm Mitsunobu's interest in this subject, it also supports Tosa Mitsuoki's 17th-century claim inscribed on the Metropolitan *byobu* [7] that Mitsunobu painted them.

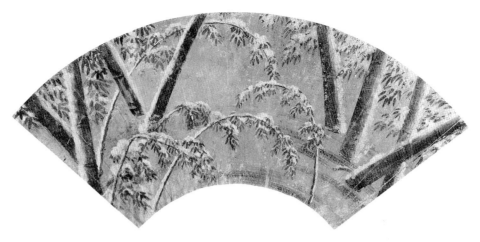

Figure 1.

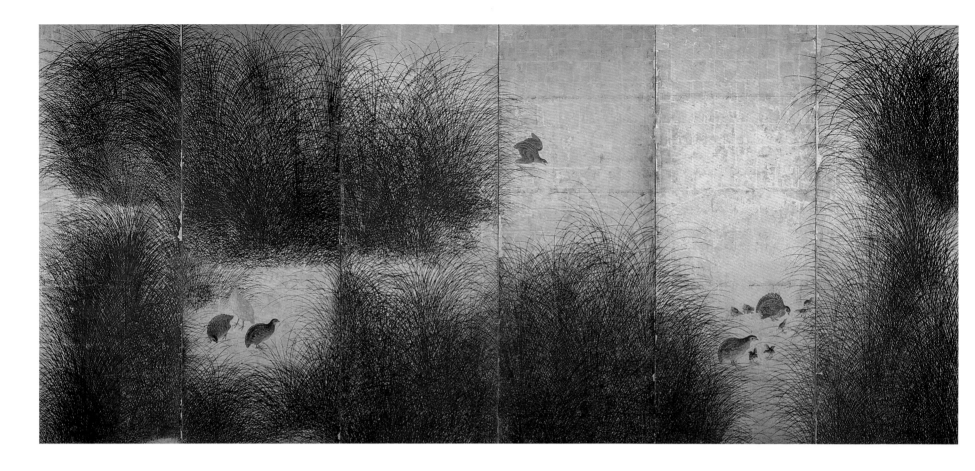

9 Quail among Autumn Grasses

Pair of six-fold screens; ink, color, and gold
on paper
Each 151.5 x 354.5 cm
Attributed to Tosa Mitsuoki (1617-1691)
Edo period
Nagoya City Museum
Important Cultural Property

Illustrated handscrolls provide numerous opportunities to peruse the interior settings of
Japanese homes, palaces, and temples. There
the accoutrements of daily life or religious
ceremony are set before the viewer in an
architectural setting that invariably includes
sliding wall panels (fusuma) or folding screen
paintings (byobu). In addition, objects made

for use as serving or display vessels appear
prominently: lacquer stands and bowls,
ceramic sake containers, or flower containers.

But among yamato-e subjects, pampas
grasses (suzuki) are clearly favored, as is discussed further in [10].[1] Rarer are marshes,
plains, or waterside vistas with reeds (ashi)
and grasses such as appear in this pair of folding screens (which were formerly fusuma).
Included are families of quail searching for
food. The environment of these delicate creatures is described by a fine latticework pattern
of grass fronds that surround and delineate the
quail. Each of the fronds appears as a single
brushstroke tapering ever so slightly as it arcs

towards a fine tip. The grouping and meshing of
individual plants form an attractive, dense
hedge of mineral green lines, which, against
the gold foil, establishes the picture plane.

In contrast to the Cleveland Pampas Grasses
[10], also once fusuma, these Nagoya paintings
do not attempt a faithful description of grass
stalks (or the textures of quail feathers). Sixteenth-century descriptive narrative has been
surpassed here by a refined stylization of color
and form, set within a thinly disguised background. The selective arrangement of a few
repeated elements on the two-dimensional
surface, each adjusted slightly in gesture and
scale, determines space. In its artificiality it
recreates a fresh view of nature, much like the
Horse Race at the Kamo Shrine [26]. There,

too, an unusual but familiar elegance of figural
portrayal and setting is achieved through descriptive detail and highly selective stylization
of landscape and background elements—such
as clouds—to "situate" the observer.

These two pair of byobu bring Tosa School
painting firmly into the 17th-century Edo
period. Yamato-e by mid-century fared well in
the hands of acknowledged masters such as
the Rimpa artists Sotatsu, Koetsu, and Mitsuoki. Mitsuoki's reputation, particularly in the
West, rests on a large number of finely colored
paintings on silk of quail and grasses in hanging scroll formats that are loosely based upon

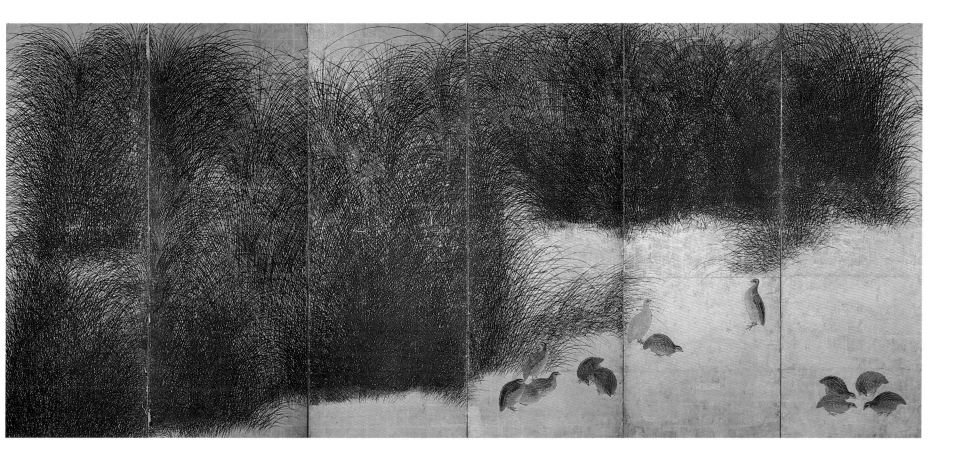

Southern Song (1127-1279) paintings of similar subjects in established Japanese collections. But his finest achievements are large-scale *yamato-e*,[2] including a registered pair of eight-fold screens of quail among millet and autumn grasses set against an expansive waterscape.[3] Although its composition is quite different, the pampas grasses at both ends and the rendering of the quail concur with the Nagoya paintings. In his revival of the Tosa School status, Mitsu-oki has adapted a *suibokuga* (ink painting) composition and a painting style reflective not so much of *yamato-e* as that of lacquer decoration in the Kodai-ji style. (The Itsuo Museum cosmetic box design [47] is a fine example of the kind of painted decoration he was likely familiar with in the mid-17th century.)

The Nagoya *byobu* then represent a new stage in the development of *yamato-e*, in which 16th-century naturalistic representation gave way to a renewed interest in the painterly refinements of much earlier works (Heian period, 794-1185). The theme of quail among grasses appears then in such poetic anthologies as the 8th-century *Manyoshu* and the 10th-century *Ise Monogatari* (Tales of Ise).

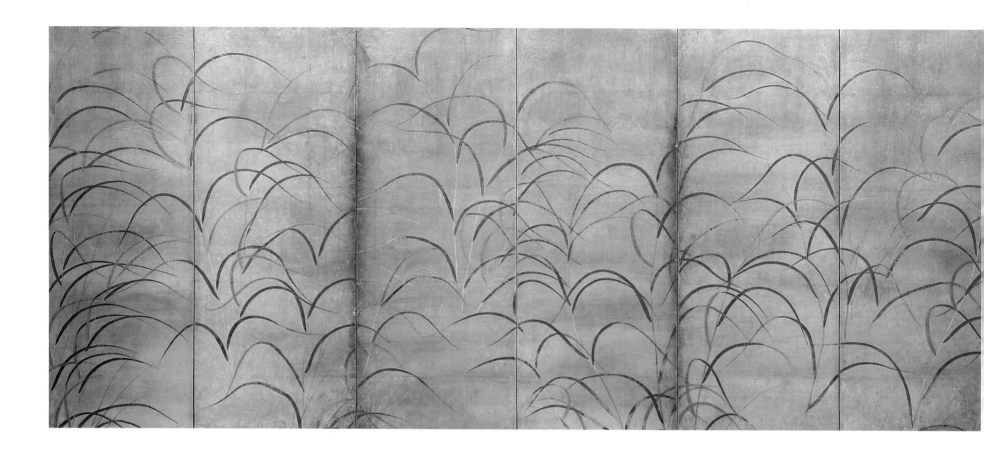

10 Pampas Grasses

Pair of six-fold screens; ink, color, and gold
on paper
Each 150.3 x 348.8 cm
Attributed to Tosa Mitsuyoshi (1539-1613)
Momoyama period
The Cleveland Museum of Art, John L.
Severance Fund, 84.43, 84.44

These screens, painted about the same time as
Birds, Animals, and Flowers [17], bear a tradi-
tional attribution to Tosa Mitsuyoshi. A num-
ber of Tosa School *emaki* (illustrated hand-
scrolls) contain depictions of pampas grasses
on *fusuma* and *byobu* alike.[1] In fact, the first
scroll of the *Kuwanomi-dera Engi* [33] pro-
vides a clear case in point. There, the ailing
princess Abe no Kojo lies in a corner palace
room flanked by two *byobu* of pampas grasses.
Although it is impossible to discern the com-
position for these autumn grasses, they fill the
height and breadth of the *byobu*, much like
these Cleveland paintings. It is also apparent
that they are not painted on gold foil back-
grounds, but rather on paper with mineral pig-
ments. In this respect, they belong to the
yamato-e lineage of the Metropolitan Museum
of Art *Bamboo in Four Seasons* screens [7].

These *Pampas Grasses byobu* have been
converted to their present format from sliding
door panels (*fusuma*). They should therefore
be viewed as perhaps seriously abridged from
their previous state, where they formed an
essentially stationary, flat pictorial element in
an interior setting. The subtle, interwoven
rhythms of the grass blades lend themselves to
either format, however.

Most likely the pampas grass theme arose
from the Heian period literary genre of *aki-
kusa* (autumn grasses).[2] Translated from the
literary realm to the visual world, it retained
references to landscape, figure, and architec-
tural representation. Literary customs of that
time included poetry contests in which paint-
ings inspired poems, while poems likewise
inspired painting. One outcome of these
competitions can just barely be seen here:
papers bearing poems applied to the painted
surface. These poem-papers (*shikishi*) were
viewed not as adjuncts to the visual statement
but as integral components in enriching the
visual subject.

The surface of the Cleveland screens re-
veals that approximately thirty *shikishi* were
formerly applied to the painting surface. Al-
though not random, their placement across the
panels clearly altered the appearance of the
composition and surely added a further dimen-
sion to its understanding and appreciation by
learned Japanese viewers. In recent times,
however, these *shikishi* were removed so that
the modern viewer could enjoy the lyricism
of the *suzuki* fronds undisturbed. Most of the
golden tufts of the grasses are essentially invis-
ible today, further emphasizing the pure line
drawing of the artist.

Judging from *emaki*, it seems reasonable
to conjecture a later 15th-century date for
straightforward pampas grass (and bamboo)

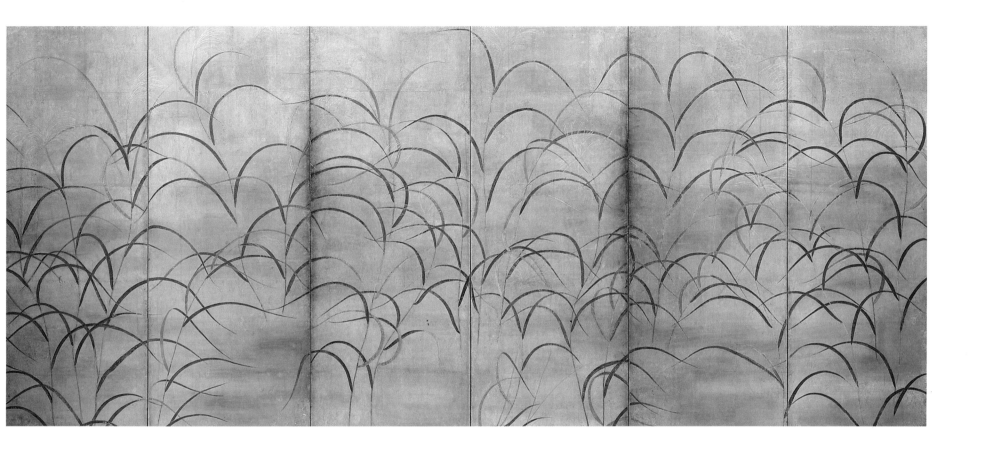

paintings, which were formerly included with *akikusa* (autumn grasses) and figural or landscape subjects. The mineral pigments, abbreviated composition, and sinuous, pale drawing echo features of the Metropolitan Museum of Art *Bamboo* screens [7], without the obvious seasonal elements. Indeed, these two pairs of *byobu* also currently represent the earliest examples of this type known in, or outside of, Japan.

The presence of *suzuki* (pampas grasses), however, certainly conveyed another reference to *yamato-e:* autumn. Their appearance in the *Kuwanomi-dera Engi* interior scene [33, fig. 1] signals this and reinforces the autumnal landscape elements (red maple foliage), depicted outside.

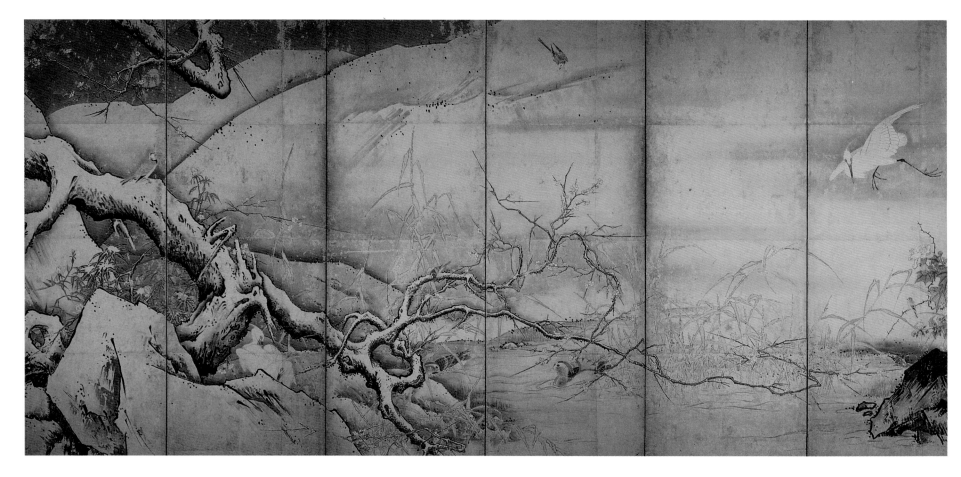

11 Flowers and Birds in Four Seasons

Pair of six-fold screens; ink and color on paper
Each 164 x 355 cm
Attributed to Sesshu Toyo (1420-1506)
Muromachi period
Agency for Cultural Affairs, Tokyo
Important Cultural Property

One measure of Sesshu's genius and fame in Japan lies in his versatility. Broadly defined, his work embraces all formats; he painted in ink as well as color and tried his hand at numerous subjects, both Chinese and Japanese. The quality and range of his skills remains as astonishing as it is subtle.

This pair of *byobu*, which bears neither signature nor seal of the artist, has nevertheless long been assigned to his hand in Japan. Indeed, among all screens attributed to Sesshu, these paintings have traditionally been given pride of place. Less than a dozen pairs of screens are currently known to have any claim to the artist's name.[1]

Two features of the bird-and-flower *byobu* immediately attract one's attention: the palette of light yellow greens, chalky pinks, and thick reds; and the surprising lack of depth in the composition. Contrary to so much 16th-century painting in the *kanga* (Chinese painting) style, space in these screens is severely diminished—more so than in any other large composition attributed to this artist. Some of

Sesshu's works suggest a conscientious application of massive, natural landscape features as blocking elements in his painting design, so as to strike dramatic visual effects within a shallow pictorial plane.

In these screens the shallowness is made apparent by the pine branches and by the craggy wall of rock behind the majestic crane (in the left screen). And the snow-covered mountain obstructs any retreat into middle or far distance, thereby focusing the viewer's attention on the extraordinary branching system of the aged plum tree. In both instances, one wonders whether this treatment of space derives from Sesshu's familiarity with *yamato-e*, where, characteristically, spatial depth is so shallow as to be, in conventional Western painting terms, "contrived." Through the

conjunction of *yamato-e* and *kanga* Sesshu achieves a new visual dimension in these screens.

Considered from this point of view the bird-and-flower painting shares more features in common with the *Stable* screens [22, 23], for instance, than with its fellow *suibokuga* (ink painting), [13] or [14]. Later in the century *suibokuga*, such as Shoei's birds and flowers *byobu* [16], often appear, scarcely acknowledging Sesshu's works or the contributions of *yamato-e* to advances in pictorial composition in the century. If it is reasonable to see in Sesshu's screens *yamato-e* elements of design, palette, and heightened form, then perhaps further effort can be put into exploring ties between *suibokuga* and *yamato-e* beginning in the late 15th century.[2]

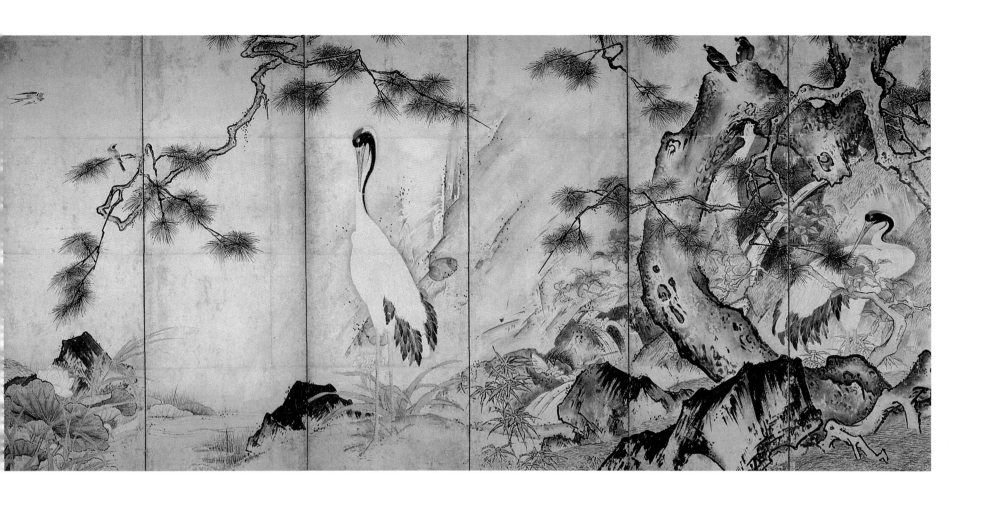

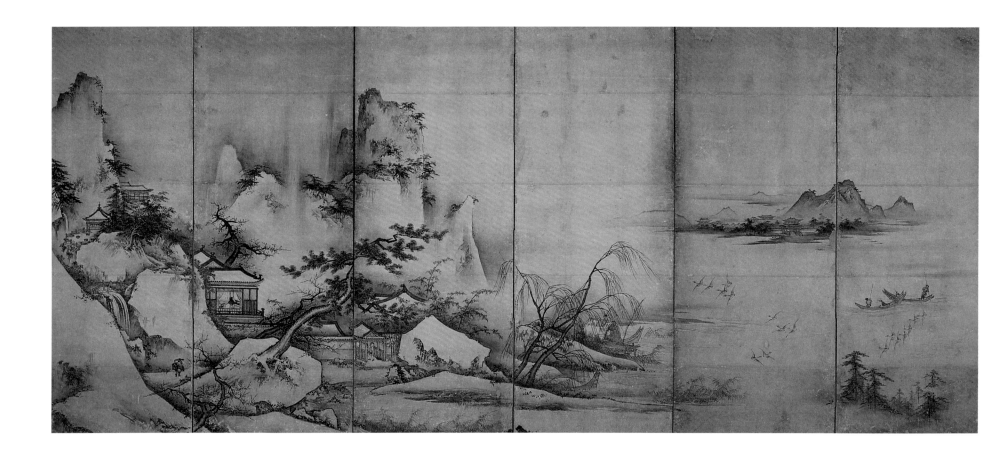

12 Landscape in Four Seasons

Pair of six-fold screens; ink on paper
Each 152 x 343 cm
Muromachi period, 16th century
Nagoya Betsu-in, Aichi Prefecture

This pair of screens depicting an idealized
Chinese landscape is introduced here in the
West for the first time, having only recently
emerged from the Betsu-in storehouse. Their
composition is typical of late 15th- early 16th-
century Japanese ink painting (suibokuga).

The framing elements of scholars' retreats
set against towering peaks echo those in other,
contemporary screen painting. Between the
passages of spring to summer (right) and fall to

winter (left) a generous expanse of river and
lakes extends into the far distance. The fisher-
men, the boats under full sail, a gaggle of
geese, and the temple buildings set along the
distant shore refer to the popular Muromachi
subject of the *Eight Views of the Xiao and
Xiang Rivers* [13].[1]

These Betsu-in paintings represent a calcu-
lated yet imaginative interpretation of this
traditional Chinese literary theme, intertwined
with seasonal and travel subplots. The anony-
mous artist's sensibility is particularly evident
in the delineation of the major framing units
with their rock massifs, sprawling pines, and
circling spatial units. The eccentric-curving
pines, the lush mountain slopes, and sharply
contrasting brushwork in the rock forms mark
the artist, separating his hand from a sizeable

group of large-scale *suibokuga* generally
associated with Shubun and his followers in
the late 15th century.

A pair of registered screens owned by the
Tokyo National Museum and attributed to
Shubun and his circle provide a similarly
distinctive style and composition for consider-
ing the Betsu-in *byobu*.[2] Both pairs possess
an idiosyncratic approach to the landscape
subject, which at the time was known through
scroll paintings brought back to Japan by trav-
elers on the Continent rather than through
first-hand experience. Consequently, the grace-
ful, willowy brushwork as well as the tonal
and volumetric ink effects seen in the broad
mountain contours reflect the artist's creative

response to what had become, by 1500, a
"set" theme in *suibokuga*. Apparent too is the
fact that the *byobu* format provided the most
challenging medium for the *Xiao-Xiang* theme,
given its generous size.

In the West, the single screen in Cleveland
of *Winter and Spring Landscape* (fig. 1), once
part of a pair, represents another example of
the subject, albeit painted in a more orthodox
manner. Details from illustrated handscrolls of
the 14th century tell us clearly that panoramic
vistas of high mountains and broad waterways
executed in *suibokuga* occupied places of
prominence in secular as well as monastic
settings. Requirements of the interior architec-
ture affected size or material, as can be seen
in the three screens mentioned here.

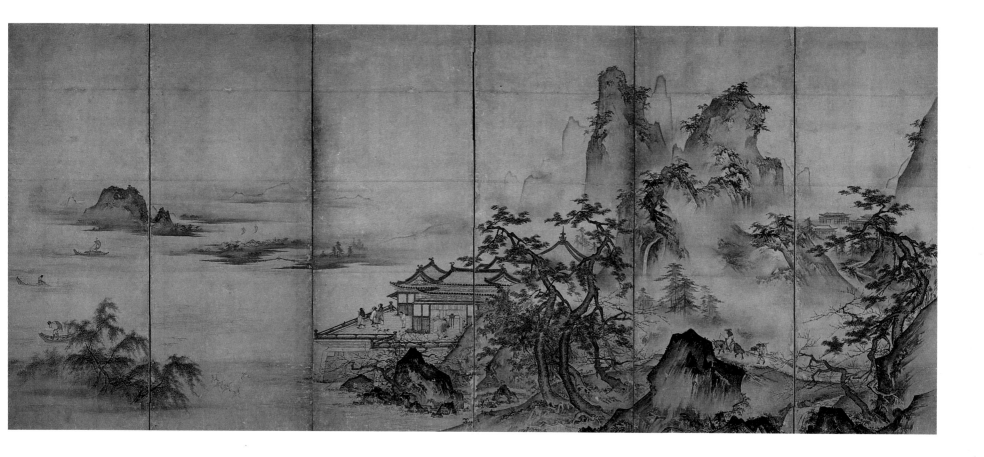

All three works can be safely dated to the last quarter of the 15th century, and all reflect painting styles broadly associated with the monk-painters Shubun (active 1414-63), Shokei Ten'yu (active 1440-60), and Gakuo Zokyu (active 1504-20). This is also precisely the era in which Tosa Mitsunobu was beginning his career, and the Kano School of painters were appearing in Kyoto circles. Their patriarchs, Masanobu (1434-1530) and Motonobu (1476-1559), studied Tosa School painting but pursued independent paths, eventually earning shogunal patronage. Masanobu's work, and indeed the majority of subsequent Kano masters in the 16th century, indicates that they set the standards for preferred subjects and formats—usually Chinese figural or landscape themes done in a carefully circumscribed composition and brush manner.

By contrast, surviving paintings attributed to Shubun and other independent "amateur" ink painters include *byobu* that stray from orthodox thematic interpretations to incorporate strong seasonal references, a staple of *yamato-e*. While future research will surely examine the relationship in the late 15th century between Tosa, Kano, and Shubunesque painting, these Betsu-in screens will have already taken a secure place within that era.

Figure 1.

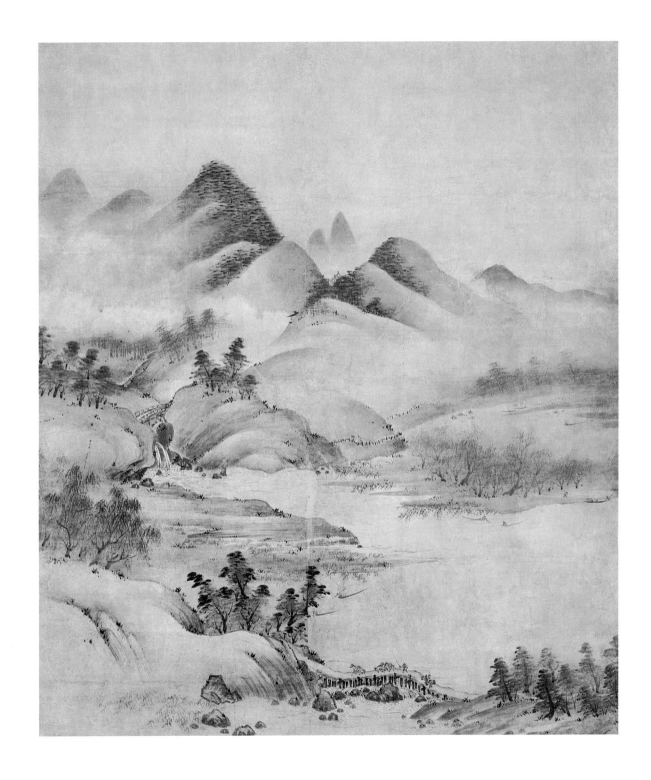

PAINTINGS

13 Eight Views of Xiao and Xiang Rivers

Hanging scroll; ink on paper
128.5 x 111.7 cm
Soami (1485-1524)
Muromachi period
The Cleveland Museum of Art, John L.
Severance Fund, 63.262

It is doubtful that there was a more influential artist at the turn of the 16th century than Soami. His position as principal cultural advisor to the shogun Ashikaga Yoshimasa (1436-1490) secures this estimate of his status. Both as a painter in his own right and as successor to his father, Geiami (1431-1485), as shogunal advisor, Soami enjoyed the enviable position of being familiar with the largest collection of Chinese paintings in the country.

His paintings reflect this knowledge and his comfortable mastery of Song and Yuan dynasty ink styles, even though adapted for Japanese taste. Thus, no matter which foreign brush or ink style he chose to work in, the contouring brush lines, interior ink tones, and the very forms of the landscape or figure painting appear not only dynamic but also more palpable and more intense in tonal values.

This large hanging scroll has traditionally been regarded as coming from a set of *fusuma* (sliding door panels) from the Daisen-in sub-temple in Kyoto. Founded in 1508, this Zen temple possesses a most remarkable rock garden. But while Daisen-in retains some *fusuma*, a complete cycle of the imaginary vistas of the Xiao and Xiang Rivers has not survived.[1] Nevertheless, large-scale ink compositions by Soami and his followers are known, some of which have only come to light in recent years.

One large hanging scroll in the Hasegawa collection (in Yamagata Prefecture) is contained in a 17th-century Kano School sketch scroll of old paintings published some ten years ago.[2] There the left side of a pair of ink landscape screens bearing the signature of Soami illustrates the Hasegawa painting as the two right-hand panels of the *byobu*. The two left-hand panels show the Cleveland painting. This leaves the two middle panels and the right screen unaccounted for, but at the same time confirms the physical evidence of the Hasegawa and Cleveland paintings. Recent restoration and remounting of the Cleveland painting reaffirmed the presence of a vertical seam and losses in the middle of the composition, just where a fold in the original screen occurred.

Since it is now clear these paintings are not part of the remaining Daisen-in Xiao-Xiang *fusuma* sequence, their dating becomes more fluid, despite a close stylistic relationship. Future examination of Soami's *byobu* paintings and hanging scroll sets ought to prove helpful in this regard, since he preferred to work in these formats (judging from extant paintings). The followers and admirers of his brush style, such as second- and third-generation Kano School painters, also emulated his predilection for sets.[3]

While his older contemporary, Sesshu [11], shares few of Soami's stylistic and compositional traits, especially when considering their strongly divergent approaches to the treatment of space, there exist solid links with the Kano painters, such as Shoei [16], but more so with Shikibu [14], who like Soami, seems to have paid little attention to *yamato-e*.

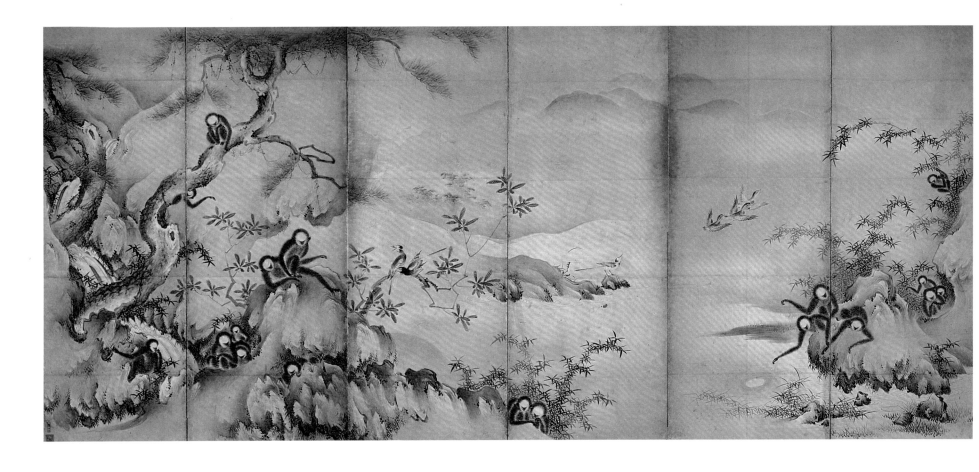

14 Monkeys on Rocks and Trees

Pair of six-fold screens; ink, color, and gold
on paper
Each 148.5 x 339 cm
Shikibu Terutada (active early 16th century)
Muromachi period
Kyoto National Museum
Important Cultural Property

Shikibu's *Monkeys on Rocks and Trees* fea-
tures a subject well known in Japan since the
15th century, when Chinese monkey paintings
were brought into the country by travelers
returning from the Continent. Most of these
were ink paintings (*suibokuga*), either on silk
or paper, which enjoyed popularity with the
Zen Buddhist community and later with fledg-
ling tea ceremony practitioners. Japanese

monks in particular favored them as quasi-
religious icons, emblematic of the spirit's un-
fettered, even playful, state following the at-
tainment of enlightenment. Single paintings,
pairs of hanging scrolls, and *byobu* depicted
this subject by mid-century in Japan.[1] A quar-
ter century later Sesson Shukei [15] and
Hasegawa Tohaku (1539-1610) produced fresh
interpretations that would stand as the finest
monkey paintings until the 18th century.

These screens by Shikibu reflect his most
ambitious, and mature, *suibokuga* style—one
that owes a clear debt to Soami. This is appar-
ent in the brushwork of the rocks and distant
mountains, as well as in their shapes, to which
Shikibu adds an energetic, tremulous quality.

Like Soami's *Eight Views of Xiao and Xiang*
[13], deep spatial recession plays an important
role in this *byobu* composition, serving, to-
gether with the extensive gold paint washes, to
highlight the foreground setting for the mon-
key families. Framing boulders and large trees
proscribe lateral borders, as in a typical Kano
School work, such as Shoei's [16]. The pres-
ence of the gold wash throughout the painting
surface is a notable departure from basic
suibokuga conventions, but then Shikibu's
screen paintings all employ this colorful fea-
ture to considerable dramatic effect.[2]

But it is the playful groups of monkeys in
tandem with the screens' dynamic brushwork
and tonal nuance that carry the picture and
delight the eye, much like the animated sur-
face of the Kongo-ji *Sun and Moon byobu* [1].

The degree of stylization and smooth integra-
tion of forms compares favorably. The pace of
the brushline and the modulation of the ink
tones is remarkably assured. The tree branches
and bamboo foliage in particular resemble
Yusho's in the Cleveland *Pine* and *Bamboo*
screens [31]. Both artists reveal adroit
suibokuga techniques imbued with an
attractive *yamato-e* sensibility that is transmit-
ted by either careful applications of color or
mannered brushwork. Comparison with
Shoei's *Birds and Flowers* screens [16] of ap-
proximately the same period points up
Shikibu's freedom from the academic stan-
dards of the time. His possible influence on
Yusho or the monk-painter Sesson and his
followers bears investigation.

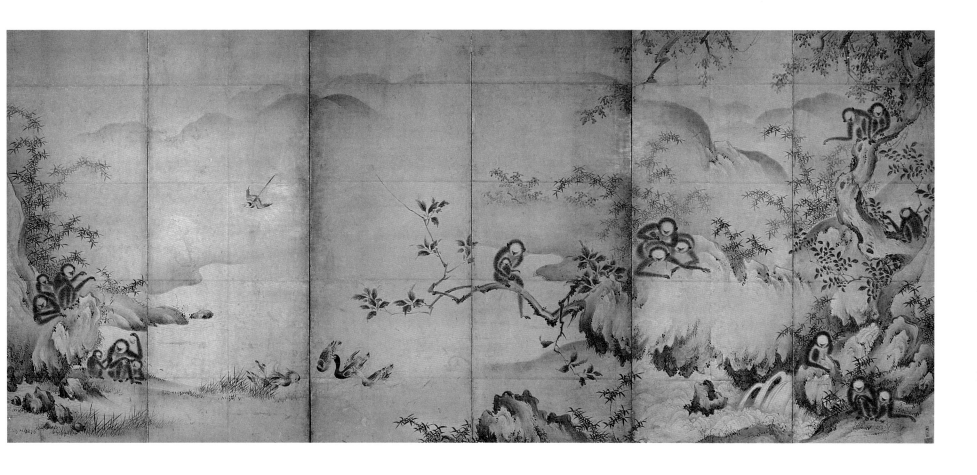

The seemingly effortless attractiveness and mood of felicity that characterize the best work of these late 16th-century masters also marks these Shikibu *byobu*. It demonstrates once again the assimilation and transformation of foreign subject matter in Japanese art, whereby an image succumbs to native stylistic conventions—in the process, accruing the attributes and spirit of *yamato-e*.

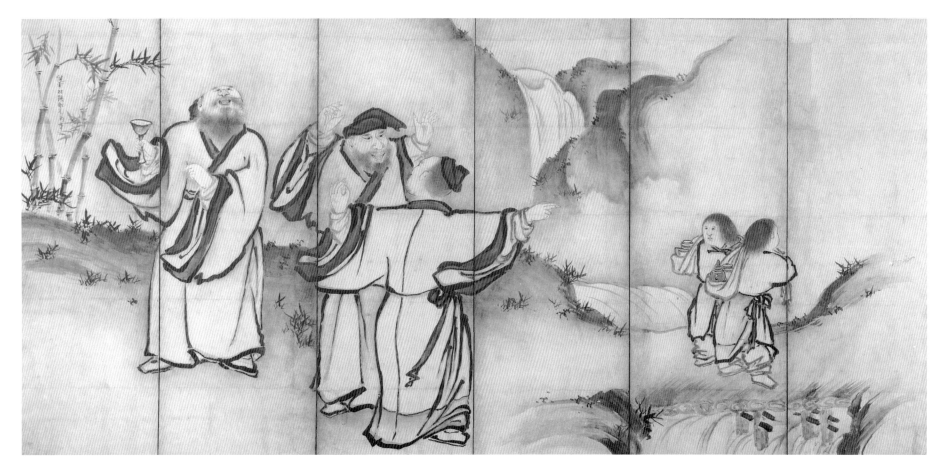

15 Seven Sages in a Bamboo Grove

Pair of six-fold screens; ink on paper
Each 160 x 325 cm
Sesson Shukei (1504-ca. 1589)
Muromachi/Momoyama periods
Hatakeyama Kinenkan, Tokyo
Important Cultural Property

This pair of linked monumental figure paintings represents what is arguably Sesson's greatest achievement in figural composition. Based upon the 3rd-century Chinese theme of a group of officials who retire from government service and flee into the countryside, the bold characterization in these screens possesses a more charged, personalized appearance than the artist's other renditions of Chinese figural themes.[1]

In large measure this is due to the spareness of the setting. Bamboo, shrubs, rocks, and water elements appear in abbreviated forms, unadorned by spectacular shapes or brushwork. The latter treatment is reserved for the figures, each of whom exhibits an individualized stance, gesture, or facial expression. The placement of these imposing figures, either singly or as overlapping rhythmical units, represents a fresh order in the development of Sesson's work, and in later 16th-century figure painting generally. Sesson's control of the byobu's horizontal expanse for the purposes of narrative has never been more convincing or

dramatic. Among the classically trained Kyoto artists, only Kaiho Yusho [30] or Unkoku Togan (1547-1618) approached such grandeur.

While Sesson's earlier paintings reflect his studied appreciation of classical Chinese, Korean, and Japanese ink paintings (suibokuga) —his travels to Odawara and Kamakura from his northern provincial home gave him opportunities to view collections there—his later work took on an impressive scale and wit. His proclivity for brilliant brush technique and startling expressions of light and dark contrasts have subsided here to an unusual degree, such that the figural characterizations and gestures of mirth appear to meld effortlessly across the entire landscape and off the screens' surfaces.

An air of strong classicism marks these byobu, in which time-honored subjects are reinvoked with new emotional intensity and nuance. This achievement is not unlike that of Tosa Mitsuyoshi (1539-1613) in revitalizing yamato-e subjects such as the Genji Monogatari in the later 16th century.[2] But whereas they worked most successfully in the small album format with jewel-like clarity and resplendent mineral pigments, the scale and tonal restraint of Sesson's byobu suggest a classic revival closer to examples in Western

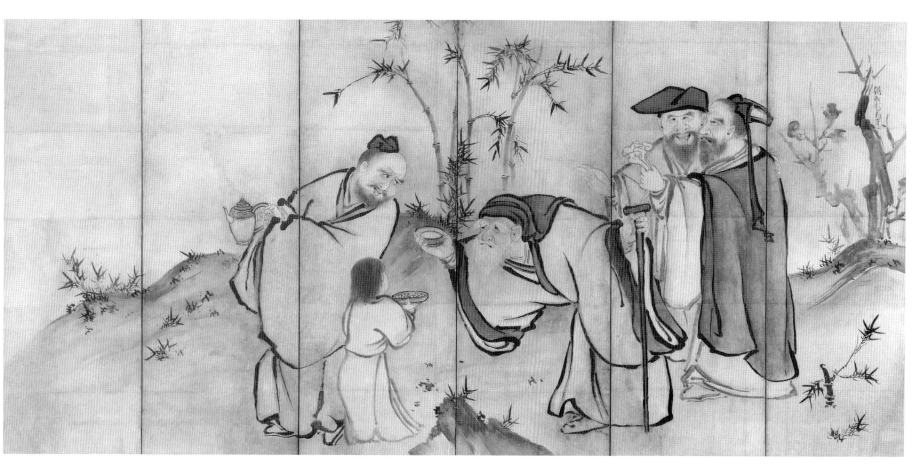

art such as Ingres' (1780-1867) in 18th-century France in which light, stoicism, and monumental reverence for the past inculcate contemporary painting traditions, thereby transforming them in both spirit and form.

Sesson of course knew no Western paintings and, judging from his oeuvre, was little affected by *yamato-e* themes, if at all. It is nevertheless worth reflecting upon the degree to which these screens acknowledge an awareness of genre painting in *yamato-e*. Two details will suffice to make the point. First, the mirthful expressiveness of the elderly revelers, particularly in the left screen, reminds one of the

seated figures playing both *go* and *shogi* in the Tokyo National Musuem and Cleveland *Stable* screens [22, 23]. Since traditional Chinese and Korean figural painting scarcely evinces clear emotional expression or the observation of the human social condition, might the secular nature of *yamato-e* have become a component of Sesson's attitude towards *suibokuga?*

Secondly, the rendering of the earthen bridge and distant waterfall is reminiscent of *yamato-e* design as seen in *Bamboo and Morning Glories* [31]. The foreshortening and awkward placement—from a Western perspective —seem curious, but visually successful. The compositional transition between the screens is also rather abrupt.

Finally, it should be noted that Sesson has presented these imposing, jovial characters within a sharply abbreviated landscape, thereby creating a foil not unlike that apparent in a number of *yamato-e* screens in this exhibition. Consequently, the screen's subject and its emotional thrust is immediate, allowing minimal retreat into a distant, natural setting. This kind of compositional shorthand has a beguiling simplicity that permits economy of "reading" by the viewer. It is, as we have seen, a staple of *yamato-e* through the centuries.

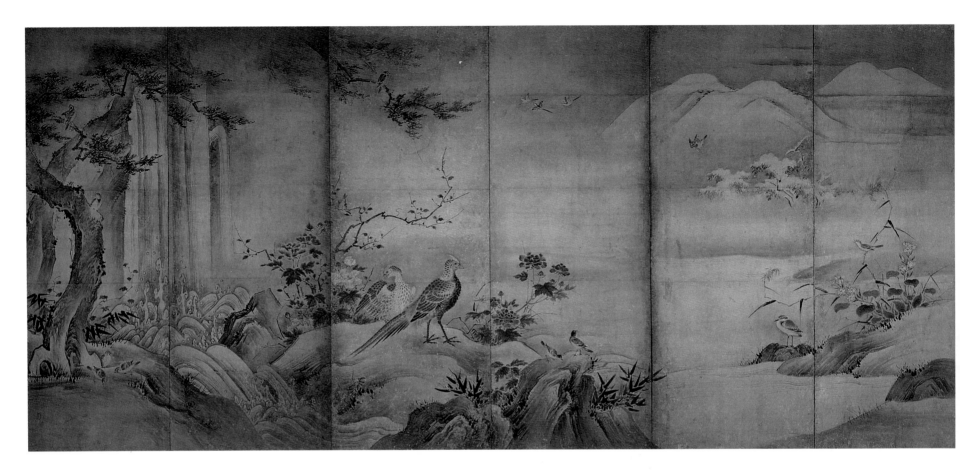

16 Birds and Flowers

Pair of six-fold screens; ink and color on paper
Each 156.5 x 350.5 cm
Kano Shoei (1519-1592)
Muromachi/Momoyama periods
Agency for Cultural Affairs, Tokyo

These screens have traditionally been identified by Japanese art historians as a cornerstone of Shoei's oeuvre, mainly because their extensive publication and exhibition history emphasize the presence of a "Naonobu" seal clearly impressed on each screen. The identical seal appears on Shoei's other key work, the large *Nehan-zu* (Death of Buddha) in the Daitoku-ji, of 1563.

Here, the composition is a fairly standard one in which bird-and-flower motifs fill a landscape setting framed by large rocks and trees. Water elements not only bind these lateral compositional features but also provide linkage between near and far distance. The brush manner reflects Shoei's assimilation of the Ami School style at mid-century, particularly as adapted by his father, Motonobu. Comparison with the mountain forms as a well as "dotting" brush technique to indicate vegetation in the Cleveland *Xiao-Xiang* hanging scroll [13] illustrates the stylistic reference here.[1]

But the shallow spatial recession of these *byobu*, highlighted in the cascading waterfall or grove of pine trees with their sharp, angular features and attenuated brushwork, points to a new, dramatic turn among Kano School painters at mid-century. One notes, however, that Sesshu [11] foretold this attention to a more abrupt two-dimensional surface some fifty years earlier. Perhaps an even more telling historical and visual reference presents itself when these Shoei screens are compared to *yamato-e* bird-and-flower screens in the exhibition—such as [3] or [6].

These paintings accurately describe a distinguishing characteristic of later 15th- and 16th-century *yamato-e*: the projection of enlarged landscape elements in the foreground so as to produce a dynamic, rhythmical picture surface. The entire composition reads horizontally at a glance, rather than across and through pockets of space. Both the Shoei and Mitsuyoshi [6] *byobu* portray a rather artificial, almost garden-like scene. Yet through the determined lack of background in those screens—replaced instead by a wall of gold leaf that emphasizes the sense of "stop time" and un-naturalness—the *yamato-e* composition achieves a concentrated visual harmony beyond that apparent in contemporary ink paintings (*suibokuga*).

Nevertheless, a particularly intriguing aspect of Shoei's vision that enhances the sinewy brush manner while promoting spatial contraints is the artist's aversion to overlapping structures. Liberal amounts of space surround the natural elements so that pictorial

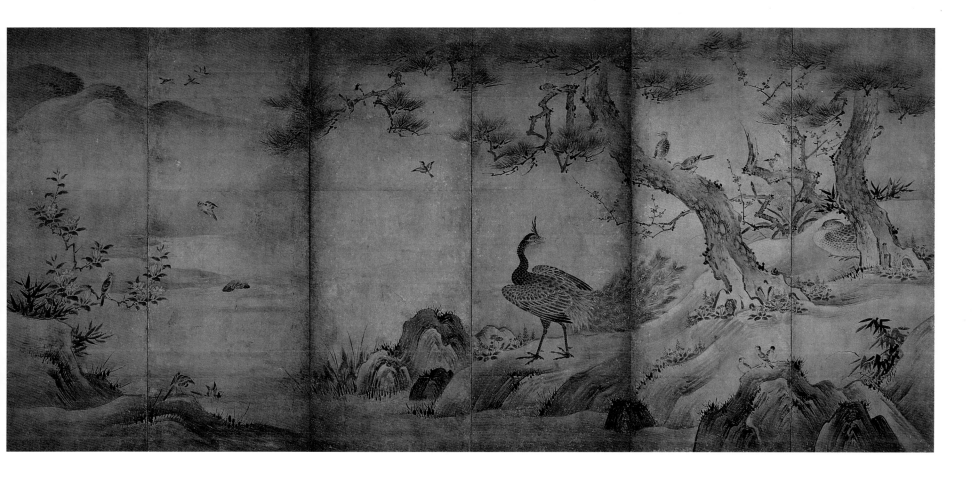

clarity triumphs. A similar but more height-ened organizational clarity can be seen in the Suntory Museum's *byobu* of *Flowers and Birds of Autumn and Winter* [4]. Rocks, trees, birds, and flowering bushes are portrayed separately. Three "islands" of rock outcroppings tie to-gether the seasonal theme with the bird-and-flower subject. Although twin pines wrap about one another in the far left panel, land-scape components remain clearly delineated, even independent.

The Shoei and Suntory *byobu* both occupy a familiar time frame, despite their different painting school backgrounds (Kano vs. Tosa). Both also reflect attenuated, miniaturized interpretations of traditional school composi-tions and subjects. The masterful layering of

blue "water" and gold "cloud" lozenges in the Suntory *yamato-e* screens achieves a kind of elegant play on the mutability of forms and substance. Here, Kano Shoei's depiction of zig-zagging, slender branching systems or iso-lated, floating leaf groups reflects a similar organization of patterns. The visual language is a shared one, therefore, in the third quarter of the 16th century—one that will quickly metamorphose.[2]

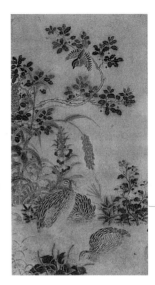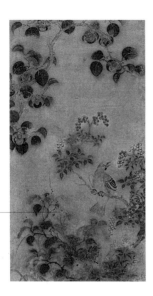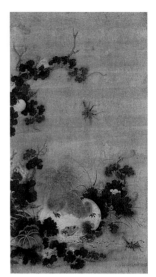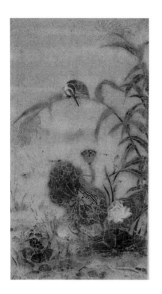

17 Birds, Animals, and Flowers

Pair of six-fold screens; ink, color, and gold
on paper
Each 99 x 282 cm
Attributed to Tosa Mitsunobu (1434-1525)
Muromachi period
Virginia Museum of Fine Arts, Richmond,
Museum Purchase: The Arthur and Margaret
Glasgow Fund, 66.72.1, 66.72.2

The bird-and-flower screens belonging to the
Virginia Museum of Fine Arts are perhaps the
most atypical paintings attributed to Mitsu-
nobu by recent scholarship.[1] Each painting is
individually mounted and set against a paper
background to which a thin gold wash (kinde)
has been applied. Numerous single bird-and-
flower scrolls (with color) from the period exist
today, usually with seasonal references and in
landscape settings. A few have become
paired, but only one other early 16th-century
screen ensemble—by Toshun, a pupil of
Sesshu—is known.[2]

The Virginia paintings eschew references to
a landscape setting, focusing instead on a
wealth of flora and fauna keenly observed. An
impressive assortment of plants highlights the
activities of the birds, insects, and animals in
each panel. A few of the animals are quite
unusual in Japanese painting, but taken to-
gether they appear only slightly different from
the traditional panoply of plant and insect life
seen in the bird-and-flower painting genre.

What is more unusual—and fascinating—lies
in the scenes of predation, a subject rarely
treated in yamato-e but which occurs with in-
creasing frequency in suibokuga (ink paintings)
during the later decades of the 16th century
(see, e.g., [29]). But the rich palette and lush
vegetative ambience of these screens mitigate
the predatory activity that appears alongside
more benign panels in the set.

It is precisely this air of colorful, rich beauty
interspersed with ominousness that character-
izes these paintings and distinguishes them
from contemporary or later suibokuga, or for
that matter, lacquerware in the Kodai-ji style
that incorporates insect life into the decorative
schema in an unobtrusive manner. There is,

after all, a considerable distinction to be made
in 16th-century painting between traditional
yamato-e and the rare yamato-e exemplified
by these Virginia byobu by other and bird-and-
flower paintings by artists copying (or inspired
by) Chinese and Korean painting styles.[3]
One describes nature in its manifold settings,
seasons, and appearances with the intention
to draw the viewer into that world. Chinese
bird-and-flower painting, on the other hand,
seeks a cooler, more aloof approach that
shuns the overtly beautiful or lush manifesta-
tions of nature. The assemblage of subjects in
the Virginia byobu represents one of the most
intriguing yamato-e visions of the natural
world to have survived through the centuries
as a paradigm of a Japanese interpretation of
Chinese bird-and-flower painting.

 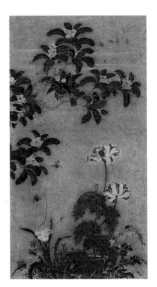 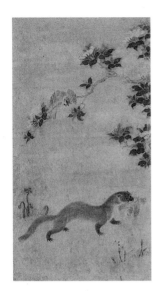 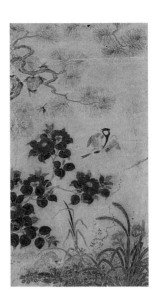

A hanging scroll with the identical composition and subject—a squirrel eating a melon—by the ink painter Yamada Doan (died 1571) demonstrates the common thematic thread available to 16th-century artists.[4] It is virtually certain that Tosa painters enjoyed access to paintings imported from China and Korea and treasured by clerics, merchants, and military men alike. The evidence of the paintings depicted in illustrated handscrolls (emaki) from the 14th century onward, most of which emanates from Tosa School or Tosa-related artists, illustrates an astonishing range of subjects executed in both suibokuga and yamato-e stylistic idioms. Unfortunately, small bird-and-flower screens comparable to these Virginia byobu have not appeared in emaki.

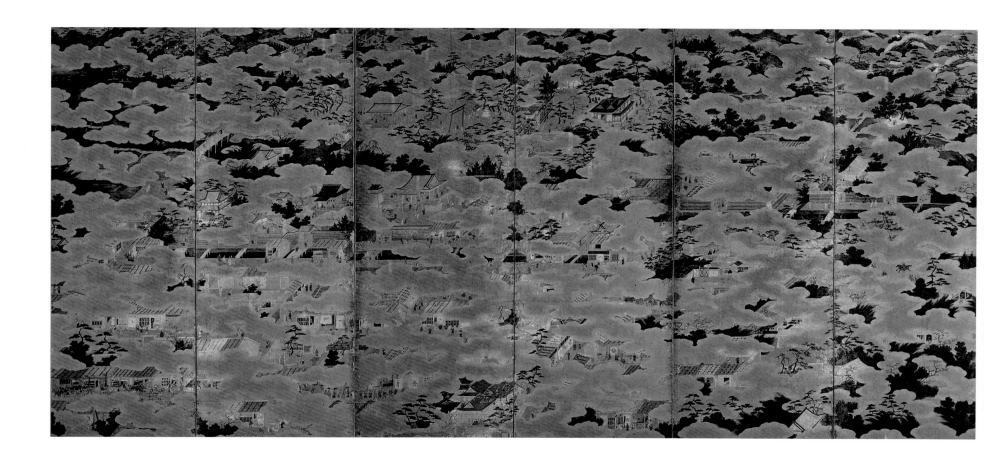

18 Scenes in and around Kyoto
(*Rakuchu-Rakugai*)
Pair of six-fold screens; ink, color, and gold
on paper
Each 158.3 x 364 cm
Muromachi/Momoyama periods, 16th century
National Museum of Japanese History, Sakura,
Chiba Prefecture

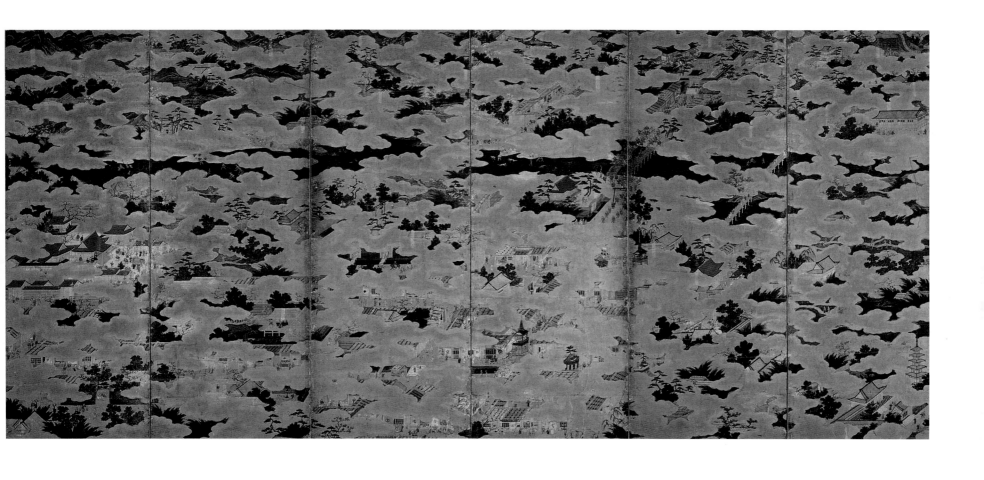

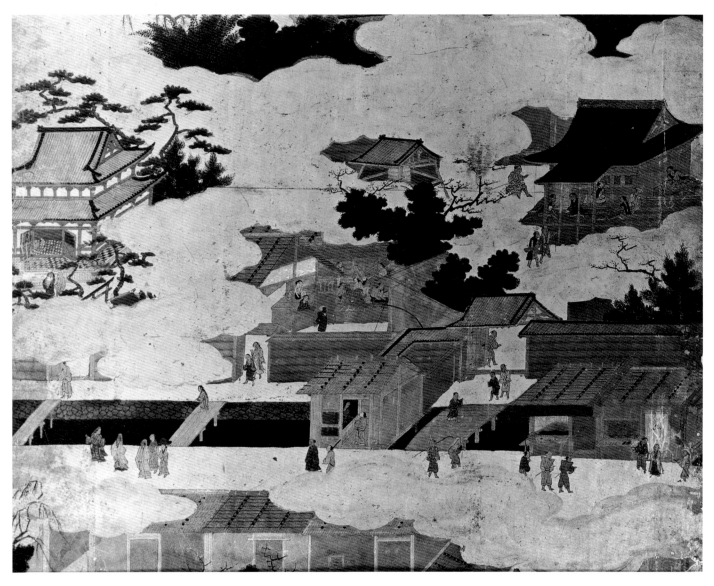

Detail.

"Scenes in and around the capital [Kyoto],"
known in Japan as *Rakuchu-Rakugai*, is a
subject pivotal to *yamato-e* in the 16th cen-
tury. Of the thirty or so examples known, the
present screens are among the earliest of this
period, reflecting their status as primary visual
emblems celebrating the reemergence of this
beautiful city from the ashes of war. As the
seat of the court and of the nation's restored
political authority, Kyoto was perhaps never
more keenly recognized and appreciated as
the heart of the nation.

Rakuchu-Rakugai compositions typically
present the city during the four seasons in a
panoramic, bird's-eye view. This schema
resembles—indeed ultimately derives
from—the Heian period *emaki* (illustrated
handscroll) technique called *fukinuki-yatai,* in
which a myriad of interior court scenes are
revealed to the viewer (or partially hidden
from the viewer) by a mobile roof. But be-
cause in their compositional layout *Rakuchu-
Rakugai* strive to provide a comprehensive
understanding of places, their conception also
owes much to the venerable Japanese tradition
of description through map-making.[1]

This pair of screens marks an important event in *Rakuchu-Rakugai* history. They came to light only within the last decade, and they are generally accepted as 16th-century examples of the genre. The earliest pair of *Rakuchu-Rakugai* screens currently known dates to the first half of the 16th century, while this pair follows approximately fifty years later.[2] Features of particular note include the expansive use of gold for both cloud and ground formations, the rectangular slips of paper pasted to the *byobu* surface identifying important sites and the relative dearth of people and structures.

Unlike other 16th- and 17th-century *Rakuchu-Rakugai*—and to an unusual degree—the view of the capital depicted here can be characterized by a discernible air of calm and spatial ease, precisely because the artist has restricted the numbers of people, events, and architectural structures.

The *byobu* are "read" from right to left, and depict locales from the south and east (right screen) moving towards the north, and the western parts of the city from downtown northward (left screen). Viewing in the same direction, spring follows summer, and fall follows winter in the capital. On the right screen the viewer proceeds from the southern border with the temples Tofuku-ji and the popular Kiyomizu-dera, past the Shijo [4th] Street Bridge spanning the Kamo River to the Imperial Palace. The left screen then continues northward to describe streets, neighborhoods, and temples focusing on the west side of Kyoto. Snow-capped mountains sheltering the great Zen temple Daitoku-ji proclaim winter before continuing into a colorful autumn, occupying four full panels of the screen. This northwest sector of Kyoto is perhaps most fascinating, since until recently this area has developed less vigorously than the central and eastern hill areas.

This screen also includes narrative vignettes of city life rarely seen outside of *yamato-e*. In the fourth and fifth panels, for instance, is a straightforward description of beggars and the homeless seeking refuge at a temple (detail). Although a continuation of the abiding Japanese interest in the "high and low" in society, so characteristic of *yamato-e*, within the context of these richly executed screens extoling the virtues of a new economic order in the capital, such vignettes come as a surprise.

In fact, the viewer is treated to an abundant array of architecture and citizens' activities in these *byobu*. Contemplating these paintings— unlike contemporary *kanga* (Chinese style paintings) [12, 13]—proves to be an absorbing experience for the viewer. The organization, design, choice of materials, and actual painting techniques alone provide ample visual interest to sustain viewing. What is more, the modern display of *Rakuchu-Rakugai* screens deviates sharply from the original intention.

In the 16th century the *byobu* were not usually shown joined together. Rather, they were placed across from one another, so that people could sit in a room on *tatami* mats between them. In this way the city emerged from a central, "downtown" perspective as one gazed eastward (right screen) or westward (left screen). It reminds us again of the impulse in *yamato-e* that seeks concrete visual routes that permit the viewer to observe intimately—as in *Rakuchu-Rakugai*—almost to the point of participation. Indeed, it is the creation and use of these visual techniques that provide the humanistic and emotional fabric inherent in *yamato-e*, distinguishing it from *kanga*, or Korean and Chinese painting models.

The authorship of these screens has been attributed to an anonymous Kano School artist, working in the manner of Kano Shoei (1519-1592) [16]. Comparison with Shoei's "map-paintings" and fan paintings bearing his seal suggest that this time frame is reasonable.[3] Further study remains to be done, however, especially since more than one hand is surely at work in these *byobu*. Records identifying the subject of *Rakuchu-Rakugai* on folding screens in the early 16th century specify that Tosa School artists first embraced this theme. And illustrations of *fuzokuga* (genre painting), *byobu*, and *fusuma* (sliding door) panels appearing in illustrated handscrolls of verifiable Tosa authorship support such a view. There is every chance, then, that these *byobu* will prove to be the collaborative production of a Tosa studio, once scholars focus more energetically on *fuzokuga* in 15th- and 16th-century *yamato-e*.[4]

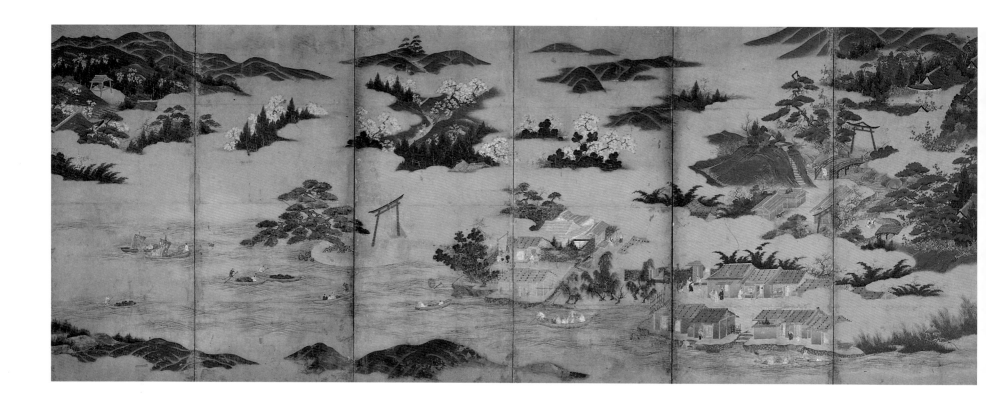

19 Famous Views of Lake Biwa
Pair of six-fold screens; ink and color on paper
Each 137 x 361 cm
Muromachi period, 16th century
Shiga Prefectural Museum of Modern Art, Otsu
Important Cultural Property

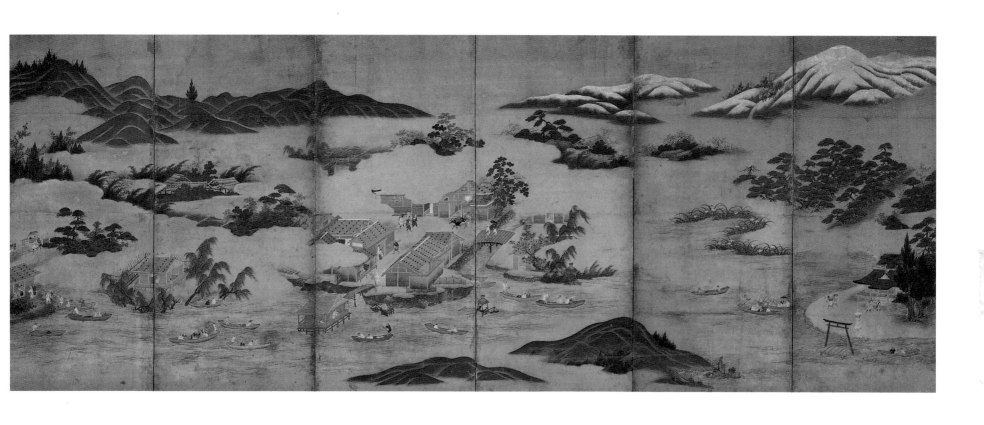

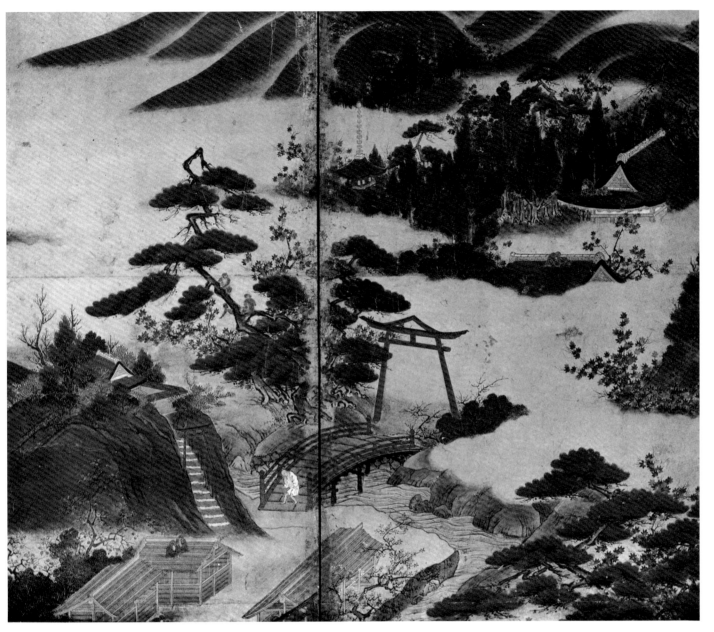

Detail.

With the expansion of the area's economic productivity in the 16th century and with the keen awareness of its strategic location for governing the country, present-day Shiga Prefecture (east of Kyoto) thrived. Just as the previous screens highlight various aspects of life and commerce in Kyoto [18], these *byobu* record the rich cultural heritage and human activity centering on Shiga's primary geographical asset: Lake Biwa, the largest body of fresh water in Japan. The screens are unique in 16th-century *yamato-e*.

The lake's environs have served as resting place and home to visitors, pilgrims, and inhabitants alike since at least the Nara period (AD 645-794). In particular, the road along Biwa's western shore provided a direct, picturesque route for religious travelers between the ancient capitals of Nara and Kyongju (in Korea), as well as those traveling to the outlying provinces along the Japan Sea coast. The northern valleys came to house small but active Buddhist temples, still relatively inaccessible and unheralded in Japan. The eastern shores and adjoining plains became important as unrivaled rice-growing areas and strategic military outposts.

While records state the existence of paintings depicting places (*meisho-zu*) in Omi during the later Heian period, and then in the Kamakura era (1185-1336), these *byobu* are the oldest versions known today.[1] The right screen shows snow-clad Mt. Hira in the background with Shirahige Jinja (Shrine) on the shore at its base. Pilgrims are seen entering and leaving the shrine, as well as being ferried to the shore past the prominent *torii* (gate) erected in the water directly in front of

Shirahige. (This feature, identified so closely with Itsukushima Jinja far to the west, near Hiroshima, occurs elsewhere with some frequency in Japan.) The shoreline meanders past clusters of *shobu* (iris) and a distant village before coming to the focal point of this screen: the town of Katada on the western shore of Lake Biwa, north of the modern city of Otsu.

The town scene is a lively one, composed of modest shops, fishing enclosures, and a pavilion in the water for relaxing and for observing the lake's scenery. The season has changed to summer; its languid air is apparent in the anonymous artist's rendering. Relatively few structures are depicted in their entirety—a typical *yamato-e* device—so visual emphasis rests on the shoreline vista, particularly the various water activities. Work and pleasure have been cleverly intermingled so as to convey the village's importance as a place of human interest as well as commerce.

There is almost no hint of provincialism here, either in execution or sentiment. Evidently, both the artist and the patron for these screens were aware of the benefits of restricting the number of geographical and religious sites, while arranging the seasonal elements to convey natural vividness and the passage of time.

An air of timelessness, yet imbued with such specificity in human activity and in referential treatment of space, is an enduring characteristic of Japanese art. Particularly in the handscroll tradition of the Kamakura period, and then in *yamato-e* of the 15th and 16th centuries, the viewer is led like a traveler through the landscape as a partner in time.

This palpable sense of an intimate, shared time through distinct locales is evident, for instance, in the *Kumano Mandala* (fig. 1) in the Cleveland Museum collection. This complex of shrines in the lower Kii Peninsula attracted thousands of pilgrims annually in the Kamakura era, and its upkeep required the employment of many local workers. Woodcutters, almost hidden from view, labor off to one side of the lower composition, rather like some shopkeepers or fishermen in the Lake Biwa screens. Read from top to bottom (or vice versa), the world depicted allows the "traveler" to linger and return at ease, all the while picking up additional information through visual signals of season, topography, plant and water life, and man-made structures.

Similar features appear prominently in the right half of the left-hand screen of these Lake Biwa paintings in which Hiyoshi Taisha (Grand Shrine) and the waterfront village of Sakamoto dominate. (Like Katada, Sakamoto is located on the western shore of Lake Biwa; in this era both villages were larger and far more prominent because of their proximity to influential shrines and temples.) The famous Karasaki pine, which Hiroshige immortalized in the 19th century as part of a "Famous Views of Lake Biwa" series, appears to the left (south) of Sakamoto, followed by the Mii-dera temple in the last panel.

In the left screen, therefore, the narrative impulse is stronger, despite the reduction in sheer numbers of people and landscape elements. The Grand Shrine at Hiyoshi is embraced by the red of autumn maples, highlighted by meandering clouds of gold. Only two groups of pilgrims are visible near a bridge on the mountain path linking the shrine to the busy shoreline below. Mountain monkeys appear on the rooftops of the outbuildings near the entrance to the shrine, acting as sentinels or observers of shrine pilgrims (detail). In other paintings in this exhibition, monkeys serve as the ostensible subject [14, 17] and as stable guardians, a role also closely linked with Shinto custom [20, 22, 23].

Clearly the anonymous artist's interest in conveying the specific seasonal, geographical, and genre aspects of this important religious site at Hiyoshi abounds. The screens stand as one of the most historically significant and aesthetically impressive links of early narrative *yamato-e* to 16th-century *yamato-e*, and subsequently to later developments in Edo art.[2]

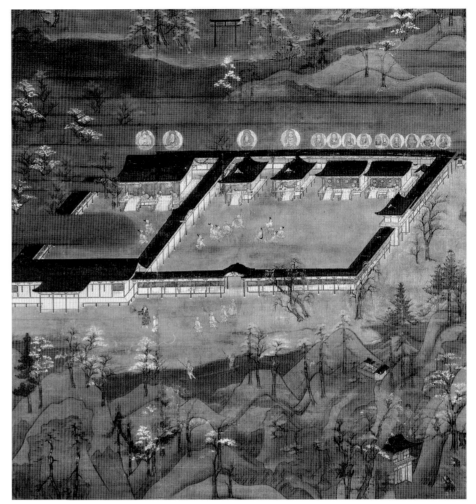

Figure 1.

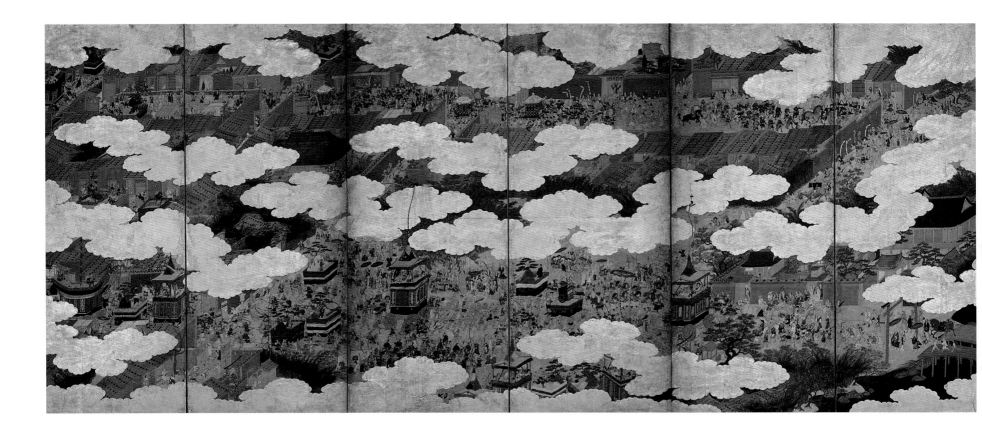

20 Scenes of Hie-Sanno and Gion Festivals

Pair of six-fold screens; ink, color, and gold
on paper
Each 122.4 x 297 cm
Muromachi period, 16th century
Suntory Museum of Art, Tokyo

These two screens depict festivals held by
important shrines on either side of the Higashi-
yama Mountains, bordering Kyoto. The left
side depicts the Gion festival, which celebrates
Kyoto's Yasaka Shrine each summer in mid-
July. Begun in the Heian period, the festival
became the capital's most popular until the
15th-century devastation of the city by warfare.
At the beginning of the 16th century it was re-
vived, and is still the focus of Kyoto's summer
festivities.

Today the high point of the festival for
most people centers on the parade of large,
wheeled floats (sponsored by local neighbor-
hood associations) that are elaborately deco-
rated with architectural ornaments, colorful
textiles, and metalwork. Usually children and
musicians ride high up in the carts, while men
from the neighborhood associations pull them
along a route winding through central Kyoto.
This spectacle still attracts tens of thousands of
spectators, most of whom realize only slightly
its connection to Yasaka (Gion) Shrine and its
origins in early Japanese history as a petition
from the people of the city to their shrine's
deity seeking relief from a severe pestilence.

The festival's revival in the early 16th cen-
tury coincides with improved economic condi-
tions, and, thereby, patronage of the arts.
Once thought to date only from the 17th and
18th centuries, now *Rakuchu-Rakugai* (Scenes
in and around Kyoto) screens as well as those
of other genre subjects point unmistakably to a
16th-century revival of vigorous town life, and
its concomitant portrayal in the arts—as is il-
lustrated in this exhibition. Some of the details
of the Gion screen, for example, reveal both
the technical skill of the artist and his extraor-
dinary attention to describing events. The
early *yamato-e* tradition of carefully depicting
dress, tools, and the identifying equipment of
the professions is not only clearly present but
also well developed in these mid-century
byobu (see also [38]).

The bands of gold clouds (*suyari*) both con-
ceal and disclose natural elements and the
cityscape, so that the painting surface assumes
a rich, narrative web of linked human events.
The vignettes thus revealed show utterly capti-
vating, self-contained moments in the experi-
ence of reading the whole.

The joining of these two festival subjects
as a *byobu* pair is unusual, if not unique.[1]
The right screen provides a panoramic vista
of Lake Biwa's west coast, focusing on the
village of Katada and, to the south (left), the
famous Karasaki Pine. Pilgrims throng the vil-
lage streets and outlying paths. The two sites
are on the way to the Hiyoshi Shrine, marked

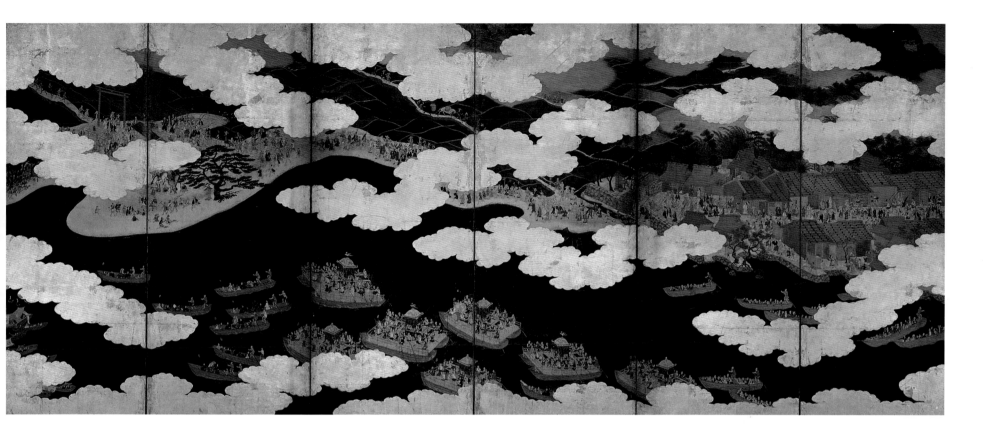

by a large gate (*torii*). This shrine houses one of the sanctuaries of the Shinto diety Sanno (the "Mountain King") of Mt. Hie, which looms over the northeast quadrant of Kyoto. The worship of Sanno flourished with the support of Tendai Buddhism (headquarted on Mt. Hie), especially following the move of the capital from Nara to Kyoto in the 9th century.[2]

On the lake, seven portable shrines (*mikoshi*) are transported by makeshift boats, each consisting of two boats lashed together and covered with a wooden platform. Each shrine symbolizes a deity, which taken together form the seven principal *kami* (spirits) identifying the Sanno cult. Depicted here is the mid-April festival in which local parishioners escort the deity to the Karasaki Pine, having already

brought the shrines down from their sanctuary at the top of Mt. Hochioji. The waterborne procession approaches the shore, where a crowd awaits them, dancing, chanting, and beating drums (*taiko*) and gongs. The flotilla of boats accompanying the *mikoshi* includes priests, dignitaries, and traders approximating in numbers those on land.

The drawing of the people and their activities in these screens formed the primary interest and focus of the artist. The agility of his characterization as well as his attention to details of individuality are wonderfully apparent, and perhaps unique in 16th-century

yamato-e. Furthermore, the screen's expansive composition provides dynamic sweeps of blue and gold color fields interspersed with stretches of chalky gray lake shore and patches of rich greens. In particular, the quilt pattern of rice fields ascending from the lake into the foothills demonstrates once again the special ability of early *yamato-e* to expand the story-telling aspect of horizontal formats (e.g., *emaki*, *byobu*) out of a single dimension. The multiplicity of human activity urges the viewer along, but the pace of revelation extends along diagonal pathways stretching through and off the picture plane. This occurs even more dramatically in the second scroll of the *Kuwanomi-dera Engi* [33, fig. 1].

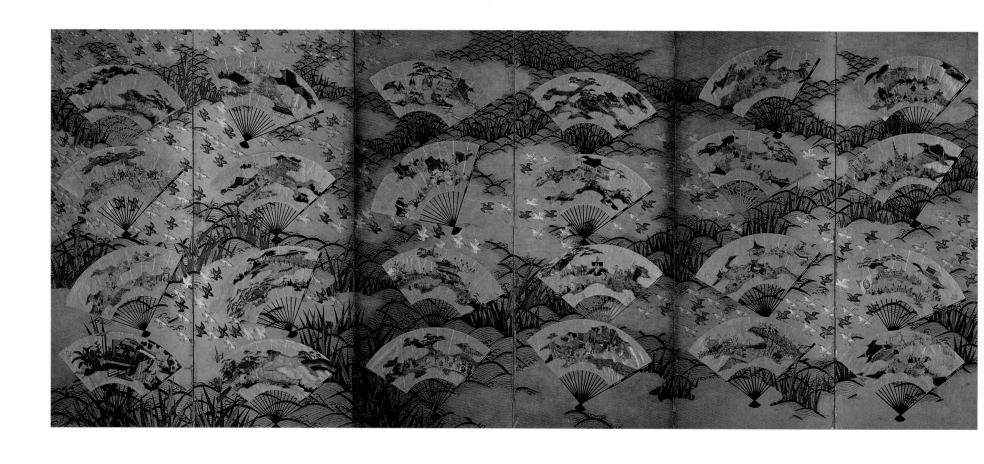

21 Genre-Scene Fans in a Landscape

Six-fold screen; ink, color, and gold on paper
150.5 x 357.5 cm
Muromachi period, 16th century
Koen-ji, Kyoto

Whereas the *Famous Views of Lake Biwa*
screens [19] focus on assorted sites of histori-
cal, religious, or social importance in one
geographical area, another type of *yamato-e*
painting records important events as they
progress through the calendar year. Called
tsukinami-e (festivals of the twelve months),
the Koen-ji screen provides a finely executed
early example of its kind, of which only a few
have survived. Other *tsukinami-e* fan assem-
blages have been brought together as albums,
no doubt from scattered sources. The fan
album in Tokyo [37] is perhaps one such
example.

Sufficient evidence exists to suggest that fan
paintings with *yamato-e* subjects applied to a
folding screen constituted an important type of
decorated painting in the later 15th and 16th
century in Japan.[1] Sometimes the fans were
attached to the *byobu* with little or no back-
ground painting; in other instances, the surface
design of the screen appears to have been
added later.[2]

The twenty-four fans have been organized
both according to the vertical panels as well
as the horizontal effect of the fan shapes. The
overall pattern is immediately recognizable.
Further scrutiny, however, reveals a zigzag
lozenge (or diamond) network emerging from
the diagonal pathways formed by the reed

clusters amid the waves. The placement of the
fans upon the axes of this pattern or within the
net-like framework disguises it, as it creates its
own design. The addition of the sea plovers
(*chidori*) throughout enriches the visual and
thematic content [45, 46]; that they don't dart
headlong past one another in large groups
adds a distinctive, yet dramatic, compositional
element in viewing the whole.

Except for the fan at the bottom of the left-
most panel—a later Chinese-style replacement
—all the fan subjects are related to *tsukinami-
e* of Kyoto. Moreover, since the festivals and
yearly events depicted occur within the first
five or six months of the year, the panels of
the mate to this *byobu* surely completed the
progression through the twelve months. The
combination of these small narrative paintings
within gold-leaf fan borders set against a foil
of water-and-bird theme harking back to the

Heian period adds a resonance to the image
for the Japanese viewer. It suggests the web of
yamato-e themes and felicitous, imaginative
designs frequently used in the century.

The screens were part of the temple's or
patron's interior furniture, used to enliven a
room as well as define the spaces within it.
Illustrated handscrolls (*emaki*) of the period
(and earlier) contain depictions of such
byobu.[3] But in the Koen-ji example, the visual
interrelationship between the small, detailed
fan paintings and the expansive *byobu* design
is particularly dynamic. It has the advantage of
being eminently readable from afar as well as
up close. And this is surely how people in the
16th century would have viewed it.

Although the fans bear seals of Mitsunobu,
they are considered later additions, perhaps by
his pupils.

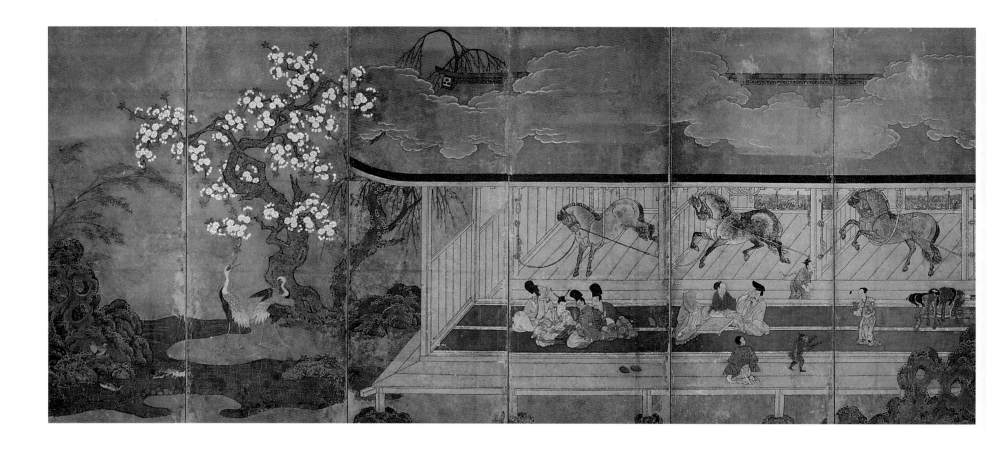

22 Horses and Grooms in the Stable

Pair of six-fold screens; ink, color, and gold
on paper
Each 149.5 x 355.5 cm
Muromachi period, 16th century
Tokyo National Museum
Important Cultural Property

By viewing these screens with the Cleveland
Museum pair [23], one can discern an early
phase in the development of *yamato-e*—
particularly with regard to this subject, known
as *umaya-zu*. Since early versions are rare,
the comparison is valuable for scholars and
public alike.

The stable in the Tokyo *byobu* is depicted
in an intriguing landscape setting that lacks
reference to any other buildings. The changing
seasons are noted by a flowering cherry tree
(spring) and wisteria (summer) lacing through
the large, bending pine tree. Cranes, herons,
and waterfowl browse in the blue azurite
streams that lap at the perimeters of the build-
ing. All are the traditional auspicious emblems
of long life, fidelity, and good health. Over-
head, a bank of rhythmically balanced gold
clouds partially obscures the roof. A large rock
looms up near the mid-point of the stable,
serving as a compositional device to join the
two folding screens.

None of this apparatus appears in the
Cleveland, Honkoku-ji, or Imperial collection
screens, although the activities within the
stable confines bear a close resemblance.[1]
Yet the subject of horses tethered in a stable
had surely become an established one in
large-scale *yamato-e* by the early 16th cen-
tury, judging by surviving examples. The earli-
est depictions in *ema* (votive plaques) and
emaki (illustrated handscroll) formats were
executed in *yamato-e* style. Both the Tokyo
National Museum and Cleveland Museum

screen pairs reflect this tradition, although in
the late 15th century Kano School artists took
up the subject of horse painting in *ema*, do-
nated to Shinto shrines. A complete *umaya-zu*
composition firmly attributable to a 16th-cen-
tury Kano artist has yet to appear. Similarly,
the subject is unknown in the ink painting
medium associated so closely with *kanga*
(Chinese style painting).

It is noteworthy, therefore, that the Tokyo
byobu have traditionally been attributed to an
anonymous Kano School artist. If this were
firmly established, it would go a long way in
confirming the indebtedness of Kano painters
to *yamato-e* conventions in the 15th and 16th

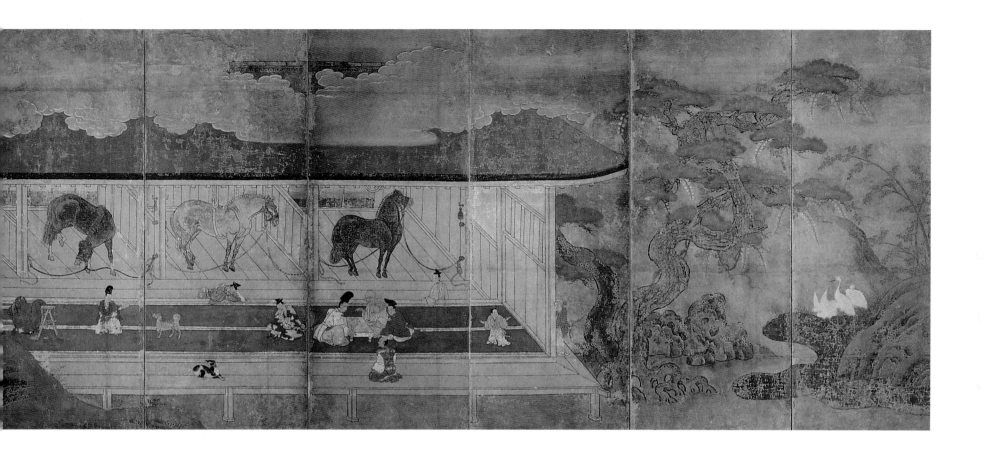

centuries. For instance, the *byobu* by Kano
Motonobu (1476-1559) of *Flowers and Birds in
the Four Seasons* (in the Hakutsuru Museum of
Art collection) represents a splendid, early ex-
ample of the Kano synthesis of this *yamato-e*
subject.[2]

Another approach would be to consider the
Tokyo screens as Tosa School products, based
on their genre elements. The accomplished
figural style—large scale, natural in appear-
ance and gestures, and sympathetic to social
distinctions—points to an assured under-
standing of Tosa practices.

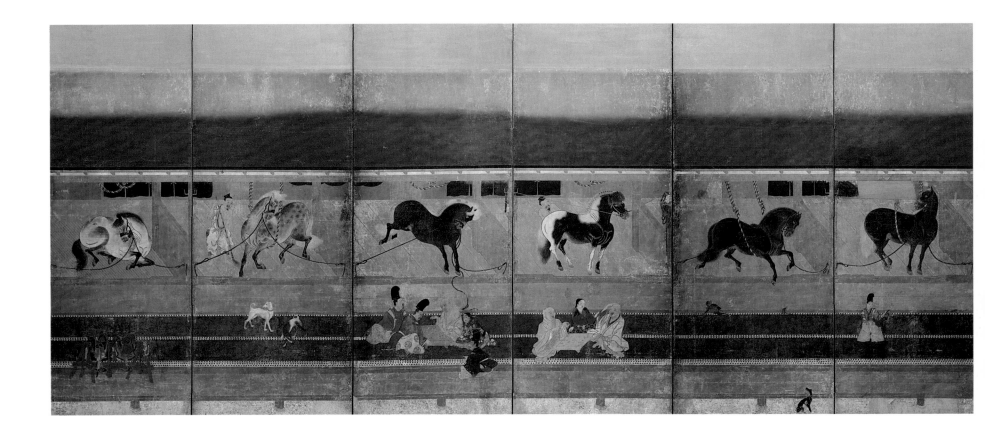

23 Horses and Grooms in the Stable

Pair of six fold screens; ink, color, and gold
on paper
Each 145.7 x 348.6 cm
Muromachi period, 15th-16th century
The Cleveland Museum of Art, Edward L.
Whittemore Fund, 34.373-374

These screens relate to the previous pair in
several important ways, two of which bear
special mention. First, it is apparent that origi-
nally they were shorter, the top band of gold
painted paper having been added to the com-
position. The intention was to bring these
byobu into conformity with 16th- and 17th-
century standards for this format, as can be

seen in the Tokyo National Museum examples
[22], which possess close stylistic and the-
matic similarities.

The extra band of paper not only increases
the height but also helps to disguise the abrupt
foreshortening at the bottom edge of the
byobu. Such early umayu-zu (stable scenes)
employed an acute compositional "short-
hand," similar to methods used in portrait
painting. Consequently, the supports or ancil-
lary accoutrements for the subject—be they
tatami mats or the foundation stones for
pillars—were eliminated in favor of a more
direct, abridged description. As a result, the
painting appears lower within the entire byobu
format than was originally intended, but it
nevertheless retains its internal balance. Its
relationship to intensely described genre

painting within the yamato-e tradition, such as
appears in the Scenes of Hie-Sanno and Gion
Festivals [20] or the Kuwanomi-dera Engi [33]
remains unassailed.[1]

The second issue relating the Tokyo pair
[22] to the Cleveland byobu focuses on the
inclusion—or the absence—of landscape ele-
ments in the basic umaya-zu composition.
When included, as in the Tokyo screens, these
elements place the stable in an idealized gar-
den setting that mingles Chinese and Japanese
imagery. In this regard, and with subsequent
developments of this subject in mind, it ap-
pears likely that the Cleveland painting repre-
sents a type of yamato-e preceding that in the
Tokyo byobu. How far apart in date these two
screen pairs should be placed however, is an-
other matter yet to be resolved. But linking

them to the 17th-century Kasuga Shrine's Horse
Race at the Kamo Shrine [26] establishes a use-
ful historical marker, especially with regard to
figural style, palette, and spatial design.

A distinct possibility that the Tokyo National
Museum screens are in fact embellished copies
of their Cleveland Museum of Art counterparts
deserves consideration. It is plausible that the
landscape and bird-and-flower motifs were
added to the Tokyo byobu so as to bring the
subject into more current 16th-century stand-
ards of pictorial representation. In so doing, the
traditional painterly divisions between Tosa
and Kano School methods and themes become
blurred once again. Clearly the primacy of the
core subject overshadowed matters of author-
ship or stylistic allegiance, a recurrent issue in
16th-century Japanese art generally.

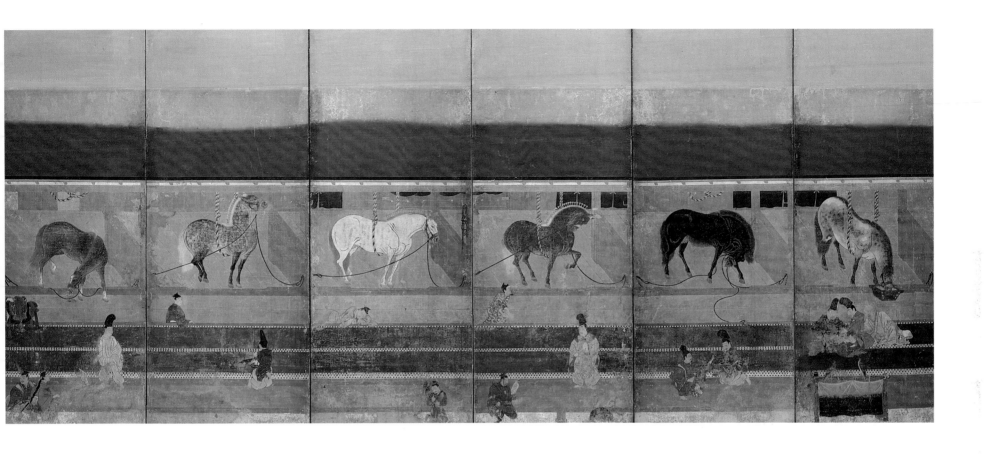

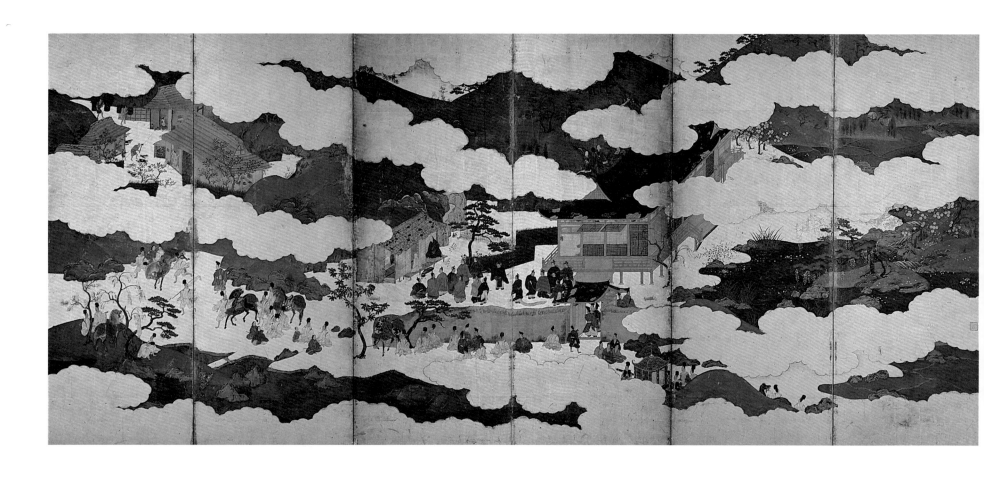

24 Emperor's Visit to Ohara

Six-fold screen; ink, color, and gold on paper
149.5 x 355.5 cm
Hasegawa Kyuzo (1568-1593)
Momoyama period
Tokyo National Museum

The role of this single screen is misleading to those unfamiliar with Japanese history, for it possesses the ring of "pomp and circumstance," appearing to describe a royal fête in the country. But in fact this *byobu* depicts in lavish mineral pigments and gold foil one of the most poignant episodes in early Japanese history, immortalized in the *Heike Monogatari*, chronicling the rise and fall of the powerful Heian period Taira (Heike) family.

The viewer observes the retired Emperor Goshirakawa paying a visit to his daughter-in-law, Kenreimon-in.[1] She lives in exile at a small nunnery, Jakko-in, in the rural village of Ohara, northeast of Kyoto. The mother of the heir apparent, Antoku (1178-1185), she is the sole survivor of the once mighty Taira clan, having been spared by the victorious Minamoto (Genji) clan against her wishes.

In the background of the screen she appears unobtrusively with another nun returning along a mountain path towards the nunnery. Goshirakawa, attired in a brown silk robe with pale blue pants, inquires about her whereabouts from an elderly nun kneeling on the veranda. The retired emperor's palanquin and bearers are located to the right, outside the gate at Jakko-in, and below a splendid garden in which wisteria and cherry trees bloom. Gold clouds, garden rocks, waterfall, and pine trees are simply but masterfully synthesized and composed to produce a serene prospect in concert with the natural spring landscape and the rice fields.

The larger part of the entourage accompanying Goshirakawa waits outside the nunnery wall, gathered in groups that identify their duties. As in most Japanese genre painting (*fuzokuga*) their positions, gestures, and facial expressions create individuality among what might otherwise be "type" figures. These features also lead the viewer's eyes rhythmically across the composition in the foreground towards the left. Noting the selective placement of the few trees and horses on this gold ground, one is reminded of any number of Kamakura period *emaki* (handscroll) designs. Indeed, the overall design derives from earlier *Tale of Genji* compositions, although the intensity of figural clustering and the rhythm of the spatial intervals between groups is here more relaxed and expansive—a characteristic of later 16th-century *yamato-e*.[2]

As in earlier *fuzokuga*, a sociological component of the subject occurs prominently, here in the upper part of the left panel. Ordinary inhabitants of Ohara are shown going about their daily chores: faggot gathering, wood chopping, and child rearing—all essential activities for survival in the mountainous countryside. A sense of impoverishment is evident, albeit one mixed with overtones of happy domesticity. As in Heian literature and paintings, the social commentary here also contains a discernible Buddhist flavor in suggesting the merits of an unencumbered existence (see also [25]).

The artist's intent is clear: to highlight the pathos of the historical subject in which someone of the highest station falls to the loneliest, abject depths. For Kenreimon-in, this once beautiful daughter of Japan's leading family and mother of a future emperor, the afternoon in 1186 recorded here was to be her last contact with the outside world. She died twenty years later, at Jakko-in.

The seal on the right panel identifies the artist of this single *byobu* as Hasegawa Kyuzo (1568-1593), son of the more famous Momoyama artist Hasegawa Tohaku (1539-1610). Both father and son collaborated on the wall painting cycle at the Chishaku-in temple, part of which appears in [32]. Since Kyuzo's oeuvre remains small, the presence in this exhibition of three works by him or attributed to him—[24, 27, 32]—each a different format and with divergent subjects and brush styles, provides a special opportunity for comprehending the artist's identity and talent.

First, it seems clear that Kyuzo was comfortable with *yamato-e* painting conventions despite training under his father, a master ink painter. The design of this screen, for instance, bears comparison with that of *Small Birds and Flowers in Four Seasons* [28]. The shape, technique, and use of gold cloud formations is consistent in these screens. A detail such as the tripartite waterfall-stream appearing through a "window" of clouds suggests the existence of a model painting, differing somewhat from earlier examples of the Imperial Visit theme.[3]

Kyuzo's hand is most apparent in the delineation of rock and flora, and in the style of the figures. The latter feature can be clearly seen as a combination of the Hasegawa studio approach, one that included portraiture and *yamato-e* in its repertory. However, the lighter, more sprightly natural forms coupled with particularized swaths of mineral greens and azurite blues amid rolling gold clouds points towards the emergence of a new visual aesthetic at the end of the century.

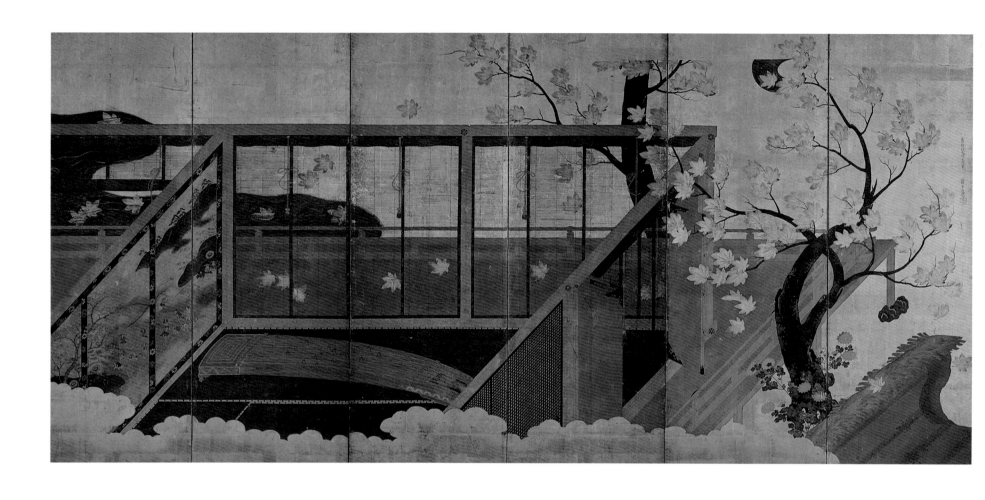

25 Scene from *The Tale of Genji*

Six-fold screen; ink, color, and gold on paper
183.2 x 324.6 cm
Muromachi period, 16th century
Private Collection, Hyogo Prefecture

A brief inscription on the right panel by Tosa
Mitsuoki (1617-1691), frequently identified
as the artist of the Nagoya *Quail byobu* [9],
states that this single screen is the work of Tosa
Mitsumochi (1496-ca.1559). Mitsumochi's
work is best represented in this exhibition by
the *Kuwanomi-dera Engi* [33], whose initial
illustration of a magnificent, imaginary Kuwa
tree resembles the elegant forms of the maples
seen here. Modern scholars have tended to
doubt Mitsuoki's assessment of authorship, pre-
ferring instead either Mitsuyoshi [6, 10] or an
unknown Tosa artist of that generation.[1] But if
Mitsuoki in the second half of the 17th century
appraised the dramatic, visual strength of this
byobu as being related to the *Kuwanomi-dera*
handscrolls, then he was not mistaken.

The scene depicted here derives from an
early chapter, "The Broom Tree," in *The Tale
of Genji*. It describes a conversation of young
courtiers, including Genji, about the nature of
the bonds between men and women. This
byobu depicts the house of a lady known to
two of the young men which they visited one
evening on the way home from court:

*Through gaps in a neglected wall I could
see the moon shining on a pond. It seemed a
pity not to linger a moment at a spot where
the moon seemed so much at home, and so I
climbed out after my friend. It would appear
that this was not his first visit. He proceeded*
*briskly to the veranda and took a seat near the
gate and looked up at the moon for a time.
The chrysanthemums were at their best, very
slightly touched by the frost, and the red
leaves were beautiful in the autumn wind. He
took out a flute and played a tune on it, and
sang 'The Well of Asuka' and several other
songs. Blending nicely with the flute came the
mellow tones of a Japanese koto. It had been
tuned in advance, apparently, and was wait-
ing. The ritsu scale had a pleasant modern
sound to it, right for a soft, womanly touch
from behind blinds, and right for the clear
moonlight too. I can assure you that the effect
was not at all unpleasant.*[2]

The gold foil background illuminates the
moonlit autumnal scene of empty rooms at
one corner of an elegant house. Two maples,
an earthen wall in disrepair, gold clouds, chry-
santhemums and a meandering stream frame
the residence. All is visible since, as is tradi-
tionally the case in Japanese narrative painting
of interiors, the roof has been deleted to allow
the viewer full observation—and thereby
participation—with the subject. All the impor-
tant textual elements are present, except one
—the figures of this episode, especially the
lady who was the subject of the mens' affec-
tion. The artist omitted the human presence,
as he did other elements in the composition,
preferring to give the viewer a sort of visual
reminiscence.

No one is present inside or outside on the
veranda, which is visible both from the outside
and from within through slit bamboo curtains
(*sudare*). These are rolled up in the left panel,
allowing another perspective of the maple
leaves floating in the stream (whose silver
color has darkened with age) much like that in
the Mitsui Bunko *Sun and Moon* screens [5].

The principal elements within the room
consist of a 13-stringed koto and a set of
fusuma (sliding door panels) depicting rice-
planting scenes. The koto occupies virtually
the entire room, signifying the presence of the
lady through her musical talent and, more im-
portantly, embodying the full romantic inter-
lude told by the narrator in "The Broom Tree."
The combination of falling autumn leaves, the
open door with no human presence, and the
deteriorating wall draws in the viewer, who
then begins to share the air of nostalgia con-
tained in the story. The relative size of the
koto—reminiscent of the relationship between
bird and human figures in the Tokyo *Hama-
matsu byobu* [3]—is perhaps less significant
than its emblematic stature and role in the
composition. It bridges the outdoors with the
indoors, the year's waning with colorful ex-
pressions of a new year's beginnings. It blends
the sound of musical notes wafting into the air
with the windswept leaves, whose trail also
points to the *fusuma* of rice planting in the two
left panels.

This *yamato-e* landscape is similar to other
examples in the exhibition, and the small fig-
ures compare well with the figural style of
travelers in *Famous Views of Lake Biwa* [19].
The mingling of "high and low," the elegant
with the plain, and the literary with folk tradi-
tion occurs forcefully in this *Genji* screen—as
in [3] and [33]. Elaborate cloth mountings and
hikidashi (hand pulls) with paulownia crest
designs on the *fusuma* proclaim the status of
the absent court lady.

The somewhat veiled disclosure of such
themes through an accummulation of visual
"signs" or emblems, such as occurs here, can
also be seen in lacquerware of the period, and
earlier. The mirror stand with assorted *maki-e*
(sprinkled) designs [52] provides an excellent
example of how lacquer subjects require inter-
pretation too. Clearly the relationship between
16th-century painting and the ceramic lacquer
objects illustrated in those paintings needs
further study.

This *byobu* is a singular example of a liter-
ary masterpiece providing the basis for visuali-
zation. However, Hasegawa Kyuzo [24, 27]
provides a close comparison—especially the
former, in which a rural peasant scene pro-
vides an unobtrusive but important backdrop to
the composition and to the underlying theme:
the frailty of human existence, even for those
born into high social status.

26 Horse Race at the Kamo Shrine
Pair of six-fold screens; ink, color, and gold
on paper
Each 183.2 x 324.6 cm
Momoyama-Edo periods, 17th century
Kasuga Shrine, Nara

Among the many annual festivals held at
Shinto shrines throughout Japan that feature
equestrian events, none possesses the pag-
eantry, sustained courtly interest, or sheer his-
torical tradition as that surrounding the horse
races at Kyoto's Kamo Shrine. Held each
spring on the 5th day of the 5th month, the
festival celebrates the enduring bond between
government in Japan and the native Shinto

religion. Thus, as befits this subject, the event
takes place in the traditional capital of the
country, within the precincts of Kyoto's most
revered Shinto shrine, located on the banks of
the River Kamo, which has marked the heart
of the city since ancient times.[1]

As depicted in these screens the races are
held on a straight course set between wooden
rails specially constructed each year for the
occasion. Behind them are a shrine building
—visible in the right screen—and *tatami* mats
(one is partially enclosed with tenting) for
guests. A landscape is indicated by the willow
(left screen) and pine tree (right screen), pat-
terned gold clouds, and low bands of blue
ground against the field of gold-flecked brown.
The composition resembles the stable screens

[22, 23] in its layered, horizontal sequences,
each distinguished by figural groupings within
a discrete band.

Although these groupings remain static, the
figures in the Tokyo National Museum [22]
and Cleveland Museum [23] *byobu* encroach
upon other registers in an undulating rhythm
across the screens' surfaces. The addition of
a landscape fully integrated into the compo-
sition separates the Kasuga and Cleveland
screens, while at the same time establishes a
common motif for linking the Tokyo and
Kasuga paintings more closely in *yamato-e*
lineage and dating.

These Kasuga shrine *byobu* present more
stylized versions of cloud patterns, trees, and
islands of greenery. The figure type also is
more generalized in form and detailing, and
more precisely defined by palette. Indeed,
seen broadly and without reference to subject
matter, these *byobu* share a similar composi-
tional sense with [4] and [28], both of which
date later in the 16th century.

The particular fervor of the horse race sub-
ject, however, defines and invigorates the
Kasuga *byobu*. The engagement of horses and
riders alike is natural and spirited. This narra-
tive mood is enhanced by the anticipation of

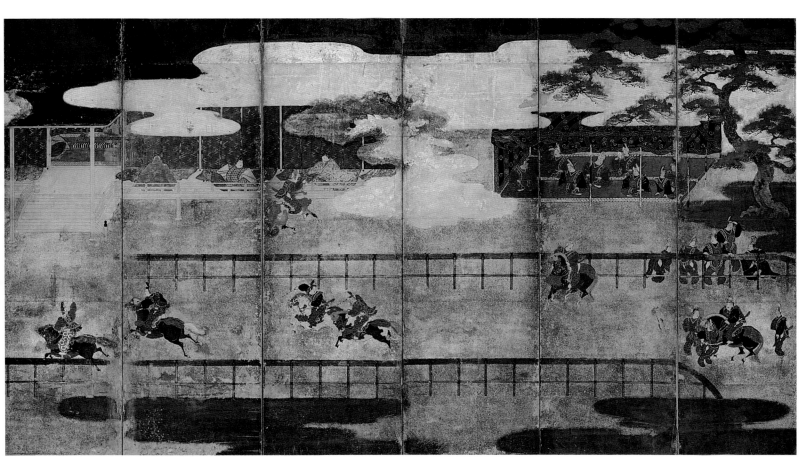

the competing team members along the rail-ings, and especially by the range of expres-sions portrayed on the faces of the numerous officials in attendance. Their interest is appar-ent but restrained, since barely visible within the shrine building are raised *tatami* mats, indicating that the emperor is present. He is attended by numerous retainers inside (their pantaloons and skirts just visible beneath the bamboo curtains) and out—including a Bud-dhist priest who sits with his back to the races. The emperor's view of the day and proceed-ings is only slightly more ample, suggesting once again the theme of nobility's futile long-ing for participation in the common world.[2] (This haunting theme of Japanese literature and the visual arts also appears directly—and obliquely—in [3], [24], and [25]).

Although the condition of these Kasuga shrine *byobu* is not good—there have been extensive repairs in the upper areas and re-painting throughout—they present an early, genuine treatment of the subject. The figural style in particular may be shown to derive from aristocratic and warrior portrayals, like those in Kamakura period *emaki* (illustrated handscrolls).[3] That lineage continues through such Tosa compositions as the Cleveland Museum *Stable* figure style [23], towards the refined figural descriptions in the album [38] of about 1600, or slightly later into the early Edo period when Tosa Mitsuoki revived the fortunes of the Tosa School with brilliant ren-derings of traditional court scenes.

27 Fighting Warriors: Votive Tablet (*Ema*)
Ink and color on wood, dated 1592
195.5 x 274.7 cm
Hasegawa Kyuzo [Hisazo] (1568-1593)
Momoyama period
Kiyomizu-dera, Kyoto
Important Cultural Property

In 1989 a superb example of an ancient votive tablet (*ema*) was excavated from the remains of the Nagaya-no-o's house in Nara. Nagaya-no-o (AD 684-729) was the grandchild of Emperor Temmu. He is known as the "tragic prince," since he was forced by his grandfather to kill himself after being tricked by the powerful Fujiwara family. Through an examination of the writing on a *mokkan* (writing tablet) recovered at the same time, plus a count of the annual rings in the wood of the tablet itself, it was estimated that the *ema* was made around AD 735. A horse with a saddle is visible, along with traces of faded paint. Several Nara period votive tablets have been discovered in the past, but nothing can compare to this one for quality of painting.

There used to be an old Japanese custom of donating horses to shrines; it is still practiced in a few shrines today. But for ordinary people, in the past as well as today, clay horses or votive tablets bearing a picture of a horse, were the norm. Throughout Japan, many small votive tablets on which different kinds of wishes are written can be seen hanging on the outside of shrine altars.

This newly discovered votive tablet proves that the custom originated long ago. Because these tablets are hung outdoors and the weather exacts a toll, none as old as those excavated from ruins has survived. As a result, a votive tablet from the Muromachi period is considered to be very rare and very important. The one in this exhibition is the oldest example found in Kyoto.

Ema (votive tablet) literally means "picture horse." Their subject was originally always a horse; but among tablets dedicated to temples, some had Buddhist themes as their motif. From the middle of the 16th century, pictures of warriors began to be painted, reflecting the prayers of the dedicators. Many of them illustrate scenes from heroic stories. As the subject matter became more complicated, professional painters were increasingly employed to paint them.

The example here shows a scene from the *Soga Monogatari*, a story of the Soga brothers' revenge for their father's murder. It was the primary duty of warriors, when a blood relative was killed, to avenge the murder. The story behind this picture reflects this. Goro, a younger brother, felt that his brother's life was in danger and rushed to the Wada family's banquet, to which his brother had been invited. But Asahina Yoshihide, a high-spirited man of enormous strength, stopped him by grabbing the mail skirt of his armor. The figure on the tablet standing firm and holding a sword is Goro, the other grasping at him is Yoshihide. The strength of both men was equal in the contest, but finally the mail skirt was torn—unlikely though this may have been in real life.

At that time in Japan there were very few large-scale paintings being made. This type, therefore, in which a full-length human figure is depicted, is rarely seen. The strange facial expressions of these two men with their hair shaken loose, as well as the depiction of the exaggerated body muscles looks unusual— even offensive. Realism had not yet developed as an important factor in painting.

The signature on the painting says that it was painted by Hasegawa Hisazo (known as Kyuzo), in 1592. Because Kyuzo died young, he produced few works (two of which are in this exhibition: [24] and [32]). The writing on the back of the *ema* says that it was miraculously saved from a fire at Kiyomizu-dera in 1629 and repaired by Kyuzo's grandchildren and students in 1631.

The tablet was originally composed of six boards, but the extreme left portion bearing his signature is a later replacement. MS

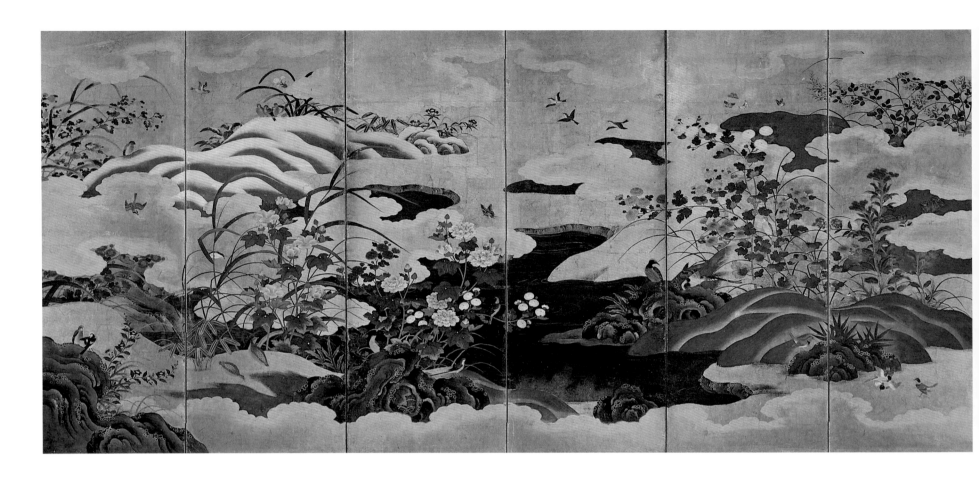

28　Small Birds and Flowers in Four Seasons
Pair of six-fold screens; ink, color, and gold
on paper
Each 158.2 x 355.6 cm
Muromachi/Momoyama periods, 16th century
Agency for Cultural Affairs, Tokyo

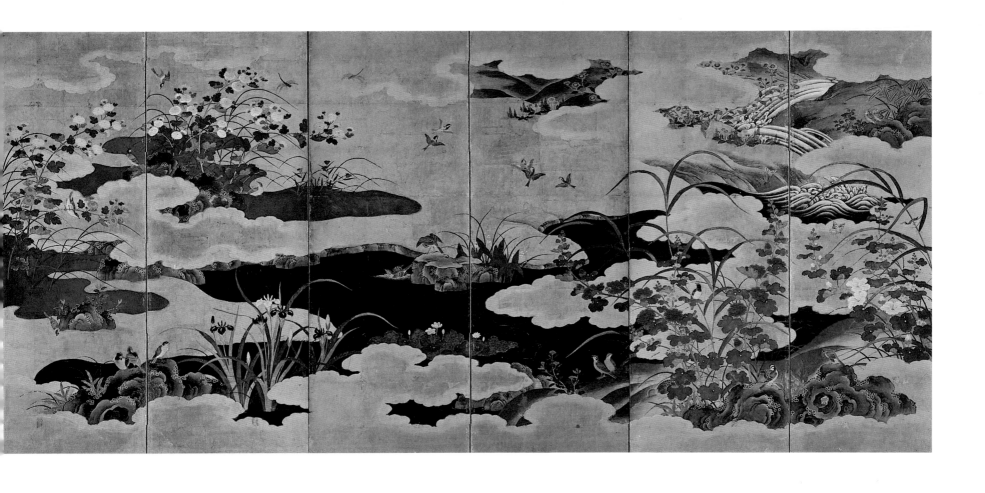

These *byobu* bring *yamato-e* imagery and painting style into the middle of the century and beyond. The seasonal composition moves from spring, through summer and autumn to the snow-clad hillocks of winter. The many flora, fauna, birds, and insects surround a central pond, which forms the organizing motif of the painting; it is fed by a cascading stream on the right, such as appears in the Tokyo National Museum *Sun and Moon* [2] and the *Emperor's Visit to Ohara byobu* [24]. Rocks, gold clouds, and snow mounds frame the left side.

The synthesis of the deep mineral-blue pond with the scattered landscape elements rendered in greenish-blue and brown hues is made possible by the encompassing field of gold clouds and gold ground. More than any others in the exhibition, these paintings extol the vibrant, pure painting materials of the day.

The pond traverses both screens and in all likelihood moves on through the gold clouds and rocks in the leftmost panel as a stream. Very faint gold wavelines ripple across its surface—as in the Mitsui Bunko *Sun and Moon* [5] or the scene from *The Tale of Genji* [25]

screens—but here they fail to describe how the water flows between the juncture of the left and right *byobu*. As in so many *yamato-e* screens, this central landscape element traverses both paintings, providing a visual connection from one side to the other.

The interpretation of such a splendid view of the world, and where to assign it in its proper place in *yamato-e* of the 16th century has only begun with its recent discovery.[1] A strong case has been forwarded for assigning it to a Kano School artist, perhaps even Motonobu (1476-1559), whose bird-and-flower screens in the Hakutsuru Museum collection demonstrates that artist's interest in and talent for *yamato-e* (fig. 1). They were done late in his life, according to his inscription on the screens, and therefore are datable to mid-century.

The present screens follow those by as much as two or three decades, being closer to the Chishaku-in panels [32] or even to Kano Shoei's *suibokuga* (ink painting) of *Birds and Flowers* [16]. In all three works, parallels exist in the attenuated drawing of natural forms as well as in the compositional layout. This view bears further study no doubt, but it is buoyed by comparison of these *byobu* with another *Birds and Flowers* composition in the Hakutsuru Museum collection assigned to Motonobu's son, Eitoku (1543-1590).[2]

Whether they will stand up to an interpretation that views them as paradise scenes, as has been proposed, a 16th-century expression of intense but veiled religious faith in gardens of salvation awaits further consideration. Such screens, as the Kongo-ji *Sun and Moon* paintings [1] discussed already, were actively sought after and used on religious occasions. They were particularly in demand for funerals. It is not yet clear in 16th-century painting, however, when the intention to create decorative emblems associated with paradise gave way to the urge to create attractive designs for purely secular objects.

Perhaps these screens belong toward the end of the religious-oriented tradition exemplified by Kodai-ji [47, 51-55] or the Chishaku-in paintings [32], executed for the building memorializing the death of Hideyoshi's son in 1592.

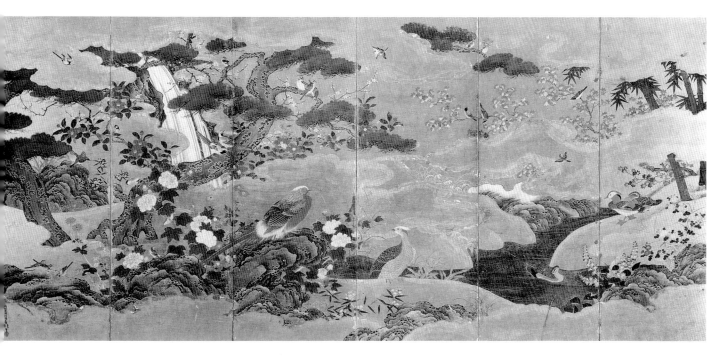

Figure 1. Left screen, above; right, below.

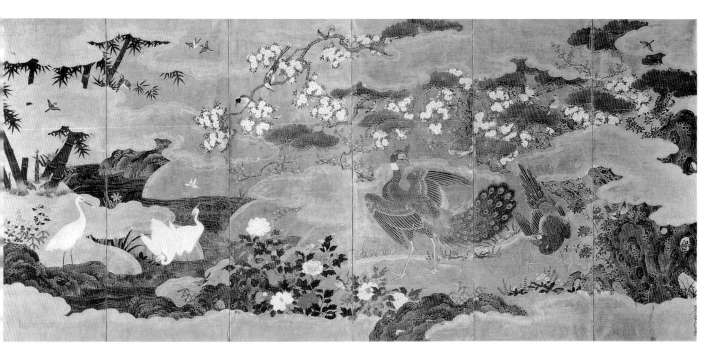

29　Hawking Scene

Pair of eight-fold screens; ink, color, and gold
on paper
Each 153 x 370 cm
Soga Chokuan, active 1596-1610
Momoyama period
Private Collection, Ehime Prefecture

Two features in these screens bear special
mention, for both contribute significantly to
the visual impact of the overall image as well
as mark this painting as one of the most inno-
vative and visually satisfying in the genre.
First, very little of the stated imagery appears
whole in the composition (to the viewer).
The setting for this subject, a grisly event, is
fragmented throughout. Formations of clouds

obscure the rocks, tree trunks, foliage—even
the ground plane—while revealing the hawks
and their hapless victim.

Secondly, the gold paint (*kinde*) thinly
brushed across the paintings' surface is of high
quality and has been very sensitively applied
so as to lend a rich atmospheric density to the
whole. Its use in conjunction with the exten-
sive cloud formations represents a dramatic
advance in *suibokuga* pictorial dynamics, as
well as in Chokuan's rather limited oeuvre.
This technique may be favorably compared to
that seen in a small group of *byobu* tradition-
ally attributed to Shubun (and followers), and
to the set of six hanging scrolls depicting *Miho
no Matsubara* in the Egawa Art Museum.[1]

Thus, in the late 15th and 16th centuries
suibokuga (ink painting) artists utilized
to advantage the appealing effects of gold—
brushed, applied as leaf, or both—found regu-
larly in *yamato-e* painting. Here Chokuan has
taken the combination of decorative techniques
yet a step further to heighten the drama of the
subject.

It is difficult to identify a more sombre, grue-
some attack scene in Japanese 16th-century
painting. The large-scale, mannered landscape
and cloud elements contrast with the meticu-
lously rendered brushwork of the hawks. Their
prey remains an enigma to scholars and public
alike: it resembles a bear, boar, or dog, yet

finally is none of these. Other contemporary
examples of its type are rare and not espe-
cially helpful in aiding identification.[2] But the
red of its tongue and the pleading eyes set in a
body of dense black states its predicament
with enriched intensity.

These *byobu* each possess two seals of the
artist, whose work focuses on hawking scenes,
Zen figural subjects, and bird-and-flower com-
positions. Of special note is the fact that each
screen is comprised of eight, rather than the
standard six panels (see also [4]). Eight- and
ten-panel screens regularly appear among
Korean screen paintings.

These *byobu* are reported to have come to their present owner from the Mt. Koya Monastery in Wakayama Prefecture. The various subtemples at Koya-san still have paintings by the artist and his followers. Such a monastic provenance helps explain the expansive scale of the *byobu* and the subject. Buddhist monks as well as the warrior class appear to have been Chokuan's most important patrons.

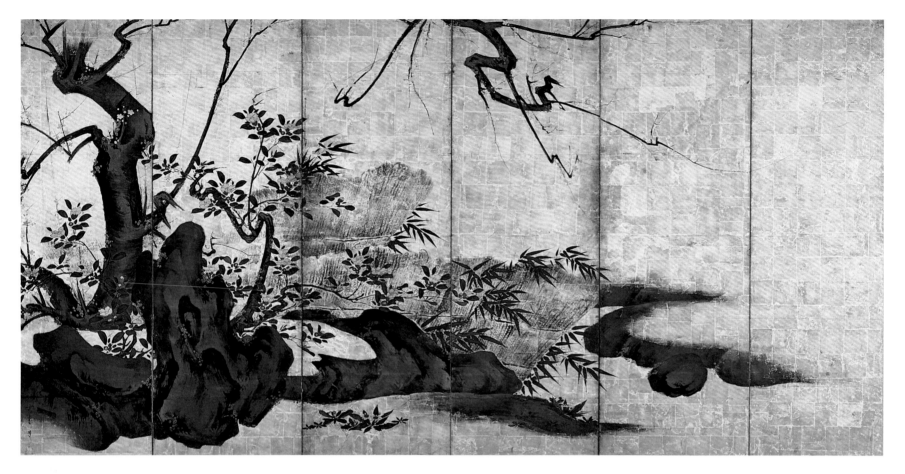

30 Peonies and Camellias in a Landscape

Pair of six-fold screens; ink, color, and gold
on paper
Each 177.5 x 356.5 cm
Kaiho Yusho (1533-1615)
Momoyama period
Myoshin-ji, Kyoto
Important Cultural Property

Myoshin-ji, the Zen temple complex in north-
west Kyoto, possesses three of Yusho's finest
compositions on gold ground. Two comprise
overtly Chinese subject matter: *The Three
Laughers of Tiger Valley*, and *The Four Pleas-
ures*.[1] But this pair of *byobu* stands as the art-
ist's most glorious and refined example of
paintings on gold ground in any collection.

The composition combines an array of natu-
ral, stabilizing elements, especially at both
ends, which lends a strong assuredness to the
whole. The imposing rock ledge to the right—
attempted numerous times in Momoyama
paintings—has never been accomplished so
effectively and with such dramatic ease. The
subtle brushwork and ink tones of the rock
surface form a textural foil for the explosion
of peony blossoms and the rhythmical pattern
of turning leaves. It is this motif, played in
variations of profusion—or scarcity—that
establishes the visual tone of these paintings.
Nowhere else in Yusho's work can this degree
of sustained visual exuberance be seen, in
color or in form.

Part of the effect is due to the imposing
scale and immediacy of the plants and rocks.
Visual depth is severely limited, as is also the
case in the 1592 Chishaku-in *fusuma* (sliding
door panels) by Yusho's contemporary, To-
haku [32]. The only suggestion of a middle or
far ground comes from the extended island of
ground depicted in the two left panels. And
here it remains unclear whether that curious
form is entire in itself or has been revealed
through the mist of gold.

This visual ambiguity, a continuing and
central feature of *yamato-e* compositional or-
ganization, forms the natural bond between
the two sides. This overlapping and intrusion
of banks of gold mist is especially subtle in the
left screen along the streambank and further

inward on the horizontal rock outcropping,
where it serves as the linking element for the
central folding panels.

If this motif appears artificial or contrived, it
is really no more so than many other styliza-
tions of form and color in the painting, and in
the context of earlier *yamato-e*—either in
byobu (folding screens) or *emaki* (handscroll)
format—represents an often-used convention.
Indeed, similar bands of gold represent the
formal, organizing motif in the Imperial
Collection *Hamamatsu Bay byobu* traditionally
attributed to Yusho.[2] Certainly Yusho's em-
ployment of such typical *yamato-e* motifs, and
of *yamato-e* themes generally in later life,
appears consistent and direct.

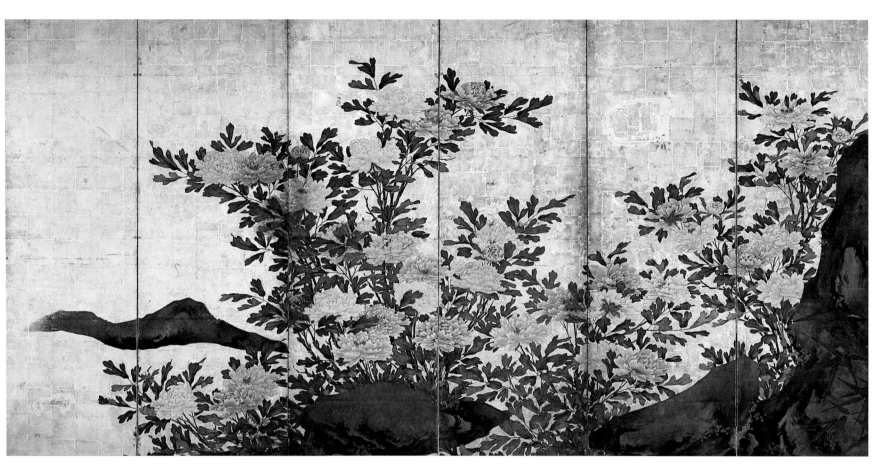

Although these Myoshin-ji screens have been variously dated by art historians within the artist's late years, there is no firm evidence for this. It nevertheless seems a reasonable view—considering Yusho's oeuvre and the numerous Tosa School or Tosa-related compositions of the late 16th and early 17th centuries. Few of these *yamato-e* works, however, exhibit such dazzling visual virtuosity of space and form contained within such an utterly calm environment.

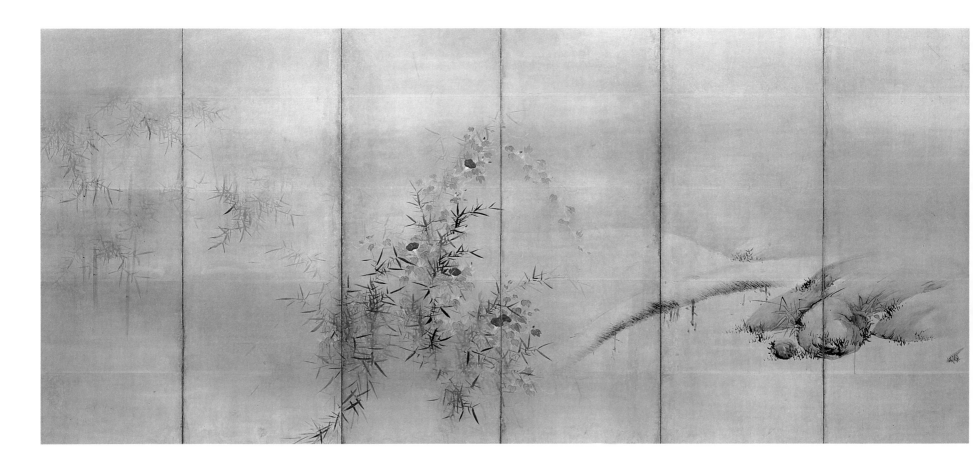

31 Bamboo and Morning Glories, Pine and Camellias

Pair of six-fold screens; ink, color, and gold on paper
Each 157 x 358.4 cm
Attributed to Kaiho Yusho (1533-1615)
Momoyama period
The Cleveland Museum of Art, John L. Severance Fund, 87.40-41

The rather startling joining of these two *byobu* by Kaiho Yusho appears more satisfactory in the company of the *yamato-e* works assembled in this exhibition than when the pair entered the Cleveland Museum collection four years ago.[1] Well known as a pure *suibokuga*

(ink painting) artist with enormous technical skills and imagination in that genre, Yusho apparently was quite familiar with *yamato-e*.

The right-hand screen combines features seen in other paintings by the artist: an aged pine with camellia set in a landscape. But here the landscape has been reduced to wisps of brush and ink faintly describing rocks, grasses, and distant hills. This portrayal stands in sharp contrast to the dynamic color and vigorous, dense brushwork that characterizes the boulders and landscape in the Myoshin-ji *Peonies byobu* [30]. The one seems ephemeral, the other beautifully obdurate.

The sketchiness of the Cleveland *Pine*, however, does not diminish its presence. It is rather like the Chishaku-in paintings [32] in scale and the manner in which both trees are truncated. Whereas Yusho suggests space solely through the outlined boulder and undulating mountain ridgeline, and the flowering camellia encircling the pine, his contemporary Kyuzo eschews any hint of spatial recession. In this screen Yusho retains spatial idioms similar to those of Soami [13], and the non-schooled, pithy brush style similar to that of Sesson [15]. None of it could be mistaken as Kano School work [16, 28].

The left-hand screen depicting bamboo alongside a stream provides an utterly fresh—although perhaps not unexpected—view of the artist's talent. Seen together, the

byobu pair at first seem awkward, even unbalanced. Yusho normally balances his compositions by providing strong framing elements at each end, as in the *Peonies* screens [30]. But here the principal images and organizing elements—bamboo supporting a trellis of morning glories and a streambank with *sasa* grasses—are joined by an arching footbridge —all within the four right-hand panels. This is an instance where asymmetrical placement establishes the visual leitmotif for the pair.

The theme of an aged pine and bamboo grove is pervasive in *kanga* (Chinese style painting) and *suibokuga* [12, 15] and has undergone diverse visual interpretations through

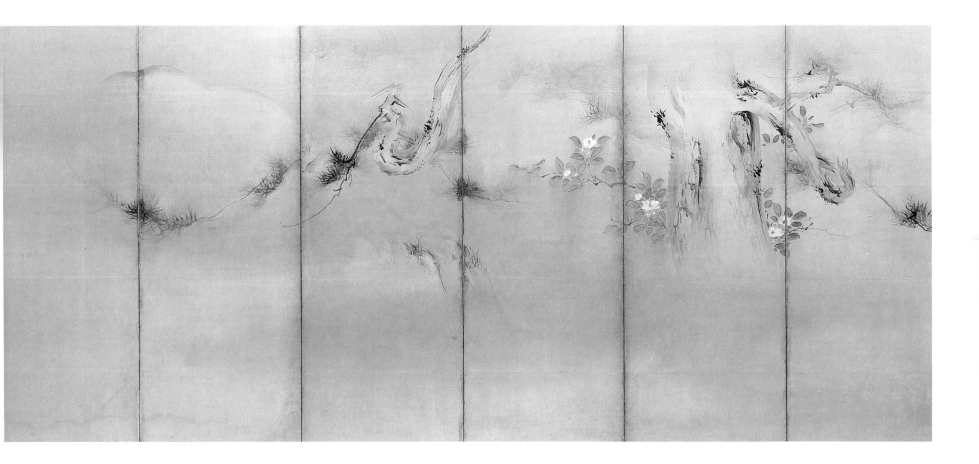

the centuries. Likewise water themes, bridges, and flowering seasonal plants constitute essential visual emblems in *yamato-e*. Here the seasons are denoted by the pine with camellia (winter) and the morning glories within a bamboo grove suffused with wet ink washes, indicative of the hot, humid Japanese summers. The pale blue and green mineral pigments stand out in contrast, as do the deeper green *sasa* leaves across the stream. Joined by the arching footbridge, these individual features comprise in toto an original—perhaps even unique—16th-century picture laden with poetic sentiments of melancholy for a Japanese audience, not unlike the single *Genji* screen [25]. In both cases a human presence is inferred in a setting of quiet beauty.

Herein lies perhaps Yusho's principal intent: the compatibility of Chinese and Japanese aesthetics and form, achieved by joining together the two *byobu*. Such innovative pairing in screen format occurs also in fan painting arrangements on *byobu* [21] and [37] and within earlier *emaki* (handscroll) illustrations. The melding of ink bamboo and colorful morning glories occurs in later Edo *byobu* in conjunction with lattice fences; but prior to these Cleveland Museum screens, it appears infrequently, and then in narrative handscrolls.[2]

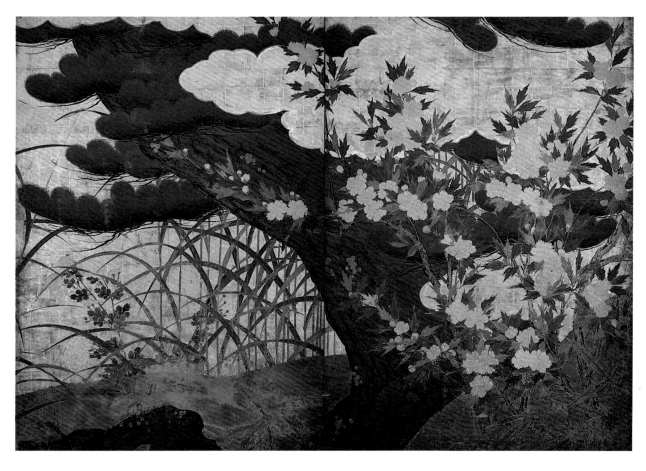

32 Pine amid Grasses and Flowers

Pair of two-fold screens, ink, color, and gold
on paper
Each 228 x 331 cm
Attributed to Hasegawa Kyuzo (1568-1593)
Momoyama period
Chishaku-in, Kyoto
National Treasure

Located a few minutes by foot from the front
gate of the Kyoto National Museum, the
Chishaku-in is today the headquarters of a
Shingon sect. These folding screens, part of a
magnificent cycle of panel paintings (fusuma)
all designated as National Treasures, came to
Chishaku-in from the Myoshin-ji temple com-
plex in northwest Kyoto sometime near the
turn of the 16th century.[1]

The fusuma originally belonged to the
Shoun-ji subtemple (within Myoshin-ji) built
between 1591 and 1592, through Toyotomi
Hideyoshi's patronage, as the mortuary temple
for his first son and heir, Tsurumatsu. Born to
the shogun's favored concubine Yodogimi
(1567-1615) in 1589, Tsurumatsu died at age
two and was given the posthumous Buddhist
name Shoun-ji dono.

With the fall of Hideyoshi to the warlord
Tokugawa Ieyasu, the Shoun-ji was destroyed
and its contents dispersed. The fusuma went to
Chishaku-in, where they have remained ever
since and have been accorded deserved status
as masterpieces of Momoyama culture. Tradi-
tionally, authorship of the paintings has been

given to Hasegawa Tohaku (1539-1610) and
his studio, although Tohaku himself invariably
receives credit for the maple tree panels in the
cycle of paintings. These two byobu were
originally part of the fusuma cycle and are
attributed to Tohaku's son and principal studio
assistant, Kyuzo (1568-1593), represented
elsewhere in the exhibition [24, 27, 32]. Both
attributions are reasonable and, what is more,
take on greater significance when considering
the paintings' provenance and patronage.

It is apparent, despite the lack of specific
historical documentation, that Hideyoshi's
commission did not go to the prominent Kano
School artists Shoei [16] or his son, Eitoku
(1543-1590), acclaimed as the most talented
painter of the era, who died two years earlier
than the painting commission. Shoei had

executed a four-seasons room cycle (now lost)
for the shogun in 1588, but in this instance
Tohaku and his studio provided the room
paintings—in yamato-e style. Although the
Kano would again be "official painters" to the
court and the shogunate during the Edo period,
the Chishaku-in commission marks the end of
their hegemony in Japan's expanding artistic
circles of the pre-modern period.

Originally, the corpus of panel paintings,
big and small, must have been impressive. In
the early 18th century more than ninety paint-
ings were reckoned to comprise the group, but
unfortunately subsequent fires at the Chishaku-
in reduced that number considerably.

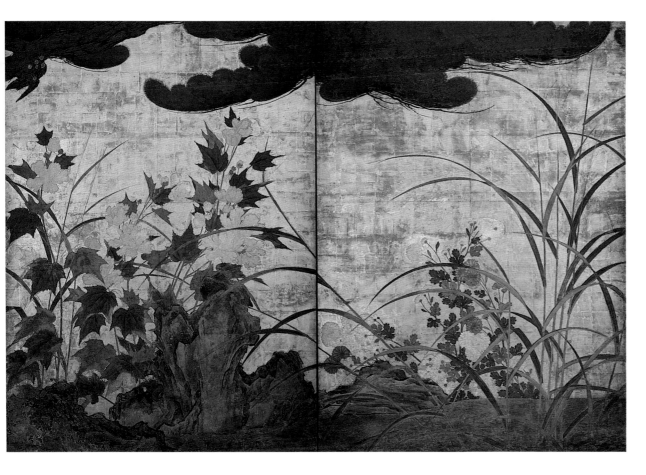

Despite differences in condition, size, authorship, and quality, all of the surviving paintings are designated National Treasures. This pair of two-fold screens is among the best preserved. Despite cropping, the paintings continue to communicate the naturalistic power of the four seasons genre through the web of grasses and flowers set against the muted gold background. Comparison with Yusho's *Peonies* [30] reveals how the muted palette strikes another tone altogether here. The suppleness of line and sophisticated tonal registration in the mineral pigments create a tapestry suggesting, perhaps more than any other painting in the exhibition, the rich variety of forms in plant life.

While Tohaku is normally regarded as a *suibokuga* (ink painting) artist, a number of *yamato-e byobu* and *fusuma* compositions attributable to him or to his followers establishes a firm Hasegawa School linkage to native painting styles.[2] In fact, comparison of surviving Hasegawa School paintings in the *yamato-e* and *suibokuga* modes points to a shift towards *yamato-e* after 1600. The Chishaku-in paintings suggest that this shift in stylistic and thematic preferences was well under way by the last decade of the century and that Kyuzo played a major, although brief, role in reviving *yamato-e*.

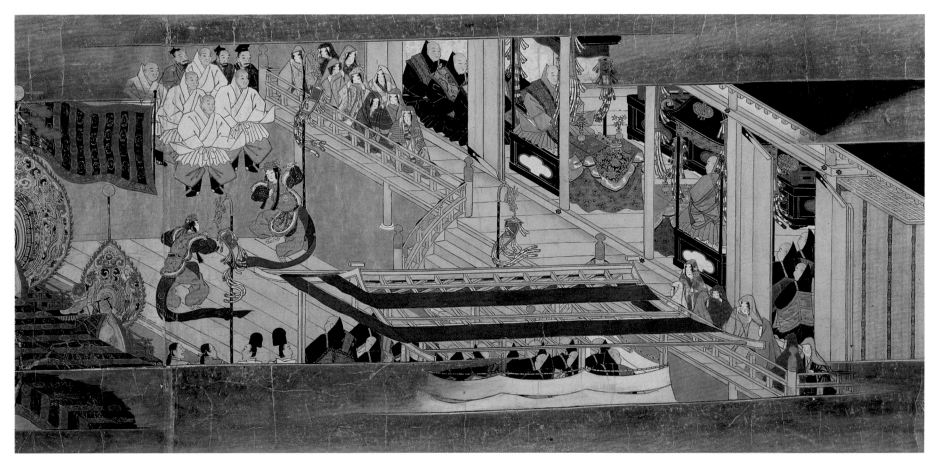

33 Kuwanomi-dera Engi (Legends of Kuwanomi-dera Temple)
Handscroll (scroll 1 of 2); ink, color, and gold on paper; dated 1532
35.2 x 1352.7 cm
Tosa Mitsumochi (1496-1559)
Muromachi period
Kuwanomi-dera, Azuchi, Shiga Prefecture
Important Cultural Property

Since the vast majority of early Japanese painting is unsigned or thinly documented— as is also the case with 16th-century *yamato-e* —the presence in the *Kuwanomi-dera Engi* (Legends of Kuwanomi-dera Temple) of such information surrounding its production date is particularly welcome. The history of this illustrated handscroll reflects the careers of three important personages of the early 16th century: the patron and shogun of the country, Ashikaga Yoshiharu (1511-1550); the "storyteller-writer" and calligrapher Sanjonishi Sanetaka (1455-1537); and the painter Tosa Mitsumochi.[1]

Ashikaga Yoshiharu's regency (as shogun) was an insecure one, coming as it did on the heels of the Onin Civil Wars (1467-77), which had racked the country. Political control of the country by the shogun through a series of shifting military alliances proved to be ever more tenuous. The seat of this military government (the *bakufu*) in Kyoto had been struggling for decades to maintain and regain authority when Yoshiharu succeeded to leadership as shogun.

But in fact his position even in the capital became so precarious that he fled Kyoto on several occasions to seek refuge on the shores of Lake Biwa [19]. There he enlisted the help of various households, in towns such as Sakamoto and Katada, in an attempt to allay the military and social chaos then prevalent in Kyoto. He also became familiar with the centuries-old Kuwanomi-dera temple on Lake Biwa's eastern shore, whose principal image of *Yakushi Nyorai* (Healing Buddha) he praised. Venerated for centuries, this image is central to the illustrations in the handscrolls. They relate the miraculous, 7th-century story of a dream that Princess Abe no Kojo had while ill in the Kyoto palace. She envisioned the emerald waters of Lake Biwa, out of which emerged the Yakushi Nyorai emitting a light, which cured her. A temple was built on Kuwanomi Mountain to commemorate this event by her father, the emperor.

Yoshiharu conceived the idea of commissioning an illustrated history of the temple in the hope that peace might return to Kyoto and the country under his rule. He asked the courtier Sanjonishi Sanetaka to provide both the storyline and the calligraphy. He also chose Tosa Mitsumochi, an "official" court artist, to design the illustrations. According to Sanetaka's diary we know, among other things, that following Yoshiharu's approval of Sanetaka's text, Sanetaka and Mitsumochi conferred about the illustrations on several occasions.

Detail.

The *emaki* (illustrated narrative handscroll) was donated to Kuwanomi-dera in August of 1532, and has remained there ever since. Although it did not alleviate the shogun's various political dilemmas, it does provide valuable insights about 16th-century *emaki* production and the Tosa paintings. The orthodoxy of *emaki* composition, with alternating calligraphic and illustrated sections, is followed throughout. Likewise, interior and exterior scenes of temple grounds (color plate) or the Kyoto palace follow traditional conventions. Seasonal and topographical references orient the viewer comfortably as the scroll unrolls.

A section from the first scroll of the *Kuwanomi-dera Engi* depicts the ailing princess Abe no Kojo in her quarters, surrounded by attendants (fig. 1). The shapes and the decoration of the lacquerware as well as the assorted paintings in this corner room provide telling information about 16th-century life. Of significance here is the presence of a pair of *byobu* with pampas grass compositions like those in the Cleveland screens [10].

But what most distinguishes Mitsumochi's work in this handscroll are his expansive landscape vistas, intense crowd scenes, and vibrant color tones. The skillful use of mixed blue mineral tones (*konsho*) washed with *kinde* (applied gold paint) to outline and conceal is particularly effective. This is best seen in an extraordinary panorama of rice fields and villages on the coast of Lake Biwa at the opening of the second scroll (fig. 2). The unfurling landscape quickly takes the viewer through a thicket of trees onto the mountain, where Kuwanomi-dera is located. This passage is one of the most dramatic pictorial statements in 16th-century painting.

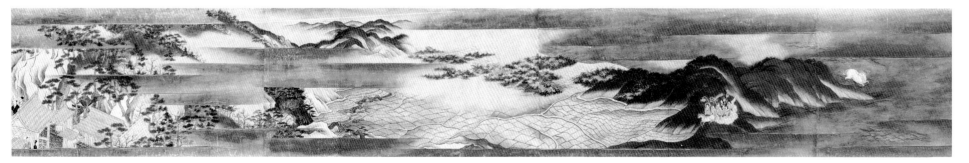

Figure 1.

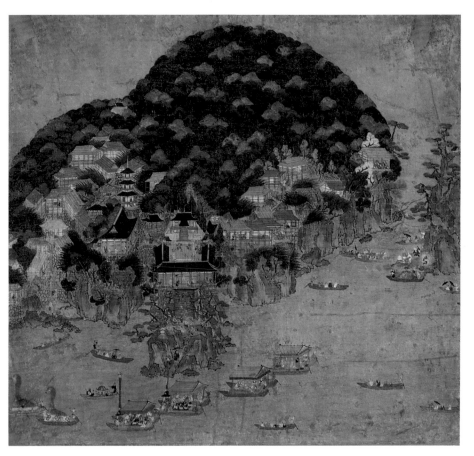

34 Festival at Chikubushima Island

Hanging scroll; ink and color on paper
89.1 x 81.6 cm
Muromachi/Momoyama periods, 16th century
Tokyo National Museum

The shrine complex featured on the central edge of the island is Tsukubusuma Jinja, a shrine associated with imperial patronage as early as the 8th century. Indeed, the island's original name derives from that of the shrine, prior to the Heian period. Then, with the advent of the Buddhist faith, Hogon-ji, a temple of the Tendai sect, was founded with Benzaiten as the principal deity. An early 14th century map-painting of the island shows the shrine and temple complex before the construction of the temple's numerous outbuildings, so evident in this 16th-century work.[1] Fires in the 15th and 16th centuries resulted in the replacement of the two main worship halls with buildings brought from Fushimi Momoyama Castle, south of Kyoto.

The lavish procession of boats at the bottom of the painting depicts the annual Lotus Festival, held in the sixth month. The procession is led by two boats (lower left) in the shape of golden-winged birds, each with a lotus leaf in its mouth. The small boat following with the shrine (*mikoshi*) containing an image of Benzaiten is accompanied by four large-roofed boats carrying chanting priests, women, and male parishioners—some dressed in armor. The festival was celebrated from the first of the month. This painting shows the principal event of the fourteenth day: *bugaku* (traditional court dance) on a stage in front of the main shrine building (see also [33]). The boating procession follows on the next day.

Of additional interest in this painting is the presence of another distinct group of boats and pilgrims centered in the narrow strait between Chikubushima and a tall, craggy offshore island (upper right). They are joined by a sacred straw rope. This scene represents a festival held at the beginning of the third month, which includes a circumambulation of the island.[2]

The unknown painter of this famous site has incorporated the colors of spring as well as the lush green of summer in one setting, a common feature of *yamato-e*. The brushstrokes are deft, the palette rich and controlled, and the vision wonderfully expansive. The painting style possesses a distinctive, quirky brush manner that, while reminiscent of *suibokuga* (ink painting) conventions—seen, for instance, in the modest-sized paintings of the Kano School —should more accurately be associated with the many anonymous artists of famous-place scenes (*meishozu-e*), such as the Lake Biwa screens [19], and narrative handscrolls.

It is worth noting that the interior of the main shrine building at Tsukubusuma Jinja contains superb lacquer architectural decoration in the Kodai-ji style [51-55]. The entire ensemble is designated a National Treasure.[3]

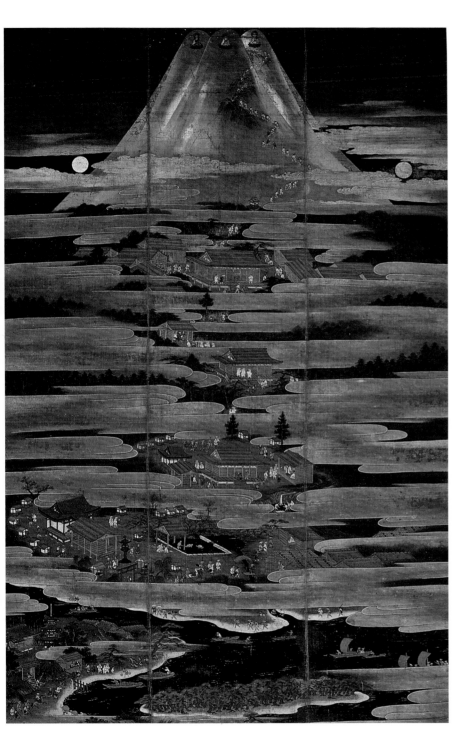

35 Mt. Fuji Mandala

Hanging scroll; ink and color on silk
180 x 117.5 cm
Muromachi/Momoyama periods, 16th century
Sengen Shrine, Fujinomiya, Shizuoka
Prefecture
Important Cultural Property

Of the five known mandalas of this sacred mountain that has come to serve as a symbol of Japan, this painting is the oldest and the most visually sophisticated example.[1] The scroll is fashioned from three pieces of silk joined vertically. Mt. Fuji, or Fuji-san, is seen from the principal eastern view, known as Murayama.

From Tago Bay past the sandbar of pines at Miho no Matsubara and the Seigen-ji temple at Kiyomigaseki, the viewer scans the throngs of people arriving on foot and by boat. Some are traveling between Edo (Tokyo) and Kyoto on the Tokaido "highway" (bottom left), while others are on their way to Sengen Shrine, at the base of Mt. Fuji.

The glove-shaped blue clouds (suyari), so characteristic of handscroll productions of 15th to 17th-century painting, part to reveal pilgrims bathing in the purifying volcanic waters of Wakutama Pond and further up, dousing themselves under the spout of "Dragon's Head" waterfall.

Following these ablutions, the pilgrims don white robes and prepare to ascend Fuji-san from the Omiya Sengen Shrine precincts up past the Dainichi (Nyorai) hall and its related outbuildings (center). In one of these, a shrine maiden performs a Shinto dance for the pilgrims.

Upon paying an obligatory fee to enter the mountain sanctuary, the pilgrims ascend, using staffs. Their goal is the tripartite peak where three Buddhist figures reside: Amida in the center, flanked by Sakyamuni (left), and a Bosatsu (right), all seated on lotus thrones. The relationship of this group, associated with Esoteric Buddhism, while noted in records about Mt. Fuji worship,[2] is perhaps more indicative of the embracing powers of medieval popular Buddhism in Japan.

The presence of the sun and moon in part alludes to the widespread practice of scaling Fuji-san during the middle of the night so as to reach the peak by dawn, to greet the rising sun. Small huts, visible in the painting, were maintained up to a specified level for travelers to rest until the early morning hours, when the ascent began. Here, rather than show the climbers with torches, the artist has chosen to let the light of the moon bathe both pilgrims and mountain slopes in pale white swaths, set against the golden brown hues of the mountain flanks.

The austere rendering of this primal mountain shape, especially when viewed with the worldly realms below, marks this painting as one of the finest expressions of both yamato-e painting and suijaku art (combining Buddhist and Shinto imagery). It indicates the sources of meaning so beautifully subsumed in the Kongo-ji Sun and Moon byobu [1]. The scroll's status at Sengen Shrine is even more exalted, residing in the principal shrine sanctuary with the resident deity of the mountain.

Although the painting bears a seal of Kano Motonobu (1476-1559), it is considered spurious. Nevertheless, a 16th-century date is reasonable, based upon stylistic, and compositional resemblances to the Lake Biwa [9], Hamamatsu Bay [3], and Hie-Sanno and Gion Festivals [20] byobu. It is also worth noting that a hall donated in 1604 by the Tokugawa family does not appear among the buildings in the shrine precincts.

36 The Pleasures of Food, Sake, and Conversation (*Shuhanrozu*)

Handscroll; ink and color on paper
30.7 x 1416 cm
Muromachi period, 16th century
Private Collection, Kyoto

This engaging handscroll contains series of scenes interspersed with calligraphy (not illustrated) depicting preparation and consumption of food and sake (rice wine). The underlying subject, however, surfaces in a variant title for the handscroll, *Jogo geko emaki*, which roughly translated means "an illustrated handscroll showing those who enjoy sake, and those who can't drink."

In Japan, sake has had an important, enduring social function—both symbolic and practical—since at least the Kofun period (AD 300-645), when rice cultivation, the single most important activity of the young nation, began. Ceramics from this period (and perhaps even earlier) allude to the binding social ritual of sake drinking. Later pictorial representations, especially those featuring seasonal festivals or special excursions into the countryside, emphasize the role of sake as a communal drink.[1]

Specially crafted vessels for storing, serving, and drinking sake have been produced since the 5th century, and a few examples in the exhibition [58-60] provide an idea of the care taken in their manufacture. Sake has also always been offered to the pantheon of Shinto spirits (*kami*) in plain earthenware or simply glazed saucers at roadside stands or small country shrines. At the other end of the spectrum, the finest glazed ceramic from the Seto kilns of the Kamakura period or imposing lacquer vessels, sometimes with painted decorations or elaborate metal fittings, were commissioned for use at the most revered Shinto shrines in the nation.

This *emaki* carefully describes the preparation and serving of elaborate meals, including both the toil and the enthusiasm of the task. In its way it represents another, more relaxed version of the tea ceremony in which a group of people come together to share a meal or drink too. In fact, the broad, popular appeal of this *shuhanrozu* subject and its existence in several *emaki* versions, attests to the degree to which its lack of artifice appealed to 16th-century patrons.[2]

The *emaki's* composition is similarly relaxed and open, leading the viewer from an elegant room with guests dining in front of a *tokonoma* (an alcove for displaying special paintings and ceramics) past a section of calligraphy to a more modest temple dinner with a kitchen and scullery immediately adjoining. The transition from one room to another is abrupt, heightened even more by contrasts in the physical appearances of the figures and the spaces they inhabit, as well as the differences in clothing and demeanor given the figures by the artist.

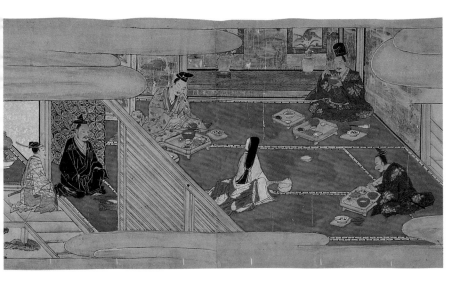

The kitchen scenes for most viewers surpass the formal dinner illustrations both in novelty and in visual interest. Their design is more complex, the space more energized, and the narrative descriptions laden with actual architectural details and cooking utensils.

Modern scholarship has placed this handscroll as the earliest example of the subject, and has suggested authorship by Kano Motonobu (1476-1559). Motonobu worked in all formats and painted a number of *emaki* illustrating legends associated with the founding of temples.[3] Motonobu also occasionally painted in *yamato-e* techniques later in his career.

This *shuhanrozu* together with a few other works indicates his attention to this native tradition and to his powers of observation. In the corner rests a single folded screen with fan painting design like the Koen-ji *byobu* in this exhibition [21].

The origin of the *shuhanrozu* as an *emaki* subject is unknown before Motonobu's lifetime. It may well prove to be an outgrowth of the short, personalized *emaki* of the late 15th and 16th centuries—known as *ko-emaki* (small narrative handscrolls)—produced by Tosa School artists at the same time they were working on elaborate *emaki* of temple legends [33]. *Ko-emaki* possess the casualness and

immediacy evident in this *shuhanrozu*, which illustrates contemporary life in Kyoto. Consequently, it is likely that Motonobu and his studio produced *emaki* of this subject, integrating Tosa and new Kano painting-style features, to serve their clientele whose interests were becoming increasingly worldly.

PAINTINGS

37 Fan Paintings

An album of 60 leaves; ink, color, and gold on paper
Page size 19.7 x 52.8 cm
Muromachi/Momoyama periods, 16th century
Agency for Cultural Affairs, Tokyo

Illustrations of interior settings in *emaki* (hand-scrolls) confirm the presence and use of folding screens (*byobu*) with fan paintings of assorted subjects—such as the Koen-ji single *byobu* [21]. These *byobu* with fans pasted to their surfaces derive from the same tradition that in the later Heian era affixed decorative poem-cards (*shikishi*) to screens, both plain and painted. As noted earlier, the Cleveland Museum *Pampas Grasses byobu* [10] once had *shikishi* glued to their surfaces.

The Nanzen-ji temple in Kyoto still possesses *byobu* with fans for decoration in a variety of subjects and styles that can be given a 16th-century date.[1] Others, usually with subjects inspired by *The Tale of Genji* are known from the hands of anonymous Kano and Tosa artists of later generations. Recently an example with background water themes by Kaiho Yusho appeared,[2] enhancing that artist's stature as an independent painter working in *yamato-e* themes [30, 31].

Numerous other *Genji*, landscape, waterscape, bird-and-flower, famous places, and *kanga* (Chinese painting style) fans survive individually from the period, usually late in the century. These are single sheets or, frequently, compilations in an album, like this example. Although many of the individual fans bear seals and/or signatures and possess a sense of historical coherence, the compiler of this album left no mark. He nevertheless combined for this album fan paintings in an array of hands, stylistic modes, and subjects—which together create a unified statement of 16th-century fan painting that is available nowhere else.

Most of the images are painted on gold ground; they include imaginary Chinese landscapes possessing inscriptions by well-known Zen monks of the time, whose colophons appear on the Nanzen-ji fan *byobu* and some of the more celebrated *suibokuga* (ink painting) of the era. This is an indication of the status of the fan format, whose intimate scale must have appealed to Zen prelates and tea collectors alike, despite the fact that they were more accustomed to the slender, hanging scroll for their "study" or tearoom alcove (*tokonoma*). Fan paintings were widely accepted into these cultural circles if only because imported Chinese examples enjoyed favor with early Japanese collectors; and Japanese versions followed soon thereafter, once it became apparent the imported supply was insufficient to meet the demand, or when native scenes and literary subjects became fashionable. Fifteenth and 16th-century historical records also note a demand in China for Japanese fan paintings on gold leaf.

Still the most impressive features of this album, aside from its size, are the number of different artists represented, and the variety of subjects depicted. Their identities are attested to by the 17th-century painter-connoisseurs Kano Tanyu (1602-1674) and Kano Yasunobu (1613-1685). Yasunobu, however, identifies several *yamato-e* examples only as "painted by Tosa," rather than citing a specific artist who in his opinion is not one of the Kano group.

The compiler brought together twenty-one *suibokuga* (ink paintings) and thirty-nine *yamato-e* paintings whose subjects range from phoenix and paulownia [6], *chidori* (sea plovers) [21, 46], peonies [30], morning glories [31], Sanno [20], Chikubushima [34], to Mt. Fuji [35]—all familiar topics among the larger-format paintings and some of the lacquerware in the exhibition. Several of the fans appear entirely fresh, especially those done in *yamato-e* style, while others suggest close stylistic or compositional affinities with *byobu* in the exhibition. Tanyu and Yasunobu's appraisals of authorship by Kano artists are noteworthy, as they provide timely historical confirmation of the active role that the so-called "academic" Kano School artists played in identifying and rendering *yamato-e* subject matter. Evidently, Tanyu and Yasunobu believed that their predecessors were actively engaged in that pursuit.

38 The Various Professions

An album of 24 leaves; ink and color on paper
Page size 24.2 x 25.4 cm
Momoyama period, 16th-17th century
Hayashibara Art Museum, Okayama

The Japanese people have traditionally honored their craftsmen along with spiritual leaders, nobility, and healers. Perhaps this is due in part to the fact that the Japanese have always lived so close to the earth, on islands lacking substantial natural resources or vast tracts of flat, arable land. Conscious of the earthenware, bamboo, wood, and cloth vital to everyday life, they have long recognized the skill—not to say genius—that is necessary to fashion natural materials into well-designed utilitarian wares.

As early as the Heian period (795-1185) court artists recorded aspects of daily life in the capital, Kyoto. Aristocratic literature echoes this curiosity about "common folk," their manners, appearances, and material culture.[1] A natural offshoot of this interest is the illustrated handscrolls (emaki) and albums depicting the various professions that appeared with increasing frequency in the Kamakura and Muromachi periods. In them, the viewer sees both the craftsperson with the tools and clothing of his trade or profession, and a vignette of Japanese life.

Although these illustrations document basic types of human activity, they also record a certain nostalgia for the simple life on the part of those in higher social circumstances. It is therefore not surprising that the fusuma (sliding door panels) visible in the screen devoted to a Tale of Genji subject—the most noble of Japanese texts—contains a rice-planting scene [25].

The earliest shokunin (various professions) depictions surviving today come from dispersed segments of illustrated handscrolls. Compositionally they appear to be based upon emaki illustrating the famous court poets, known as kasen-e. Thus whatever the inspiration for creating pictures of those who performed menial tasks in early Japan, the visual model chosen to convey those subjects was based upon that used to immortalize its literary heros.

Considerable variety occurs in these portrayals of traditional craftsmen and women because the artist often seeks to present a "rough" style appropriate to the common class subject and, from an art historical perspective, because no established models existed prior to 1300. A 14th-century poetry-contest handscroll in the Tokyo National Museum and a 14th-century fragment of a shokunin-zu in the Kyoto National Museum (unpublished) offer the earliest prototypes.[2]

For stylistic proximity as well as similarities in composition and materials to the album in this exhibition, one must turn to 16th- and 17th-century genre paintings (fuzoku-ga), especially the byobu (folding screens) that depict the street scenes, shop life, and material culture of Kyoto: Rakuchu-Rakugai [18]. Tosa, Kano School, and so-called "town painters" (machi-eshi) responsible for these large, panoramic views of urban life surely also participated individually in the more modest shokunin-zu studio efforts. Future study will determine this more clearly. It is known that the remarkable independent artist from Fukui, Iwasa Matabei (1578-1650) produced at least two of the most dynamic renditions of the subject.[3] In the 19th century, Hokusai (1760-1849) liberated the subject for all time—embracing virtually all forms of human endeavor in Japan—with the publication of his manga (picture books of daily life).

The album from which these two leaves were taken is one of the oldest and finest remaining; it is traditionally dated to the late Muromachi period. Although no text, historical documentation, and provenance accompanies it, comparison of figural style with the Matabei versions and with 16th-century Tosa School albums provide a reasonable framework in which to include it. Certainly linking it with figural compositions by such master painters of the mid-17th century as Tosa Mitsuoki (1617-1691), Kano Tanyu (1602-1674), or Kano Eino (1631-1697) proves unsatisfactory.

The figural style apparent here remains decidedly robust. Yamato-e features are echoed in the elegant, muted palette. The clothing patterns and tonalities possess the same degree of sophistication evident in [26] despite the obvious differences in their functions. Such features of general aesthetic sensibility interwoven with specific detail form an integral part of early Tosa School figural representation—as is evident in the Tokyo and Cleveland Stable screens [22, 23]. The figures in these byobu provide essential material for identifying and characterizing yamato-e figural conventions in the 15th and then 16th centuries. The beguiling mix of physicality and elegance seen in the figures in those early paintings is precisely that which inspired the innovative yamato-e paintings of Tosa Mitsumochi [26], Hasegawa Kyuzo [24], Matabei (1578-1650), Itcho (1652-1724), and Morikage (1620-1690) in the Edo period.

39 Portrait of Takeda Nobutora

Hanging scroll; color on silk
82 x 36.5 cm
Momoyama period, ca. 1574
Daisen-ji, Kofu, Yamanashi Prefecture
Important Cultural Property

Takeda Nobutora (1494-1574) was born in Kai Province (present-day Yamanashi Prefecture) into the family of a feudal lord. After succeeding his father as head of the family, he killed his uncle who had been scheming to take his place. He gained ascendancy over the powerful warriors in the area and stabilized his territory. When he became even more powerful, he attacked the neighboring provinces. Subsequently he became an autocrat.

Nobutora's attempt to transfer the leadership of the family to his second son over the head of his first son, Shingen, led to resistance from his retainers. He was exiled by Shingen in 1541 and took refuge under the protection of the Imagawa family, a feudal family with holdings nearby. It was then that he decided to remove himself from worldly relationships by becoming a *bonze* (Buddhist monk). However, when the power of the Imagawas declined, he tried to have the troops of the Takeda family take over their lands. Banished by the Imagawas in 1563, he moved to Kyoto and then wandered in western Japan, eventually dying in Takato, Shinano Province, a region belonging to the Takeda family.

This portrait shows him after he was tonsured as a *bonze*. Because his hair was completely shaved off, his unusually large head is conspicuous. More impressive are his glittering eyes. His fearless face clearly shows the nature of a warrior who had survived the warring period. His unique character is exposed in a unique manner. His costume, a black robe with an outer surplice of red and green reaching from his shoulders to his stomach, is that of a priest. He holds a fan of banana leaves with a bamboo handle. The upper and lower parts of the spine of the fan have lacquered decorations. This type of fan would belong to a hermit, since warriors usually held folding fans.

The inscription was written by Koshin Shungoku, who was the second abbot of Chozen-ji temple, where the portrait of Nobutora's wife [40] is kept. (Koshin later became the forty-eighth abbot of Myoshin-ji in Kyoto.) The inscription describes Nobutora's lineage, but among his many children, only Shingen and Nobukado's names are mentioned. Reference is also made to his discord with his first son and to the fact that he died of sickness in his hometown after returning from thirty years' absence. There is a line stating that this portrait was painted by Nobutora's fourth son, Nobukado (Shoyoken), and that Koshin wrote this inscription to comply with his request. It ends with verses about the stage of enlightenment where men become one with the universe:

The fan he holds is a symbol of his great power
Capturing all the wind in his hand.
The sun, the moon, and the stars all dwell in
 his eyes
Emitting a spiritual light which shines through
 the cosmos.

MS

40 Portrait of Takeda Nobutora's Wife

Hanging scroll; ink and color on silk
87.6 x 37.3 cm
Muromachi period, ca. 1556
Chozen-ji, Kofu, Yamanashi Prefecture
Important Cultural Property

The sitter's white hands clasped in prayer were made extremely small: through them one gains a sense of her piety. Her head, probably shaved, is covered with a blue cloth. She wears the costume of a Buddhist nun—a black robe and a small red surplice decorated with arabesque patterns. The light purple undergarments indicate her feminine tastes. The edges of the *tatami* mat on which she sits are decorated with the crests *(mon)* of the Takeda family.

She was born into the Ooi family, one of the most influential clans in Kai Province. She married Takeda Nobutora and had several children, of whom the best known are three of her sons: Shingen, Nobushige, and Nobukado. After her husband was exiled, she studied Zen Buddhism under a priest at Chozen-ji and became tonsured. Her rigid facial expression with furrowed brow suggests the suffering she endured throughout her life.

This portrait, painted on the first anniversary of her death, bears a legend written by the fourth abbot of Daisen-ji, Genin Anshi. It reads:

Nobukado brought his paintings of his beloved mother and asked me to write a legend on it; not being able to refuse his request, I immediately made a few lines. Nobukado's gratitude to his mother is reflected in this well-executed portrait. Can I, an old man, also contribute to making the painting complete by loudly shouting dirty words at her? There is no boundary between reality and nothingness after all.

The legend was inscribed on a white background decorated with cloud patterns in gold paint. Above it are two colored squares. Wild pinks (*nadeshiko*) are depicted on the red square, while a goose and reeds are depicted on the brown square. Both designs are in gold and contain a poem written by her about her enlightenment:

*Colors of cherry blossoms
and maple leaves
all fade and fall
as time passes
leaving nothing behind.*

Takeda Nobukado (Shoyoken), as is apparent from this picture, was a good painter with more than an amateur's skill. The technique of making clear shading on the drapery is rare in paintings from the medieval period. The red seal in the bottom right corner is probably his. Clearly this painting creates a different impression from his other portrait (of his father) [32], but that one was painted nearly twenty years later. MS

41 Portrait of Nishitani Tobei

Hanging scroll; ink and color on silk
75.2 x 38.6 cm
Muromachi period, ca. 1558
Tamon-in, Tadotsu, Kagawa Prefecture

Nishitani Tobei was the lord of a small castle town in the western province of Sanuki (present-day Kagawa Prefecture). In those days each province was under the control of a *shugo* (the person responsible for maintaining peace and order in each region). Since all of the *shugo* were required to live in the capital city of Kyoto, their duties were actually performed by local representatives, called *shugo-dai*. The model for this portrait was a member of the Kagawa family, which held the position of *shugo-dai*, indicated by the crests on his apparel.

Sanuki Province belonged to the Hosokawa family. Since they were in the highest position under the Muromachi shogunate (as important aides), they were continuously in battles. Tobei must have seen military service several times, although this portrait does not convey a military atmosphere. While his facial expression suggests vigor and vitality, his hair is thin and his topknot is very far back. In fact, he is already quite old. The *tatami* mat he is sitting on has a decoration of wave patterns along its edge.

He wears a light blue *kamishimo* (the formal wear of the warrior class, consisting of a sleeveless upper vest and a *hakama*, or divided skirt, over a brown *kosode* (undergarment). He has both a long and a short sword tucked into his garment.

Seemingly, there are no distinguishing characteristics in this picture. However, this is one of the earliest portrayals of a *kamishimo* and is therefore important for the study of Japanese costume history. Another point of interest is the flute in the warrior's left hand (the case for it rests on the *tatami*). It was considered a necessary accomplishment for warriors in the Muromachi period to excel in some kind of cultural activity, as it had been for aristocrats during the Heian period. But portraits that show this side of a warrior's life are very rare.

The inscription above the portrait is by a Zen priest. It says that Tobei's dutiful son had this portrait made; at his request, the priest wrote an inscription on the theme of Zen enlightenment. The date at the end says that it was written just one month after Tobei's death.

The Tamon-in temple also owns a portrait of Tobei's wife. That painting was made three years after her husband's death. She is shown reading a book with screens surrounding her. Due to the fragile condition of the painting, it could not be included in this exhibition; but it is a rare instance of portraits of a couple remaining together over the centuries. MS

42 Portrait of Hosokawa Akimoto's Wife

Hanging scroll; ink and color on silk
75.8 x 32 cm
Momoyama period, ca. 1580
Ryoan-ji, Kyoto

The subject of this portrait is the wife of Hosokawa Akimoto (the younger sister of Oda Nobunaga), whose name was Oinu (dog). While this is an unusual name for a woman, it was probably meant to convey a wish for good luck, since dogs were generally believed to experience little difficulty in giving birth—an important attribute in a time when many women died in childbirth. Oda Nobunaga had another younger sister called Oichi, who is chiefly remembered for her tragic life story. Her first husband, Asai Nagamasa, killed himself after he lost a battle against Nobunaga's troops. Following his death, Oichi was forced to marry the warlord Shibata Katsuie, but when he too was defeated in battle, they committed suicide together.

Both Oinu and Oichi were famous for their beauty. Oinu's name is not as well known in Japanese history as that of her sister, perhaps because her life was not as tragic. She died when she was a little over thirty, and during her short lifetime, she too had to marry twice. Her first husband, Saji Tameoki, was lord of the Oono region, near her birthplace. After his death, she married Hosokawa Akimoto (1548-1592) in 1577.

Oinu died in 1582, five years after her second marriage. She had one son and two daughters. Akimoto was head of the Hosokawa family, which had long served the Muromachi shogunate as very important aides. Oinu's brother, Nobunaga, and the last shogun of the Muromachi period, Ashikaga Yoshiaki, were enemies, so it is likely that the marriage between Oinu and Akimoto was the result of a political arrangement. Nobunaga himself was killed in June of the same year that Oinu died.

This portrait does not vividly convey the individual characteristics and beauty of Oinu. The white skin, long face, and slit eyes are standard components in paintings of beautiful women from this period. Straight black hair down to the waist was also an accepted requirement of feminine beauty in art.

Oinu has a pair of bushy eyebrows drawn high up on her forehead. Since the Heian period, it had been traditional for women to pluck out their eyebrows and then pencil in artificial ones. However, drawing eyebrows so high on the forehead is usually seen only in the Muromachi period. As to her costume, the outer kimono has a pattern of blue morning glories on a gold background alternating with stripes on the shoulders, sleeves, and hem. Morning glories bloom only for a day, so they were probably used as a motif in this painting to symbolize Oinu's short life. Her posture, kneeling on one knee while clasping a string of beads, has something in common with Western, Christian paintings of saints praying.

The inscription on the upper half of the scroll is by Gekko Sozu, the forty-fourth abbot of Myoshin-ji in Kyoto. It states that *"this portrait of Oinu was made at the request of her child,"* and it repeatedly praises her beauty.
MS

Lacquerware in the 16th Century

The long period of warfare that raged throughout Japan finally came to an end with the establishment of a unitary government in the 16th century. People became excited at the prospect of peace and began to plan for the reconstruction of society. It was a time when the old authority, systems, customs, and traditions gave way to a new order. The leaders who grasped power were from the rising military class (the most representative being Toyotomi Hideyoshi, the son of a poor farmer) and from the merchant class, who were becoming rich as a result of the rapid development of commerce and industry. The cultural styles that they promoted were characterized by a free and bold approach embodying many innovative ideas. European culture, which was then entering Japan, exercised an undeniable influence. The 16th century, in reflecting these exciting societal changes, was therefore a significant turning point in the fields of arts and crafts.

Lacquer had its origins in Japan as early as the third century BC. The sap of the lacquer tree, *Rhus vernicifera*, was applied in many thin layers (with long drying times in between) to earthenware vessels, basketry, wooden hunting equipment, and even cosmetic items, not only as a protective coating but also to enhance appearance. Since lacquer sap is toxic, additional care was required during the repeated applications. Color was added in the final coatings by mixing pigments with the raw lacquer.

With the introduction of Buddhism to Japan in the 6th century, native workers learned new techniques from skilled foreign craftsmen, and together they began to provide the hundreds of lacquer items requested by the court and by the growing number of Buddhist temples. By the 8th century, lacquer production became an official activity supervised by the government. Extraordinary lacquerwares from that period are still preserved in the Shoso-in in Nara, the imperial treasure house filled with objects belonging to the Emperor Shomu (died AD 756).

A variety of shapes and techniques occur among these pieces, including the process in which gold filings, or dust, was sprinkled on wet lacquer to produce a design. This technique—*maki-e*—developed from the Nara through the Heian and Kamakura periods into a highly sophisticated lacquer art form.

When we look at the lacquerware made during the 15th century (Muromachi period), we quickly realize that some of the earlier techniques had disappeared. For instance, the use of mother-of-pearl, prominent during the Kamakura period, lost favor, as did *choshitsu* (carved lacquer) and *chinkin* (inlaid gold). In fact, the last two short-lived techniques seem to have been valued only for their exotic appearance. The refinement of high quality *choshitsu* and *chinkin* techniques had to wait until the 16th century.

Exquisite *urushi-e*, *Negoro* lacquer, and *kamakura* carving were widely diffused; but since they were used mainly for tableware and the furnishings of Buddhist altars, they employed few explicitly decorative features. In general, the major decorative lacquerware was *maki-e*. By the 1500s, the fundamental techniques of *maki-e* had been perfected, so that more complicated and elaborate design expressions were possible. These same techniques are still in use today.

This new sophistication was apparent not only in the elaborate designs but in the themes of these designs. In other words, there was a coalescence between producers (designers and *maki-e* artisans) and users of lacquerware. From the side of the producers, the most important thing was deciding how to best use the available symbolic designs; for the users of this ware, however, the most important thing was learning to understand and appreciate the symbols and motifs employed in the designs.

These two tendencies originated with the tableau-type designs that first appeared in the 13th century and became more common during the 15th century. Sources for these designs were found either in *waka* (thirty-one-syllable poems) or in classical literature, such as the *The Tale of Genji*. The design style that illustrates themes from *waka* poetry is called *uta-e* (poem-picture). The motifs depicted are based mainly on a scene described in the poem, or on views of the places mentioned most prominently in poetry. The idea of placing some words of the poem randomly in the design also became popular (see [43, 44]).

Such motifs could create a world of intellectual play, appreciated only by those with a knowledge of literature. The fact that many masterpieces of this type of design are found on writing boxes—an essential tool for intellectuals or men of culture—underlines the necessity of this knowledge, particularly within the context of *waka* or *renga* (linked poetry). The latter was a sophisticated game in which *waka* poems were composed in sequence by several people; it was fostered in the aristocratic salons of Kyoto and became popular during the 15th and early 16th centuries.

During the 16th-century wars, however, these salons disappeared. The power at the top of society was taken over by the new warrior class. Because they lacked the educational background to enable them to comprehend the traditional, classically based, culture, these leaders preferred designs that emphasized visual effects over meaning. Thus, the following developments occurred: (a) Autumn flowers and motifs of vessels and family crests became popular, gradually replacing designs illustrating classical literature. (b) Instead of depicting the whole of something, lacquer artists depicted only an enlarged part or a close-up view, resulting in a bolder image. (c) The composition called *katami-gawari* (differing halves) was invented. By dividing the area diagonally and applying a different background to each with *nashiji* (pear-skin ground) or *ikakeji* (fine-powdered ground) on one side and black lacquer on the other, a powerful overall design resulted.

Maki-e (literally, "to sprinkle-picture") is a technique in which gold or silver powder is sprinkled on wet lacquer. Made from the 16th to the early 17th century with the above-mentioned characteristics, it is usually divided into these four styles:

1. *Traditional maki-e.* Gold (*kirigane*) or gold and silver (*kanagai*) are extensively employed in the *takamaki-e* (relief sprinkled-design) technique, dating from the Muromachi period. The motifs are often based on classical literature or ancient customs. A composition with a wide area of empty space was also employed, in emulation of the Chinese paintings that were introduced in this period. Still prevalent in the Momoyama period, this style reflected the taste of the age, but designs became bolder and more extravagant.

2. *Kodai-ji maki-e.* This name derives from the style of *maki-e* used in the mausoleum architecture, tableware, and utensils at Kodai-ji temple, Kyoto, where Toyotomi Hideyoshi and his wife, Kita no Mandokoro, are enshrined. Hideyoshi is a symbolic role model in Japanese history: as an ordinary citizen, he attained a position second only to the emperor. Kodai-ji *maki-e* style often takes as its theme flowering autumn grasses and crests of chrysanthemum and paulownia. Gorgeous effects in color and decorativeness were attained within the simple techniques of *hiramaki-e* (flat sprinkled-design), *e-nashiji* (pictorial pear-skin ground), and needle engraving.

Even before the Momoyama period, there were examples of Buddhist temples whose interiors were decorated with *maki-e* and mother-of-pearl in order to present an imitation of the Pure Land (Jodo) with Buddhist sculptures enshrined in altars. But in the Momoyama period, *maki-e* was adapted to ornament not only religious places but also the living spaces of castles and palaces. Kodai-ji *maki-e*, due to its striking visual effect and simple techniques, was the most suitable for this usage.

3. *The style for export goods.* The 16th century was an age of exploration for many European countries. The Portuguese first came to Japan in 1543, and Christianity was introduced by St. Francis Xavier in 1549. After that, European culture (Portuguese, Spanish, Dutch, and English) rapidly invaded the country and active trading began. These events had a profound influence on Japanese culture.

Household articles (chests, chests-of-drawers, liquor bottles, and mirror boxes) as well as religious items (portable shrines and pyxes) were made for European traders. At first glance, the designs look exotic, but they are composed of Japanese motifs that have been arranged in a complex manner—the result of *maki-e* artisans not knowing anything about European tastes, yet still striving to satisfy the demands of the traders. Although the basic technique employed was in the Kodai-ji style of *maki-e*, a variety of designs showing decorative ingenuity was added through the use of mother-of-pearl. Portable shrines decorated with flowers and birds in *maki-e* and mother-of-pearl are good examples of this technique.

4. *Koetsu maki-e.* This style is named after the artist Koetsu Hon'ami (1558-1637), who also expressed his natural creative talents in calligraphy and ceramics. It is characterized by the following: (a) The designs are often taken from themes in classical literature. (b) Many have close-up depictions, innovative motifs, or unconventional shapes. (c) The use of different ornamental materials is outstanding and highly decorative.

Compared to the traditionalism of style 1 and the lack of individuality in the mass-produced items of styles 2 and 3, Koetsu's style seems to offer a unique, personal touch with a feeling of openness. Koetsu himself was probably not involved in the actual production of *maki-e* (requiring a much longer period of apprenticeship than calligraphy or ceramics), but there is no doubt that he contributed to the designs. They are clearly endowed with his aesthetic sense. It is difficult, however, to attribute individual designs to Koetsu; rather, one might think of his designs as forming the style of his day.

European culture played no small part in the progression of lacquer art from the 15th to the early 17th century. Utterly different from that of the familiar Chinese or Korean cultures, the European influence can be recognized in pieces designed for export, as well as those made for domestic use, on which new Western designs and curious, exotic human figures and utensils were depicted. Such designs, however, never became central, as Japanese *maki-e* lacquer had successfully established its own styles that maintained Japanese motifs and technical ingenuity.

Suzuki Norio
Curator, Fine and Applied Arts Division
Agency for Cultural Affairs, Tokyo

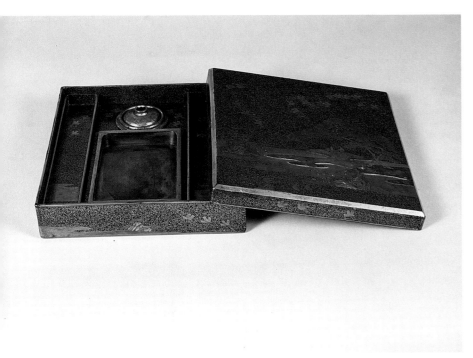

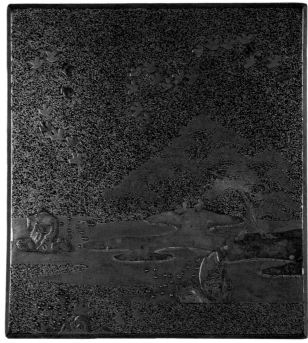

43 Writing utensil box *(suzuribako)*

Lacquer on wood with decoration in *maki-e*; copper, stone, silver, gold, and silver disks
5.2 x 24.7 x 22.8 cm
Muromachi period, 15th century
Tokyo National Museum

This almost-square box for writing utensils has a covering-style lid (*habuse-buta*). The interior contains a round water-dropper of gilded copper, a black inkstone (*suzuri*), and two long trays (*kakego*) for brushes and inksticks. The top, sides, and interior of the lid are decorated with pine trees and a beach. The design on the lid exterior—trees fronting the sand, rolling waves, rocks jutting out into the sea below, and a flight of plovers in the sky—is especially elaborate and delicate.

Judging by the design—hidden in the rocks—of "flying plovers and pine trees on a beach" and two Chinese characters (one for "emperor" and the other for "congratulations"), the motif is probably meant to illustrate the following *waka* (thirty-one-syllable Japanese poem) by an unknown poet included in volume 7 of the *Kokin Wakashu* (Collection of Ancient and Modern Waka Poetry, AD 905):[1]

shio no yama The plovers dwelling
sashide no iso ni at Sashide-no-iso
sumu chidori by Shio-no-yama
kimi ga miyo o ba cry *yachiyo*, wishing
yachiyo to zo naku our lord
 a reign of eight
 thousand years.

The poem not only refers to a noted place—in this case, Shio-no-yama—but also expresses a wish for the longevity of the emperor. The green pine trees and the mandarin orange tree beside the rock on the left also symbolize blessings and good omens, as do the plovers. All of these elements fit the meaning of the poem well.

The technique of hiding a character of a poem in a picture is called *ashide-e*; it had been used since the Heian period as a sophisticated design theme to convey both intellectual refinement and a sense of playfulness.

This work may also be called an *uta-e* (poem-picture) because the theme of the poem is made visual in the picture. Other fine examples of *uta-e* are writing boxes made in the medieval period (12th-15th centuries).

Pine trees and rocks are raised slightly above the surface by means of the *takamaki-e* (relief sprinkled-design) technique, and flecks of silver (*kirigane*) are scattered about. Part of the beach and the dewdrops on the reeds are formed from small silver disks. The background is decorated in *hirameji*, over which *hirame-fun* (fine, powdered gold) is sprinkled. The corners of the lid are faceted and covered with designs of pine needles in *maki-e* (sprinkled design) over the densely sprinkled fine gold filings (*ikakeji*). SN

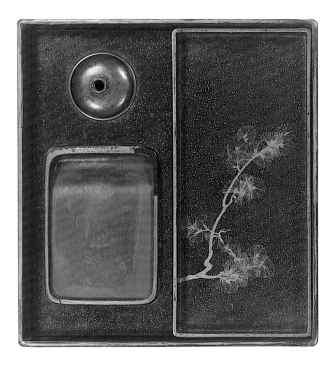

44 Writing utensil box (suzuribako)
Lacquer on wood with decoration in *maki-e*
4.5 x 24.4 x 21.2 cm
Momoyama period, end of 16th century
Agency for Cultural Affairs, Tokyo
Important Cultural Property

This writing box contains the requisite water-dropper and rectangular inkstone (*suzuri*), but only one shallow tray (*kagego*) for writing utensils. On the top of the lid and spilling over onto the sides is a picture of the moon behind a mountain, identified as Mt. Hatsuse, near present-day Sakurai City in Nara Prefecture. Cherry and other trees grow luxuriantly on the slopes of the mountain. The picture illustrates a poem from the *Shinzoku Kokin Wakashu* (New Collection of Ancient and Modern Waka Poetry), published in 1439.[1]

The overall design is in the *yamato-e* style of painting (Japanese-style painting), but the design components are Chinese painting motifs. The picture is divided diagonally, with mountain and moon on the right half and a blank area on the left. Inside the lid is a painting of an adult monkey and its offspring hanging from a pine tree over a precipice, trying to grasp the moon reflected in the river below. It illustrates the metaphor "*enko-sokugetsu*" (a monkey tries to grasp the moon reflected in the water), which is found in the *Sogiritsu*, a Buddhist text. In the story, the branch broke and the monkey fell into the water and drowned—thus leading to sayings such as: "If one tries the impossible, he will fail," or "If one doesn't know one's limitations, he will lose everything." This Chinese motif became a favorite subject and was used repeatedly in Japanese art.[2]

The box is covered inside and out with *nashiji* (pear-skin ground), the technique of sprinkling fine gold powder onto the damp lacquer surface, producing an effect similar to the skin of a Japanese pear (*nashi*). The mountain and trees on the lid exterior are covered with gold and bluish-gold (an alloy of gold and silver) in *takamaki-e* (relief sprinkled-design). A thin layer of silver seems to have been used for the moon's reflection, but this is now missing. The pine branch on the tray is in *hiramaki-e* (flat sprinkled-design).

The idea of combining Chinese motifs in a Japanese-style painting and of composing the picture diagonally was a common technique in the Muromachi period. But continuing the picture from the top of the lid onto the sides of the box and affixing a very thin silver sheet (*kirigane*) on part of the design were innovations peculiar to the artisans of the Momoyama period. Rounding the corners of the lid was also typical of this period. SN

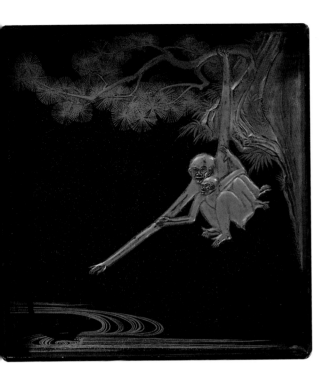

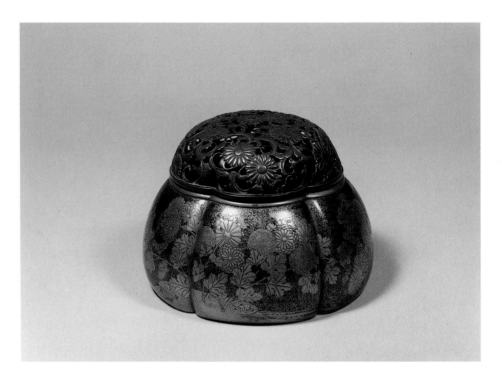

45 Incense burner (*akoda koro*)
Lacquer on wood with decoration in *maki-e*;
copper
Diam. 17.8 cm
Muromachi period, 15th century
Itsuo Museum, Ikeda, Osaka Prefecture

The shape of this incense burner derives from
melon or gourd forms, hence its designation as
an *akoda koro* (melon-shaped incense burner).
It represents a traditional style originating in
the Heian period. On each facet are three
chrysanthemums with widely spreading stems;
two facets include a sand bar with waves.
The branches are in thin *takamaki-e* (relief
sprinkled-design), as are some parts of the
flowers and leaves, while others are in *to-
gidashi maki-e* (polished-out sprinkled design).
The sand bars are in *hiramaki-e* (flat sprinkled-
design) with flecks of gold and silver scattered
on parts of the shore. The blank areas are in
nashiji (pear-skin ground), as is the bottom,
where gold powder was only lightly sprinkled.

Made of openwork copper in a chrysanthe-
mum-arabesque design, the lid is a later re-
placement for the original. SN

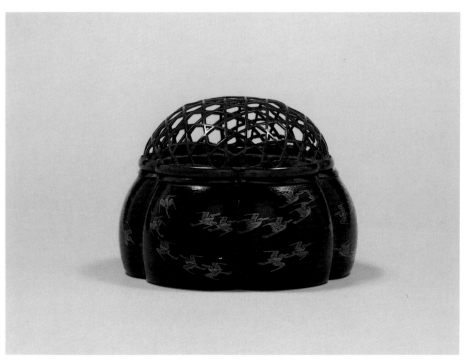

46 Incense burner (akoda koro)

Black lacquer on wood with decoration in
maki-e; metal rims and bronze lid
Diam. 10.8 cm
Nambokucho period, late 14th century
The Cleveland Museum of Art, Purchase from
the J. H. Wade Fund, 60.195

The theme of plovers (*chidori*) flitting over
waves appears initially in Heian period litera-
ture in the *Kokin Wakashu* (Collection of An-
cient and Modern Waka Poetry, AD 905).[1]

The continuing appearance of *chidori* as a
subject in 15th- and 16th-century decorative
arts illustrates once again the subdued but firm
presence of *wayo* (Japanese-style) designs in
Muromachi Japan when so much Chinese-
inspired subject matter enjoyed popularity.
Chidori designs were produced especially for
lacquerware and textiles, and subsequently, in
the early Edo period, enjoyed an exuberant
acceptance in ceramics. The Koen-ji *byobu*
illustrates its adaptation for painted composi-
tions [21].

Incense burners of this shape and age are
rare, and their designs invariably possess overt
poetic or seasonal references that encompass
the undulating surface.[2] In this example, the
maki-e (sprinkled-design) decoration was ap-
plied to the base as well. This feature is curi-
ous, since the incense burner would probably
have been kept on a stand much like [56], its
base invisible. Otherwise, it functioned as the
source for specially prepared scents that per-
meated women's gowns—a custom originating
in the 9th century. This practice is depicted in
the mirror stand design [52] in which a gar-
ment lies suspended among tree branches,
with a melon-shaped incense burner (*akoda
koro*) below.

47 Cosmetic box

Black lacquer on wood with decoration in
maki-e; copper
26 x 26.5 x 34.6 cm
Momoyama period, ca. 1600
Itsuo Museum, Ikeda, Osaka Prefecture

Used mainly for cosmetics, this type of box
was also used for a variety of small belongings.
Painted on the surface are autumn flowers such
as pampas grass (*suzuki*), yellow-flowered
valerian (*ominaeshi*), bush clover pink (*nade-
shiko*), thoroughwort (*fujibakamu*), Chinese bell
flower (*kikyo*), and others. Turtles—symbols
of immortality—appear on the front side.

The box is decorated in *hiramaki-e* (flat
sprinkled-design) with *e-nashiji* (pictorial pear-
skin ground) and needle engraving. Needle
engraving is a technique for drawing delicate
lines by scratching the surface with a needle-
shaped tool. *Hiramaki-e* is a simple technique
compared with *takamaki-e* (relief sprinkled-
design) or *togidashi maki-e* (rubbing the sur-
face where metal sprinkles have been applied

with a piece of charcoal to expose the design
underneath). The gilt-copper fittings are in the
shape of paulownia crests.

In the late 16th century, the long period of
incessant warfare came to an end. As the
newly elevated military class and the mer-
chant class rose to the top of Japanese society,
maki-e (which until then had been admired
and used by only a few of the aristocracy) be-
came a sought-after style of art for these
groups. Because of the increased demand for
maki-e (sprinkled-design), its popularity spread
rapidly. Instead of producing pieces by means
of the traditional, time-consuming techniques
of *takamaki-e* and *togidashi maki-e*, artists
simplified these techniques to enable them to
produce many more items in less time. Simpli-
fying the techniques, however, did not affect
the quality of decorations: they continued to
be visually superb. SN

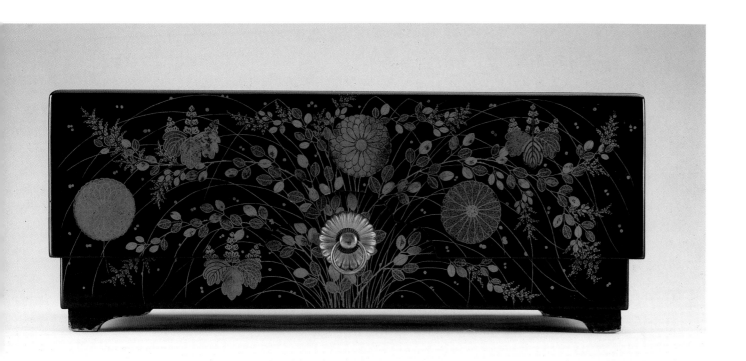

48 Document box
Black lacquer on wood with decoration in
maki-e; metal fittings
17.8 x 44.5 x 28 cm
Momoyama period, 16th century
The Detroit Institute of Arts, Founders Society
Purchase, funds from an anonymous donor,
81.1

The motif of autumn flowers (bush clover, or
hagi) and pampas grass (*suzuki*) together with
chrysanthemum and paulownia crests leaves
no doubt that this box belongs to the large and
varied groups of 16th- and early 17th-century
lacquers called "Kodai-ji style" lacquerware.
Along with Negoro ware they form the pre-
dominant lacquerware types in 16th- and
17th-century Japanese decorative arts. Kodai-ji
style lacquer in particular had a tremendous
impact on Edo period (1615-1868) lacquer-
wares and painted ceramics—such as the
e-karatsu types [71, 72].

It is not clearly known just when the term
"Kodai-ji *maki-e*" came into common usage
as a way of describing a group of lacquers
with similar decorations.[1] Nor has much prog-
ress been made in identifying its creators, or
for that matter their successors in the artisan
studios producing this kind of *maki-e*
(sprinkled-design). Generally speaking, any
lacquer form with recognizable autumn
grasses, flowers, and paulownia crests has
been called "Kodai-ji style" despite questions
of dating, technique, and/or style. Since the
repertory of designs was rather limited and the
actual lacquer-making process so exacting
and time-consuming, it seems reasonable to
assume that the studios producing these pieces
will eventually be identified through painstak-
ing research.

Since the range of Kodai-ji designs is nar-
row and repetitive, artisans sought diversity
through color and form, as can be readily seen
in this box, used to hold writing paper. Its out-
line creates a series of three profiles as the box

recedes inward toward the feet at each corner.
The lid covers more than three-fourths of the
box and has generous cutouts for the metal
attachments, done in a stylized chrysanthe-
mum pattern. The box shape, featuring an ex-
tended, overlapping lid, probably derives from
earlier clothing chest (*karabitsu*) forms. It is
unusual among Kodai-ji style lacquers of this
size and function. Essentially, it offers the con-
tents of the box double protection from injury
and the elements.

The designs on the lid side panels are al-
most continuous with those on the box. They
highlight the rhythmical lines of the stalks of
the *hagi* and *suzuki* accompanied by dew-
drops. The top, on the other hand, stresses a
rather formal, alternating pattern of chrysan-
themum and paulownia crests. In each case
the leaves are outlined in dense gold with the
inner parts comprised of flat gold, or *e-nashiji*
(pictorial pear-skin ground), in red or amber-
colored lacquer; this lends considerable tonal
and textural variety to the appearance of the
hagi and paulownia leaves.

Occasional changes of color within the
leaves indicate where they are drying out or
are diseased—a reference to the passage of
summer and fall and the arrival of winter.
Similar visual motifs noting the passage of
time occurs in the Cleveland Museum *Phoenix
and Paulownia byobu* [6], the Tokyo National
Museum *Octagonal Food Box* [54], and many
other Kodai-ji style pieces. The withering of
even the most beautiful aspects of nature re-
curs as a leitmotif in 16th-century art, as it
does in *yamato-e*, and has done for centuries.
Here, in the 16th century, this theme takes on
a special poignancy due to the colorful materi-
als and large, attractive surfaces and appeal-
ing subject matter of the art of the period.

The drawing and the variety of color combi-
nations in the designs on this box combine
with its unusual shape to mark it as one of the
finest Kodai-ji style lacquerwares in a Western
collection.[2]

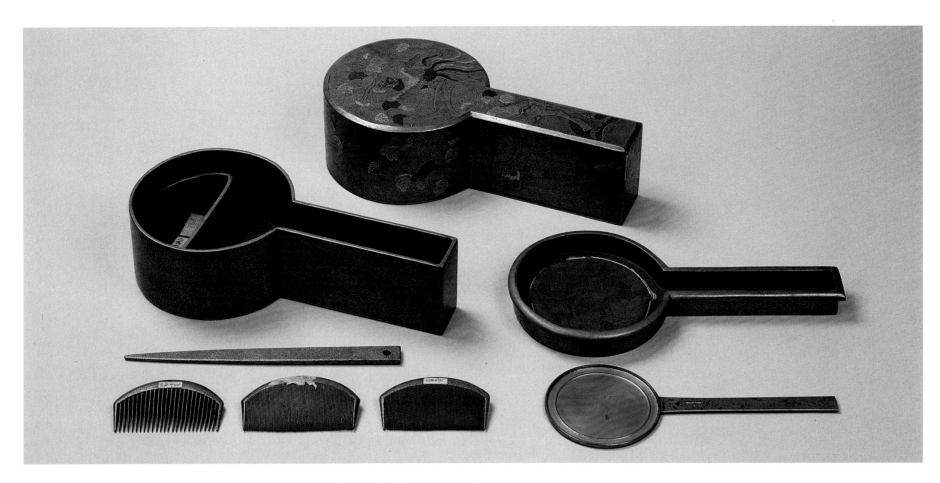

49 Cosmetic set

Lacquer on wood with decoration in *maki-e*;
copper
Box 6.6 x 25.7 cm
Momoyama period, late 16th century
Myoho-in, Kyoto

The box contains a copper hand mirror and
three combs. A signature engraved on the mir-
ror reads "Tenka-ichi Nakajima," indicating
that it was made by a highly skilled craftsman
named Nakajima, who signed his name
Tenka-ichi ("best in the realm"). This style of
mirror, with an easily held handle, began to
appear in the very early 1500s. Earlier mirrors
had a smaller mirror face and longer handles.

The box has designs of paulownia trees and
phoenix in thin *takamaki-e* (relief sprinkled-
design) with gold and silver sheets (*kirigane*).
The ground is covered in *nashiji* (pear-skin
ground). The pattern of paulownia trees with a
phoenix originated in China, where the bird
was a symbol for the emperor or supreme au-
thority. This imaginary bird was said to sit only
in paulownia trees and to eat only their fruit.
The *maki-e* (sprinkled-design) style used here
is a traditional one invented in the Muromachi
period, well before the appearance of Kodai-ji
style lacquerware.[1]

This set is believed to have been used by
Toyotomi Hideyoshi, who governed Japan in
the late 16th century. SN

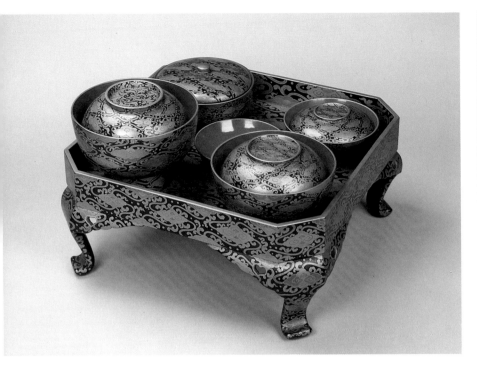

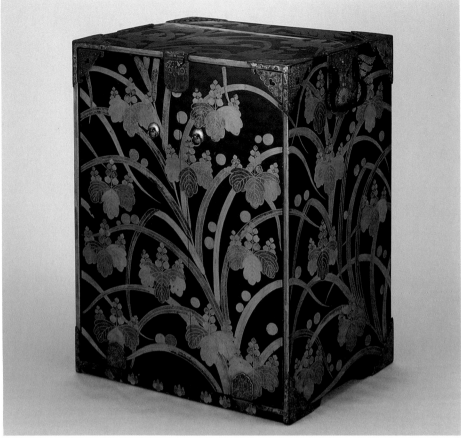

50 Footed tray with serving bowls
Lacquer on wood with decoration in *maki-e*
Tray 14.3 x 33.3 x 33.3 cm
Momoyama period, end of 16th century
Myoho-in, Kyoto

This is a fine example of the traditional Japanese portable table and tableware used to serve food to guests while seated on the floor. The large bowl on the left is for rice; the one on the right, for soup. All of them, except the flat one in the left rear, can be nestled with their lids into the large rice bowl. Other bowls were sometimes used for various kinds of seasonal foods.

The outer surfaces of the bowls and the tray are covered with arabesque cloud patterns in gold *hiramaki-e* (flat sprinkled-design)—a rare, even unique—design in the Kodai-ji style. SN

51 Portable chest
Lacquer on wood with decoration in *maki-e*; copper
50.2 x 38.9 x 30.8 cm
Momoyama period, late 16th century
Suntory Museum of Art, Tokyo

Each side of this chest bears a design of large pampas grasses and numerous paulownia crests. Dewdrops are scattered randomly on the blades of the pampas grass. The techniques used here are *hiramaki-e* (flat sprinkled-design) and *e-nashiji* (pictorial pear-skin ground) with needle engraving in the Kodai-ji style. The handsome visual image and bold composition are enhanced by the colorful atmosphere created by the effective use of gold powder.

Autumn flowers (*akikusa*) and pampas grasses (*suzuki*) were popular subjects during the Momoyama period. The family crest of the Toyotomi family, with chrysanthemum and paulownia—evident here in the gilt-copper fittings—also appeared frequently in the craft ornamentations of this period. SN

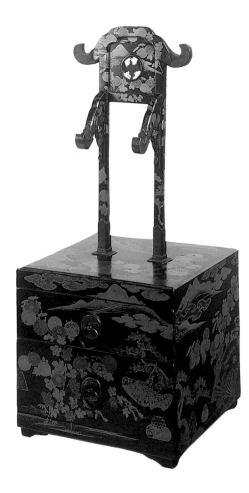

52 Mirror stand
Lacquer on wood with decoration in *maki-e*;
copper
H. 61.6 cm
Muromachi/Momoyama periods, mid-16th
century
Tokyo National Museum

This type of mirror stand with drawers for cosmetics originated in the 15th century and evolved into the style seen here about 1550. All four sides are decorated with the same motifs in the foreground: chrysanthemums, a fan, an incense burner, a costume hanging on a pine branch, and a distant view of mountains with clouds. These illustrate a poem by Empress Jito (AD 645-702) incorporated in the *Shinzoku Kokin Wakashu*, (New Collection of Ancient and Modern Waka Poetry), published in 1439.

Ama no Kaguyama Hill, depicted in the design, is in present-day Kashihara City, Nara Prefecture. Considered to be a holy mountain from ancient times, it has inspired many poems. The techniques used here are typical of the Momoyama period—*hiramaki-e* (flat sprinkled-design), *e-nashiji* (pictorial pear-skin ground), and needle engraving in the Kodai-ji style. However, the *uta-e* (poem-picture) motif and the tableau-type landscape painting are characteristics of the Muromachi period. This piece therefore is representative of the transitional stage from the Muromachi to the Momoyama period. SN

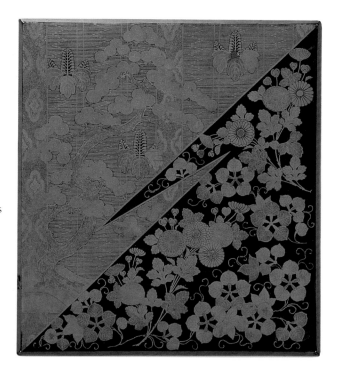

53 Writing utensil box (*suzuribako*)
Black lacquer on wood with decoration in
maki-e
4.5 x 23.1 x 25 cm
Momoyama period, end of 16th century
Tokyo National Museum

This writing box with a covering-style lid (*kabuse-buta*) contains a cucumber-shaped silver water-dropper, an inkstone (*suzuri*), and a shallow plate (*kakego*) on the right. Originally intended to hold brushes and inksticks, the plate now has only an inkstick holder. The lid exterior is divided diagonally by a lightning bolt design. The left part has a design of a pine tree and paulownia crests against a background of bamboo blinds (*misu*), while the right-hand portion is decorated with chrysanthemum and water-caltrop arabesque patterns over a black lacquer base.

The techniques used here are *hiramaki-e* (flat sprinkled-design), *e-nashiji* (pictorial pear-skin ground), and needle engraving in the Kodai-ji style. This type of composition, where the right and left diagonal portions contain different designs, is called *katami-gawari* (different halves) and was widely used in craft designs of the Momoyama period. The juxtaposition of two different images creates a striking visual effect.

The inside of the box is covered with densely sprinkled *nashiji* (pear-skin ground). The lid interior has a pine-tree design, and the plate, a chrysanthemum in gold *hiramaki-e*.

Its bold *katami-gawari* composition and extensive use of *e-nashiji* make this an extremely attractive, decorative piece of lacquerware. SN

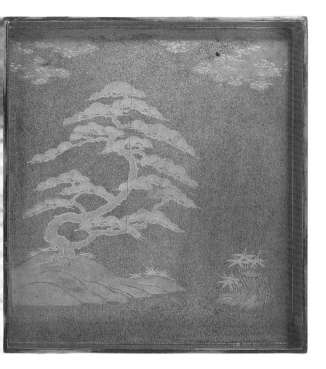

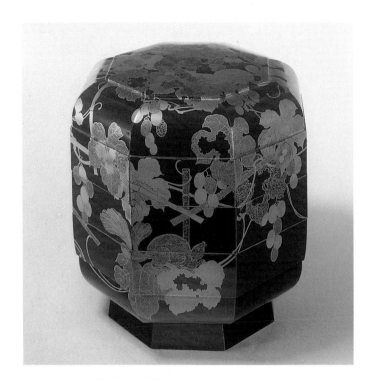

54 Octagonal food box (*jikiro*)
Red and black lacquer on wood with
decoration in *maki-e*
H. 26.4 cm
Momoyama period, 17th century
Tokyo National Museum

This eight-sided food box consists of two tiers
plus a lid and a base. The outer surface is
covered with a continuous motif of squirrels in
a grape arbor. The partially eaten grape leaves
and the busy squirrels are depicted quite
realistically in gold *hiramaki-e* (flat sprinkled-
design) and *e-nashiji* (pictorial pear-skin
ground). Where *e-nashiji* was applied, both
red and black lacquers were used as a coating
before the gold powder was sprinkled over it.
The use of gold enhanced the colorful orna-
mental effects.

The shape of the box is of Chinese origin,
and the motif of squirrels and grapes is
European—although rearranged in accordance
with the Japanese aesthetic sense. This is a
splendid example of cross-cultural harmony.
SN

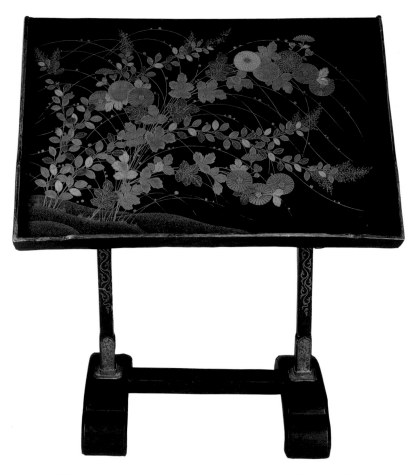

55 Reading stand

Black lacquer on wood with decoration in
maki-e; copper
H. 53.3 cm; tray 30.5 x 45.7 cm
Momoyama period, early 17th century
The Cleveland Museum of Art, Andrew R. and
Martha Holden Jennings Fund, 76.15

The intense design of chrysanthemums, bush
clover, and autumn grasses laden with dew-
drops identifies this lectern as an example of
Kodai-ji *maki-e* (sprinkled-design) lacquer-
ware. Named after the temple built in 1606 by
the wife of Toyotomi Hideyoshi as a mauso-
leum for the family, the term (Kodai-ji *maki-e*)
became generic by the 18th century. The

designs of the temple furnishings (pine, bam-
boo, and autumn grass) exhibit a boldness and
stylistic refinement unknown before the turn
of the 16th century. Among lacquer artists—
particularly those of the Koami family, most
closely associated with Kodai-ji *maki-e*
production—the appearance of such designs
resulted in an outburst of creativity akin to
that occurring simultaneously in Shino-Oribe
ceramics.

This stand and another in the Tokyo Na-
tional Museum reflect both the rarity of this
shape among Kodai-ji wares, and their stylistic
variety within common forms.[1] These objects
were not mass produced, but rather crafted
individually. The Cleveland stand possesses a
naturalistic composition with rhythmically
orchestrated lines and foliate patterns done in

gold *hiramaki-e* (flat sprinkled-design) and
e-nashiji (pictorial, pear-skin ground) in an
alternating sequence of light and dark lacquer
grounds. The shapes of the chrysanthemum
leaves and their outlining are reminiscent of
the paulownias in the *Phoenix and Pheasant*
screen [6]. And certainly the relationship
between painting in ink and painting in
lacquer seems even closer when comparing
the *Pampas Grasses byobu* [10] with this
stand's design.

The Cleveland stand is low, with a plain
support structure except for the metal fittings
and scroll design (sometimes called a "*nam-
ban scroll*"). The surface of the lectern is
framed on three sides, unlike the Tokyo Na-
tional Museum example, which represents a

later, more opulent expression of the Kodai-ji
maki-e style. The Tokyo lectern design in-
cludes three detached paulownia *mon* (family
crests), associated with the Toyotomi family.
These three *mon* appear on the back of the
Cleveland reading stand on a plain black
lacquer ground.

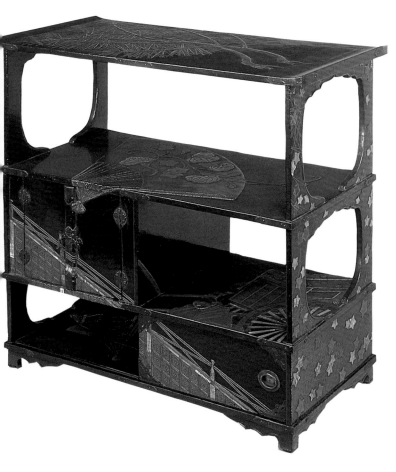

56 Display stand

Black lacquer on wood with decoration in
maki-e; tin, mother-of-pearl, metal fittings
65.5 x 72.5 x 33 cm
Momoyama period, ca. 1600
Agency for Cultural Affairs, Tokyo
Important Cultural Property

This three-tiered cabinet (*zushidana*) is used
for displaying precious family or personal ar-
ticles such as a small treasure box, a writing
box, or incense utensils.

The cabinet is decorated with different mo-
tifs: on the top shelf, a design of two young
pine trees with roots; on the second shelf, a
fan with a bottle-gourd design; on the third, a
court oxcart and coachman; and on the lowest
shelf, a fan with a bridge design. The hinged
door on the third shelf and the sliding door on
the bottom both have the same fence design.
The sides, back, and inside of the cabinet are
covered with designs of maple leaves and pine
needles. Each design—executed in enlarged
detail—is believed to represent scenes from
selected chapters of *The Tale of Genji:
Hatsune* (First Song of the Year), *Yugao* (Eve-
ning Faces), *Sekiya* (Gatehouse), *Hashihime*
(Bridge Maiden), and *Momijinoga* (Festival of
Red Leaves).

The technique used here is *takamaki-e*
(relief sprinkled-design), which dynamically
employs thick, large tin sheets and inlaid
mother-of-pearl. The pine needles and the ribs
of the fan are inlaid with fine pieces of gold,
silver plate, and mother-of-pearl. The cabinet
itself was made with traditional techniques.
The design, with its strong emphasis on visual
and sensuous impressions, is characteristic of
the Momoyama period.

This piece belonged to the powerful feudal
family of Hachisuka in Awa Province (present-
day Tokushima Prefecture) during the Edo
period. SN

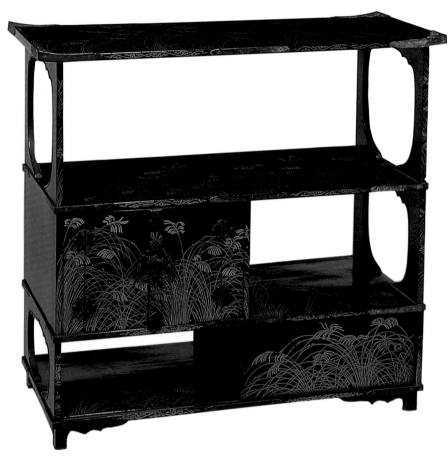

57 Display stand
Black lacquer on wood with decoration in
maki-e; copper
66 x 73 x 33 cm
Momoyama period, early 17th century
Itsuo Museum, Ikeda, Osaka Prefecture
Important Cultural Object

The overall surface of this stand is decorated
with a design of pampas grasses in gold
hiramaki-e (flat sprinkled-design). Pampas
grasses and autumnal flowers greatly appealed
to the aesthetic sense of the Japanese people
in the Momoyama period and were frequently
employed in ornamental design. SN

58 Tray
Negoro ware, red and black lacquer on wood
Diam. 47.8 cm
Muromachi period, dated 1455
Saidai-ji, Nara

This tray has a rim shaped like ten petals; the
foot repeats the shape in a more extended
form. Its design copies one of the many styles
of Chinese objects imported during the
Muromachi period.

On the bottom is written: "Saidai-ji/
temmoku-bon" and the production year
"Kyono-yon." From this, we learn that the tray
was produced in 1455 at Saidai-ji temple for a
temmoku-style teabowl. Chinese *temmoku*
teabowls of the 12th and 13th centuries were
greatly admired in Japan for their plain, flared
shapes and rich, lustrous glazes. The tray was

intended to hold the *temmoku-dai* (a lacquer
stand upon which the *temmoku*-style teabowl
was placed). An extant scroll painting from
this period depicts the same type of tray with a
temmoku-dai and a tea whisk.[1]

Red lacquerware is generally called
Negoro-nuri (a finish comprised of red lacquer
over a black lacquer undercoating). The name
derives from the Negoro Temple in present-
day Wakayama Prefecture, where much red
lacquerware was produced. Despite the asso-
ciation with that temple, however, this type of
lacquerware was produced in a variety of
places, including Kyoto. SN

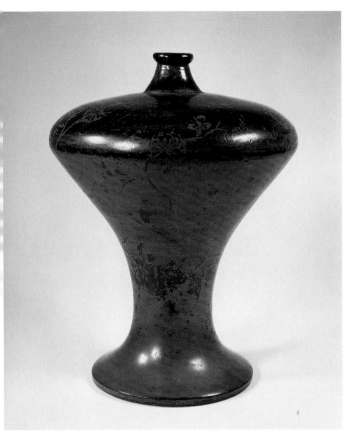
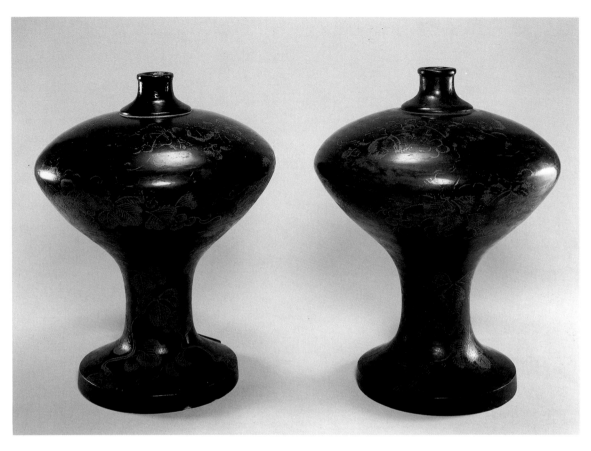

59 Sake container
Negoro ware, red and black lacquer on wood
H. 35.8 cm
Muromachi period, 15th century
Private Collection

Heishi is the term for a bottle used for an offering of sake (Japanese rice wine) before a shrine altar. In fact, sake was rarely poured into a lacquered wooden bottle like this one, since these were intended mainly as ornaments. While the Saidai-ji *temmoko* tray [58] is an example of the adaptation of a Chinese style in Japan, this bottle illustrates a style that is uniquely Japanese. In China, bottles for alcoholic beverages had straight bodies, but those made in Japan had large shoulders and narrow stems.

The top portion of this bottle has an undercoat of black lacquer; the red layer over it has worn off, leaving only the chrysanthemum design that was painted in clear lacquer. Red lacquer is fragile and can be easily rubbed off. However, the pattern made by the partially worn red over the underlying black ground results in a natural, worn texture that suits Japanese taste. SN

60 Pair of sake containers (*heishi*)
Negoro ware, black lacquer on wood
H. 30.5 cm
Muromachi period, 16th century
The Cleveland Musuem of Art, 75th Anniversary Gift of Mitsuru Tajima; Purchase from the J. H. Wade Fund, 91.47-48

Among lacquers surviving from the Kamakura and Muromachi periods, the most historically and aesthetically impressive group possesses links with Nara. There the great Buddhist temples, Saidai-ji and Todai-ji, along with the Kasuga Shrine (a neighboring Shinto shrine), have attracted extraordinary donations of lacquerware (and metalwork) through the centuries.

The earliest group of black—rather than red *Negoro*—lacquer *heishi* bearing painted designs date to the Kamakura era. They are more often found in the collections of Shinto shrines than in temples, because sake was the customary drink offered to the gods of the Shinto faith.[1] The concept of pairing is important to Shinto ritual, and thus these two examples that have survived through the centuries are rare. Their predecessors were glazed ceramic *heishi* from the Seto kilns.

Although the black lacquer "skin" has suffered losses, it retains the familiar "crackle" pattern (*damon*) and patination of fine medieval lacquerware. The painted design of grapes and butterflies shows traces of repainting. The brushwork is spirited, sinuous, and economical—quite unlike the more formal chrysanthemum design of [59] or the Kodai-ji-style lacquers [54, 55].

61 Hot water pot (*yuto*)

Negoro ware, red and black lacquer on wood
H. 35.8 cm
Muromachi period, 15th-16th century
Private Collection, Kyoto

Because this container is used only for serving hot water, it is called a *yuto* (hot water pot). Such pots had been made earlier in China, but this particular shape is uniquely Japanese. The chrysanthemum carved in relief on the lid is an especially Japanese pattern.

This type of ware, in which the relief decorations are coated with lacquer, is called *kamakura-bori* (kamakura carving). This vessel therefore represents the unusual combination of Negoro lacquer with kamakura carving. SN

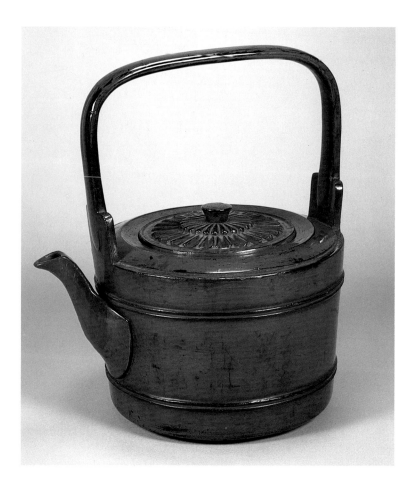

62 Tea caddy (*chaire*)

Negoro ware, red and black lacquer on wood
Diam. 11 cm
Muromachi/Momoyama periods, 16th century
The Cleveland Museum of Art, Purchase from the J. H. Wade Fund, 88.56

This carved, lidded container was made in response to the increased demand for tea utensils in various media during the 16th century. A small wooden block was shaped, carved with generous vertical ribs, and then divided into two equal parts with no overlapping (a shape referred to as *gosu* in Japan). After the insides were hollowed out, all of the surfaces were smoothed to receive black and red lacquer coatings.

Although thinly constructed, large-lobed shapes and fluted dishes appear in early Chinese lacquer, this sturdy container represents a Japanese transformation of those forms with a natural (vegetable-like) shape in mind, as in [45] and [46]. Some of the most satisfying tea utensils utilize actual vegetables such as dried gourds.

Like other Negoro ware containers for powdered tea, this example incorporates both red and black lacquer in its undercoated surface.[1] The broad, rounded fluting pattern creates a vessel nearly devoid of edges. This feature is in keeping with 16th-century Negoro cup stands, bowls, spoons, and the hot water pot (*yuto*) in this exhibition [61]. The kitchen scene in roll two of the mid-15th century handscroll *Boki-e Ektoba* illustrates similar Negoro tea caddies on a stand, although none appears to be fluted.[2]

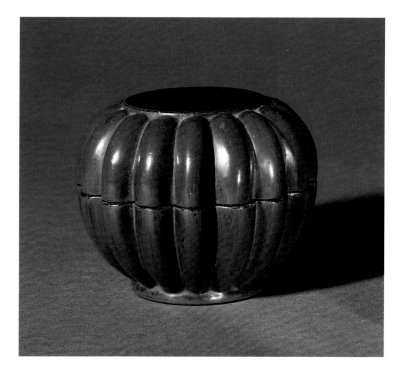

63 Formal robe (*uchikake*)
Embroidery with silver foil on silk
120.2 x 120.2 cm
Momoyama period, 16th century
Kodai-ji, Kyoto
Important Cultural Property

This *uchikake* is believed to have been worn
by Kita no Mandokoro, the wife of Toyotomi
Hideyoshi (1537-1598). The *uchikake*, worn
unbelted over a *kosode* (short-sleeved kimono),
was a formal costume for upper-class women.

The whole garment is decorated with foli-
ated diamond designs within an hexagonal
tortoise-shell lattice. At first glance, the pat-
terns appear to be woven, but in fact they are
all embroidered. This kind of repeated motif
can be monotonous and tedious, but here, the
use of different colors on parts that represent
designs of large sandbars creates an interesting
and striking design variation. Silver foil was
applied to the areas between the embroidered
parts. SN

64 No robe
Embroidery with gold and silver foil on silk
130 x 116 cm
Momoyama period, 16th century
Tokyo National Museum
Important Cultural Property

This costume has a background of alternating
blocks of red and white. A design of a shore-
line and chrysanthemums was embroidered
on the red areas, while mandarin ducks and
reeds were embroidered on the white parts.
Impressed gold and silver foil (*surihaku*) has
been applied to the spaces between these
embroidered motifs.

 The use of alternating blocks of colors,
the use of various colors to decorate a single
motif, and the use of bright colors on a red
background are characteristic elements of cos-
tumes from the Momoyama period. The nar-
row sleeves with a long collar reaching nearly
to the bottom of the costume were also the
fashion in this period.

 There was no distinguishable difference
between No costumes and the ordinary
kosode (short-sleeved kimono) worn during
this period. This costume has been handed
down in one of the traditional No schools, the
Komparu, from Nara Prefecture. SN

65 No robe
Embroidery on silk
127.3 x 121.2 cm
Momoyama period, 16th century
Kasuga Shrine, Seki City, Gifu Prefecture
Important Cultural Property

From the end of the Muromachi period (1568) into the Momoyama period, No performances called Jinji No were held before the altar of the Kasuga Shrine. This is one of the many costumes remaining from that time. On the red fabric are large drooping willow branches with snow-covered leaves, and in the circles, a design of swallowtail butterflies resting on plum blossoms—all of them embroidered. Such brightly colored patterns on a red base reflect the vivid, jaunty style of art in the Momoyama period.

During the Momoyama period, the width of a kimono became broader and the sleeves became narrower, as seen in this piece. Also seen here and in [64] and [66], ordinary plants and animals could now be incorporated into designs that had become traditional following the Heian period. In the Momoyama period, while the artistic motifs might have symbolic significance, more importance was put on their visual and decorative qualities than on the stories or symbolism behind each one. The same trend can also be seen in the lacquer-ware and ceramic art of this period. SN

66 No robe
Embroidery with gold foil on silk
138 x 125 cm
Momoyama period, end of 16th century
Tokyo National Museum

This costume, with its broad width and narrow
sleeves, exhibits the same Momoyama fashion
that characterized the previous robe. Large,
wavy, vertical bands containing geometric
patterns in impressed gold foil (*surihaku*) were
applied across the whole background. From
one shoulder to the hem, oversize lilies and
randomly placed oxcarts dominate the design.

Although the shape of this costume and its
magnificient design show a style typical of the
Momoyama period, the use of impressed gold
foil on the basic fabric and the placment of the
main motif to the side are indicative of fash-
ions of the Edo period. Other innovations are
the use of a brown rather than red fabric and
the elaborate embroidery technique used in
the oxcarts. This piece, like [64], was formerly
owned by the Komparu No school. SN

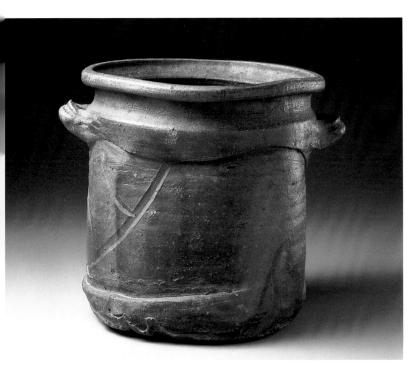

67 Fresh water jar *(mizusashi)* with two handles

Bizen ware
H. 19.8 cm
Momoyama period, 16th century
Goto Art Museum, Tokyo

Bizen pottery produced around present-day Bizen City, Okayama Prefecture, represents one of the six major kilns of the medieval period (the others are: Seto, Tokoname, Echizen, Shigaraki/Iga, and Tamba). Beginning with initial adaptations of prehistoric earthenware techniques, Bizen pottery has been produced continuously from the Heian period to the present, with significant developments over the centuries. One major innovation in the 14th century was the *yakishime* style—a non-absorbent, unglazed type of pottery fired at a high temperature. A dark reddish-brown surface was produced by using oxidation-firing techniques instead of the traditional reduction-firing techniques.

The main products of Bizen were intended for daily use: vases, jars, and bowl-shaped mortars. The principal characteristic of Bizen ware continues to be its sober surface tones, ranging from black-brown to reddish-brown, frequently covered with a dark yellow "natural glaze" that results from the wood ash falling at random and vitrifying.

By the 16th century, production of more refined pieces intended for the tea ceremony began. Many masterpieces, especially *mizusashi* (fresh water jars) and *(hanaire)* flower vases, have been produced since then. In addition to the simple beauty of the un-glazed surface, designs achieved by scraping the surface of the clay (*hera-me*, or spatula patterns) were introduced. The idea of allow-ing distorted shapes for pots created on a handwheel was accepted by the end of the 16th century.

A *mizusashi* is a jar with a lid, used during the tea ceremony to hold fresh water that will be poured into the *kama* (kettle) or used for rinsing the teabowls and the tea whisk. The *mizusashi* exhibited here was first formed on a wheel, then some of the surface clay was scraped off using a *hera* (spatula) around the mouth, parts of the body, and the base. In this particular style (*yahazuguchi*) the rim pro-trudes outward and curls under in a slightly undulating fashion. Under the rim is a deep ledge created when the potter folded the clay inward in such a way that the rim looks as though it is separated from the body of the pot. Handles were added below the ledge and both were then decorated by the familiar technique of scraping away clay. The same technique was repeated on the body of the jar, which displays powerful horizontal patterns below the handles and near the base, with vertical and diagonal patterns on the main body. ST

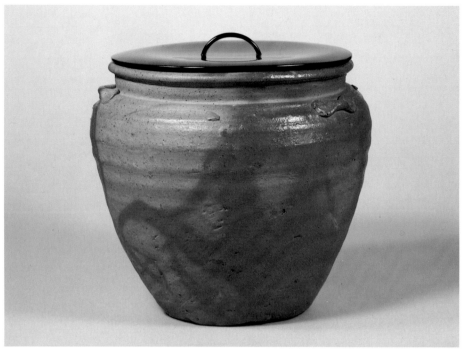

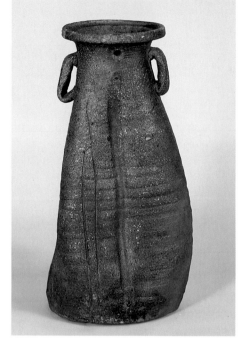

68 Fresh water jar (*mizusashi*)
Bizen ware, with *hidasuki* patterns
H. 16.2 cm
Momoyama period, 16th century
Seikado Bunko, Tokyo

This *mizusashi* has the shape associated with seed storage jars, with three small clay handles, or lugs, attached. The body of the jar, formed on a wheel, has a flat base and a slightly raised neck. The rim has a slight outward-turning lip. The beige surface is decorated in an extravagant pattern with a reddish-brown motif called *hidasuki*.

This type of decoration results from the contact of straw with the surface of the jar during the firing process. To use space more effectively in the kiln, small pots were nestled inside a larger container during firing. Because of the heat in the kiln, smaller vessels were wrapped in straw to prevent them from fusing together. The outer jar partially inhibited the passage of heat to the inner vessels, resulting in the characteristic beige surface with its marks of burnt-straw ash. Since these reddish-brown marks resemble red cords, they are commonly called *hidasuki*, which literally means "fire cords." ST

69 Flower vase (*hanaire*) with two handles
Bizen ware
H. 27.7 cm
Momoyama period, 16th century
MOA Art Museum, Atami, Shizouka Prefecture

This vase has an imperfect form, off-center with a somewhat triangular shape. It was initially cylindrically shaped on a wheel and then reshaped by hand into its final form.

The base is completely flat. Each side or facet of the vase has a central vertical line made by the potter as he ran his finger down through the wet clay. On the side that faced the heat source in the kiln, two additional vertical lines were added by running a nail through the clay on one side of the central vertical line. Under the rim, extended to a side lip with a rounded edge, are two vertical handles, made of clay cord; they have been incised with three lines made with a nail.

This vase was probably designed originally to be hooked onto a wall or pillar, since two holes were made in the neck (one was subsequently filled in). The brown surface was glazed from the rim to the foot with a "sesame seed" glaze. ST

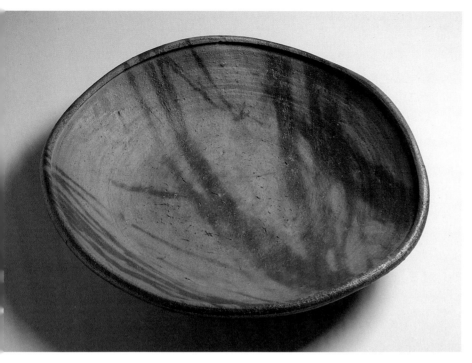

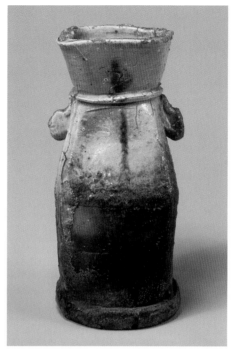

70 Bowl
Bizen ware, with *hidasuki* patterns
Diam. 45.4 cm
Momoyama period, late 16th century
The Cleveland Museum of Art, John L.
Severance Fund, 83.8

Although today the kilns at Imbe produce most of the Bizen ware, in the 15th and 16th centuries many kilns, more widely dispersed, comprised Bizen. With easy access to markets along the eastern coast, back through the central western provinces, or to ports nearby on the Inland Sea, Bizen was (and still is) better situated than most ceramic centers to market its wares. It could also react quickly to outside influences and current fashion: special commissions from tea advocates and adaptations of other ceramic wares and shapes—both foreign and domestically produced. In this respect, Bizen remained the most vibrant ceramic production center adhering to traditional standards of surface appearance and shape, combined with an awareness of new trends in taste.

This large plate-form originated as a utilitarian piece used by farming families for serving food. The surface designs result from salt-water-soaked straw that was used to keep pieces separated when fired. The straw eventually burned away in the kiln, but not without reacting with the unglazed clay body. This induced decorative technique is not unlike a glaze applied by brush, except that the volatile kiln atmosphere effected a more "natural," even accidental, design much admired by Japanese ceramic devotees.

Later Bizen teaware makers went to considerable effort to achieve these effects without seeming contrived or methodical. In the process, the repertory of Bizen shapes expanded, with sharper contours and various surface-effect designs. This plate retains the undulating form, rounded edge, and relaxed contours characteristic of pre-Edo Bizen wares. It compares quite favorably with large dishes in the Fujita and Okayama Prefectural Museum collections of similar date around the Keicho era (1596-1614).[1]

71 Flower vase (*hanaire*) with two handles
(called Jurojin)
Iga ware
H. 28.6 cm
Momoyama period, 16th century
Fujita Art Museum, Osaka

The Iga kiln, in present-day Ayama-cho, Mie Prefecture, is thought to be an offshoot from the nearby Shigaraki kilns. Production began in the late Muromachi period and continued until the Edo period. During the Momoyama period the Iga kilns produced many fine pieces for the tea ceremony. These pieces resemble Shigaraki ware, but the base color is a purer white and the feldspar content of the glaze is lower.

This flower vase is an outstanding example of the work of this period. It has a disk-shaped base, thick walls, and a white, natural glaze resembling porcelain. It was initially shaped on a wheel, then the mouth was reshaped to resemble a square trumpet, while the body of the vase was re-formed by hand to make it rectangular. The middle of the body swells out a little to form the characteristic flower vase design. On the sloping shoulders the potter attached hand-formed, ear-shaped handles or lugs. This handle design was associated with the ears of Jurojin (the god of longevity), one of the "Seven Deities of Good Fortune"— hence the name of the vase.

Around the narrow neck is a raised belt of clay that bears a trace of a small hole (subsequently filled in). A streak of light green ash glaze runs from the mouth to the middle of the vase. Around the base the glaze becomes thicker, sometimes forming green beads beneath burn marks of dark purple. The reverse side of the vase has a reddish surface from the rim to the shoulder, with a red circular burn mark on the body. ST

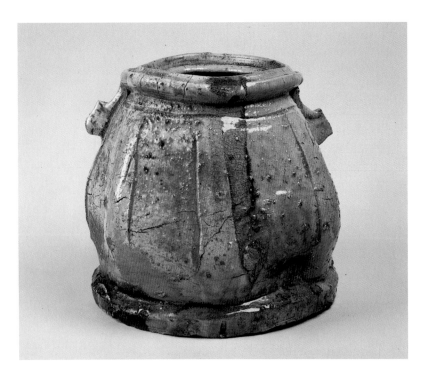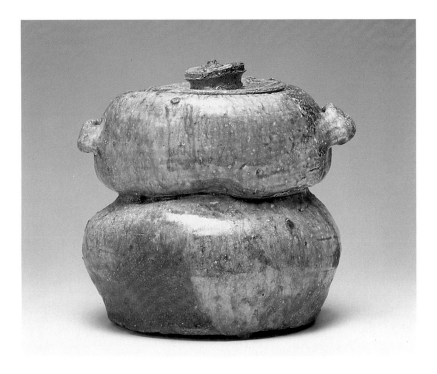

72 Fresh water jar (*mizusashi*) with two handles
Iga ware
H. 20.4 cm
Momoyama period, 16th century
Private Collection, Kyoto

This bulky water jar, shaped like a taro root, has a thick, disk-shaped base. Formed on a wheel, it gives an impression of great stability, with the lower half of the body swelling out and then tapering slightly towards the base. The rim is rounded and has a pronounced inward-turning lip with a thin area on the inside to act as a lid rest.

Two small, faceted handles are attached horizontally on the shoulders. An incised line, made with a spatula, runs around the shoulder of the vase just below the rim. The surface of the jar is uneven, and six wide lines, again made with a spatula, run vertically down the sides. (Some have interpreted this design as being symbolic of the spokes of a wheel.) The whole jar is covered with a thick light green ash glaze. During the process of firing, some ash fell along one side, which formed beads of glaze. The other side has reddish burn marks.
ST

73 Fresh water jar (*mizusashi*)
Shigaraki ware
H. 20.3 cm
Momoyama period, 16th century
Hayashibara Art Museum, Okayama

The Shigaraki kilns—located around present-day Shigaraki-cho in Shiga Prefecture—began production in the Kamakura period and have continued to produce pottery up to the present. Shigaraki ware uses a high-quality white clay containing many coarse feldspar grains. The special feature of Shigaraki ware is its bright green natural glaze, which appears over the burnt reddish-brown surface of the pots during the firing process.

In the Kamakura and Muromachi periods the Shigaraki kilns produced pottery for daily use—jars, pots, and bowl-shaped mortars—but during the Momoyama period they also produced high-quality ware for the tea ceremony, including flower vases and water jars.

This fresh water jar, in the shape of *kasane-mochi* (a two-layer stack of rice cakes), is strikingly powerful. The upper and lower parts were shaped separately on a wheel and then joined together. On the round shoulders of the thick-walled jar are comparatively large, horizontal handles made out of strip clay. The lid was formed by hand and has a rather large, flattened handle shaped like a sacred gem at its center. Feldspar grains are apparent in the white clay of the jar, which in turn has been covered by the thick vitrified natural glaze.
ST

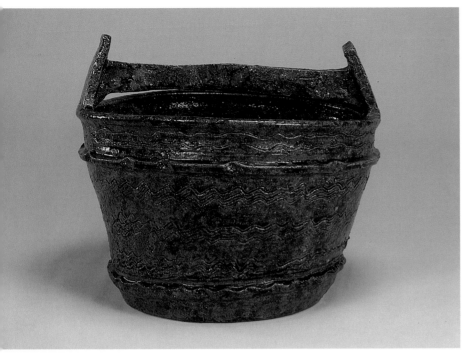

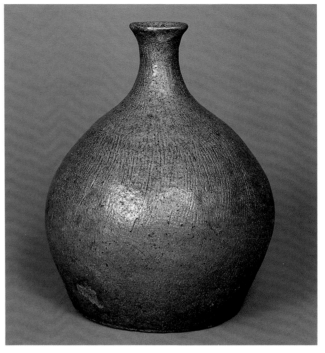

74 Fresh water jar (*mizusashi*)
Tamba ware
H. 23.5 cm
Momoyama period, 17th century
Hyogo Prefectural Ceramic Museum, Kobe

Tamba ware, produced in present-day Imada-cho, Hyogo Prefecture, first appeared in the Kamakura period and has remained in production ever since. Its characteristic features are substantial, weighty designs and rich, deep green, natural glazes that appear over the burnt dark brown or copper-brown surface of the white clay body as a result of the firing process.

Beginning with the Kamakura period, Tamba mainly produced pots for daily use. However, near the end of the Momoyama period and coterminous with the development of the characteristic Tamba glazes, a few high-quality vessels for use in the tea ceremony were also produced.

This large, sturdy water jar resembles a wooden pail. It has a flat base, and bamboo-like hoops encircle the upper and lower body of the jar. Above and below the hoops, long, wavy lines were scratched into the wet clay with a bamboo stick. A thick brown glaze was applied unevenly to the handles, the outer surface of the jar, and the inside rim. This design was produced in large quantities by the Tamba kilns. ST

75 Large bottle (*tokkuri*)
Tamba ware
H. 32 cm
Momoyama period, 16th century
Hyogo Prefectural Ceramic Museum, Kobe

This particular shape is believed to have been first made in the 16th century. Presumably, it is a copy of Chinese porcelain bottles of the Ming dynasty that were imported into Japan. It came to be called a *tokkuri*, after the shape of a sake flask.

This is the largest bottle of its kind made during this period. The body is fashioned from clay coils that were piled up and then hand-smoothed to form the easy, swelling body of the bottle. The upper part, above the shoulder, was formed on a wheel. The whole surface is decorated with rough, vertical scratched lines. A thin, dark green, natural glaze covers the light brown surface of the jar. On the shoulder is an incised character reading "up" or "top," which may represent an identifying kiln mark. ST

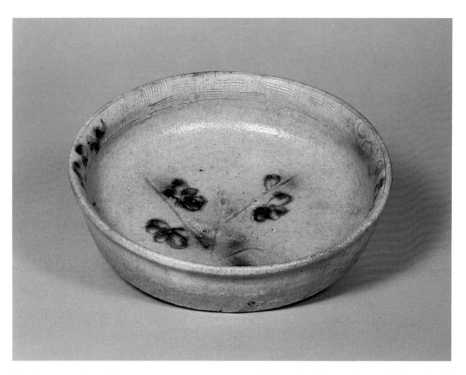

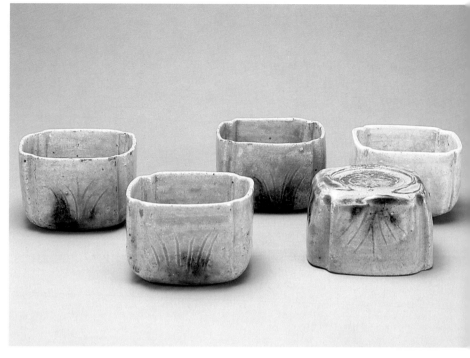

76 Bowl (*mukozuke*)
Yellow Seto ware
Diam. 16.2 cm
Momoyama period, 16th century
MOA Art Museum, Atami

The kilns at Seto in Shizuoka Prefecture were the only ones to produce glazed pottery beginning in the late Heian period, about 1150. The Mino kilns, located around present-day Tajima City and Toki City in Gifu Prefecture, are believed to have separated from their neighboring Seto kilns in the Muromachi period. Consequently, the Mino kilns also produced glazed pottery, and their style was, and is today, very similar to that of the older Seto kilns. From the Momoyama period until the beginning of the Edo period (early 17th century) the Seto and Mino kilns were at their zenith. They produced varied but unique styles of ceramics for the tea ceremony, including Yellow Seto (*Kiseto*), Shino, Gray Shino (*Nezumi Shino*), Oribe, and Black Oribe (*Kuro-Oribe*).

Yellow Seto has a characteristic yellowish surface that is obtained through reduction firing using an ash glaze with an iron compound. Many pots of this style have either a green spotted pattern resulting from the application of a glaze made from copper oxide or a brown spotted pattern caused by using an iron glaze. Other characteristics are designs of engraved lines, pressed flowers, or parallel scratched lines underneath the glaze.

This small bowl is made of coarse clay in the shape of a gong, with a slightly everted rim. Fine, geometrical wickerwork patterns, occasionally combined with simplified floral arabesque patterns, were incised around the rim. Over these an iron glaze and a green copper glaze were applied. At the center of the bowl, plum blossoms and branches were incised. The blossoms were colored with the iron glaze, while the branches were covered with green copper glaze suggestive of leaves.
ST

77 Set of five bowls (*mukozuke*)
Yellow Seto ware
Diam. 8.4 cm
Momoyama period, ca. 1600
Private Collection, New York City

More modest in size than the preceding bowl with plum design [76], these molded serving dishes nevertheless convey the sturdy character of Yellow Seto ware and its refined appearance, especially in comparison to other Mino kiln wares.[1] The size and weight of the individual pieces also distinguish them, being considerably lighter than their appearance suggests; and they are warm and comfortable when held in the hand.

In part, this is due to the gritty, matte-yellow glaze surface (called *aburage* for its resemblance to the skin color of deep-fried tofu). It is also a result of the indented corners on the gently flaring shape that appears regularly in Green Oribe serving bowls forty years later.

Seemingly plain, these *mukozuke* display the highest degree of technical skill. The incised-grasses decor is enhanced by copper (green) and iron (brown) oxides, which occasionally pass through the thin walls to appear, faintly, on the interior.

An interesting feature of these *mukozuke* is the potting of the feet—recessed rather than raised. This suggests that the initial vessel shape was wheel-thrown and then pressed into a mold before shaping. Consequently, the preference for carved, manipulated forms with low profiles that typifies much of the early Mino-area production continued in later Yellow Seto ceramics used for tewares. It may be that the large *noborigama* (climbing kiln) at Motoyashiki was responsible for not only maintaining the tradition but also producing a full range of other types and styles, especially Oribe.

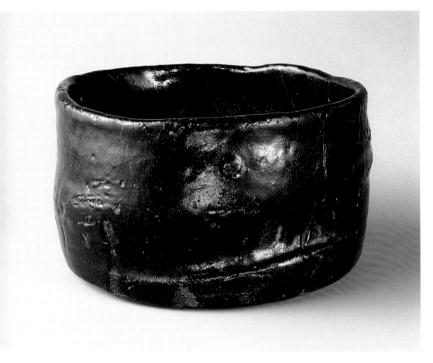

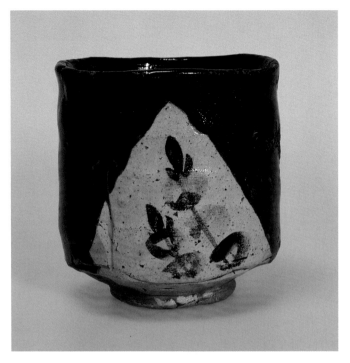

78 Teabowl
Black Seto ware
H. 7.5 cm
Momoyama period, 16th century
Private Collection, New York City

Black Seto ware is also a product of the Mino area kilns, appearing at about the same time as Yellow Seto, just after mid-century according to some accounts.[1] It was then that extraordinary changes began to happen in the Mino ceramic industry, which together with nearby Seto kilns had produced the only glazed ceramics in Japan during the 12th through 14th centuries.

Thus, this rather heavy-bodied teabowl represents yet another type of Mino product to jolt the 16th-century tea world. Its rich, lustrous black glaze inside and out suggests a date towards the turn of the century, since a crackle pattern and whitish-black skin usually occurs earlier in the development of Black Seto. The black glaze was achieved by extracting the bowl from the kiln while it was still being fired, thereby accelerating the cooling process. The bowl shape was initially wheel-thrown, then the foot was carved out of the base, and the surface was hand modeled and extensively carved prior to the application of the iron-rich glaze. The glossy surface of the glaze, which covers the entire body except for the area around the foot, derives ultimately from the tradition of *temmoku* teabowls produced in Seto-area kilns centuries earlier.

Black Oribe ware [79] derives, in turn, from early Black Seto, although both were produced simultaneously in the Mino *noborigama* (climbing kilns) of the early 17th century. Rarely found in Western collections, Black Seto clearly enjoyed favor in Kyoto, Osaka, Sakai, and Nara tea circles between 1550 and 1575.[2] With the advent of Green Oribe, Black Oribe, and the Raku wares by Chojiro and his followers [74], its popularity waned.

79 Teabowl (called *sawarabi*)
Black Oribe ware
H. 10 cm
Momoyama period, 17th century
Fukuoka City Art Museum, Fukuoka Prefecture

Black Oribe (*Kuro-Oribe*) ware is distinctive for its raven-black surface. This is achieved by removing the iron-glazed pots just as the glaze fixes and then allowing them to cool quickly. Many teabowls were made in this style, with the pot being distorted intentionally after it had been shaped on the wheel. There are a variety of different styles: some with decorations drawn on the unglazed, bare surface (as in this example); some with scratchwork decorations (sgraffito); some with a transparent glaze applied over part of the black-glazed surface. The style without any patterns is called *Oribe-guro* (Oribe Black).

This teabowl has an untapered cylindrical shape from the bottom of the bowl to the slightly undulating rim. There is a slight indentation just under the rim. After it was shaped on the wheel, the upper body was intentionally distorted and a low foot was added. The dark glaze was applied to the surface of the pot, including the inside, with a triangular area on the outside left unglazed. A design of two ferns, sloping diagonally leftward, was drawn in iron oxide on the triangular area and the bowl was then glazed with a thin feldspathic glaze. The name *sawarabi*, meaning young fern or bracken, is derived from this pattern. ST

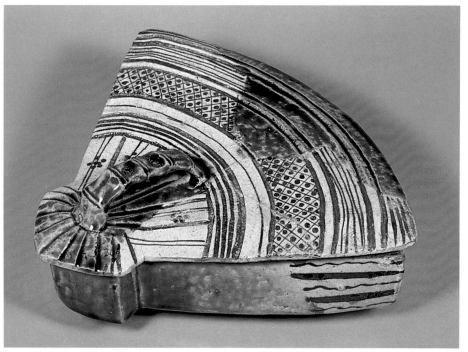

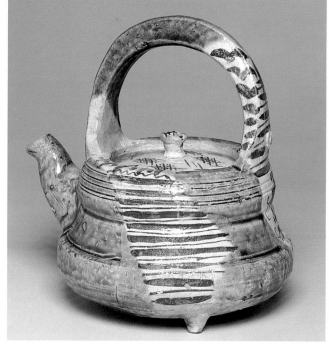

80 Covered dish
Oribe ware
H. 11.4 cm; L. 28 cm
Momoyama period, 17th century
MOA Art Museum, Atami

The name of Oribe ware derives from the tea master and warrior of the Momoyama period, Furuta Oribe (1544-1615). Born in Mino, he is believed to have guided production at some of the Mino kilns, but this has yet to be convincingly substantiated. Among the many utensils made for the tea ceremony during the Momoyama period, Oribe ware is the most innovative. With its bold, distorted shapes and countless new patterns it represents the style of the Momoyama period at its most vivid. This example is the Green Oribe (*Ao-Oribe*) type, with a bright green, copper glaze and surface designs in brown iron oxide.

This covered dish was made by pressing slabs of clay into a fan-shaped mold. The ribs of the fan were made by adding relief strips to the top surface of the lid. For the "paper" part of the fan, geometric patterns were drawn in iron oxide. The handle, shaped like a bamboo root, is attached to the pivot of the lid. A thick, transparent copper glaze was applied around the handle and the edge of the fan. Three feet were added to support the body of the dish.
ST

81 Ewer
Oribe ware
H. 21 cm
Momoyama period, early 17th century
The Cleveland Museum of Art, The Norweb Collection, 58.336

At the same time that tea masters were actively seeking new ceramic sources with potters capable of producing novel shapes and surface designs [92], the Mino area potters accelerated their pursuit of technological advances in ceramic production. Perhaps the most significant advance occurred when the first *noborigama* (climbing kiln) was built in Mino at Motoyashiki. Introduced from Korea late in the century to the Karatsu area, its praises reached Mino quickly, particularly as it allowed for larger, more controlled firings than the traditional pit kiln (*anagama*) used for Shino wares. With the increasing demand for individually designed utensils for use in early 17th-century tea ceremonies, Oribe found itself at the center of a new ceramic popularity in Japan.[1]

A wealth of shapes, surface designs, and painting styles characterize Oribe ware production through the mid-17th century. While the original creative impulse in Mino purportedly derived from the tea master Furuta Oribe (1544-1615), it was the reverberations of his influence passing through countless tea practitioners and the local potters that resulted in the green, cream, black, and red-colored vessels that have subsequently come to be known as "Oribe."

Characteristically, the shapes combine geometric and curvilinear elements, mechanical as well as organically derived features. The painted and applied decorations likewise weave an interplay of the drawn, the incised, the dark lush field next to a void. Some patterns are familiar; others derive from textile designs and other distinct ceramic traditions (such as Karatsu or Seto), or foreign influences; while some of the most beguiling pieces offer precious few clues to their creative inspiration.

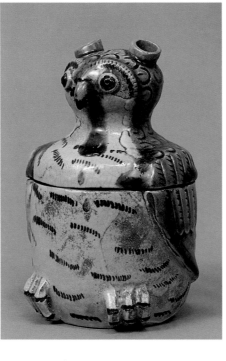

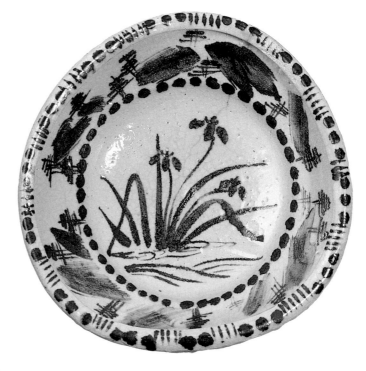

This water ewer was wheel-thrown and then modeled by hand, much like the Shino fresh water jar (*mizusashi*) [85]. The cutting of the surface, like the arc of the strap handle, is sharp but broadly conceived so as to reiterate the two broad contours that comprise the body. The spout is rather stubby and naive in appearance, although it is covered with a lustrous green copper glaze like most Oribe ewers, which are thought to have served as *mizusashi*.[2]

The lid fits onto a notched rim and appears to be original, as is the three-pronged knob. Iron-brown painted designs and the Green Oribe glaze decorate these surfaces, as they do the rest of the body in diagonal swaths. The painted designs include trees, cross-hatch segments with dots, and leaf trellis configurations similar to those seen in Karatsu ware as well as in Shino and Oribe wares. The small chrysanthemum appliques on the lower sections of the handle (where a cut-out design frequently occurs) are a distinctive feature of this ewer and a small group of related Oribe vessels.

82 Incense burner
Oribe ware
H. 13.5 cm
Momoyama period, 17th century
Private Collection, Nara

The body of this owl-shaped incense burner was formed on a wheel. The upper portion was designed to serve as a cover for the container. The clay eyes, beak, and feet were fashioned separately and added to the body. A copper green glaze was applied from the head to the tail feathers. The front feathers were then highlighted in iron brown, while the ones in back were created by scoring thick, incised lines. Two ear holes were incorporated into the design to act as outlets for the smoke from the incense.

The use of a nocturnal animal for the design indicates that the incense burner was intended for use during tea ceremonies held at night. ST

83 Bowl
Shino ware
H. 8 cm; diam. 25 cm
Momoyama period, 17th century
Fukuoka City Art Museum, Fukuoka Prefecture

A special feature of Shino ware is the thick, white surface glaze obtained by using an ash glaze with large quantities of feldspar added. This bowl, with its underglazed iron-brown decorations, is representative of the works called Shino-Oribe. In the early period of Shino ware, perhaps in imitation of the imported Chinese ware of white and blue-and-white porcelain (*sometsuke*) intended for daily use, large numbers of small, round dishes were mass produced. After the end of the Momoyama period, however, high-quality ware for the tea ceremony was also created.

This bowl was made in an imperfectly round shape with an inverted rim. The center of the bowl was deepened, leaving a ridge around the inside middle rim, and three feet were added to the outside. The design on the inside of the bowl depicts irises growing in water at the center, encircled by slightly elliptical dots. Beyond this is a pattern that figuratively represents pine-clad mountains. The whole is framed within a design of alternating dots and lines executed in iron-brown brushwork around the rim. The feldspathic glaze was added before firing. ST

84 Teabowl (called *furisode*)
Shino ware
H. 8.8 cm
Momoyama period, 17th century
Tokyo National Museum

The basic shape of this bowl was formed on a
wheel, then clay was removed from around the
rim and the whole body was slightly distorted.
The rim is correspondingly distorted, but it re-
tains an easy, undulating line. There is a slight
indentation below the rim, and the bottom of
the bowl rests on a small foot.

Patterns of pampas grass and linked tortoise
shells were drawn in fine brushstrokes onto the
light reddish-brown surface. The whole bowl
was then coated with a feldspathic glaze, ex-
cept the foot and the underside.

The name *furisode* (long-sleeved kimono)
derives from the visual connection made by
the Japanese between the tortoise-shell designs
of this bowl and similar textile designs appear-
ing in figure painting [63]. ST

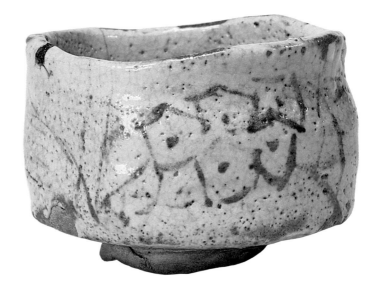

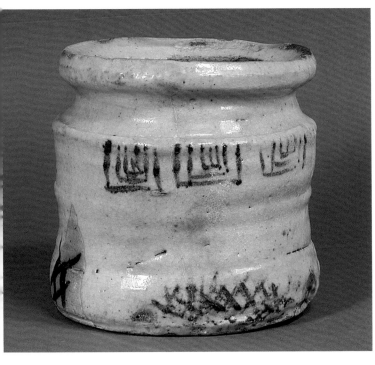

85 Fresh water jar (*mizusashi*)

Shino ware
H. 18.4 cm
Momoyama period, 16th century
The Cleveland Museum of Art, John L.
Severance Fund, 72.9

Compared to other 16th- and early 17th-century ceramic wares, Shino pieces appear quite distinct in their thick, rich—almost "furry"—glaze applications over stolid, burgeoning forms. The combination of painted design; rich, glossy skin; and heavy clay bodies in fact marks an extraordinary departure in Japanese ceramic history.[1]

Shino clay typically fires a burnt orange-red tone when in contact with—or near—iron-oxide or feldspathic glazes. The base of this *mizusashi* reveals the natural cream color of the clay, as well as the frit that appears as black pits beneath the glaze. Indentations at the edge of the base also indicate where the

water jar was grasped to remove it from the wheel after having been cut away with a wire. Fingerprints occur higher up, where the base was held during glazing—done in two separate, diagonal dippings. These dippings resulted in the triangular area on the body and a similar, sharp-edged glaze area inside the vessel. Only the base and most of the inside floor remain unglazed.

The underglaze iron-oxide design incorporates three elements summarily sketched below the shoulder: rectangular boxes open on one side; grasses (or reeds); and a lattice fence. As in most Shino *mizusashi*, there is a clear sense of demarcation between design motifs, and within parameters of a "picture frame" on the body. A certain regularity in the individual designs is therefore not surprising, although the brushwork is quite lively.

The vessel's shape is, after all, its most dynamic aspect, particularly as it rises above the shoulder, towards the indented neck, and up to the flaring, thick mouth. Carving and scraping of the thick side walls powerfully enhances the vessel's contours. Neither Tamba

[74] Karatsu [91], nor Bizen ware [67, 68] *mizusashi* customarily exhibit this degree of sculptural attention. Iga *mizusashi* [72], however, routinely strive for comparable clay and glazing effects.

Despite the fact that Shino ware was made expressly for use in the tea ceremony, very few Shino *mizusashi* of this period have survived. The magnificent vessel named "Rogan" in the Hatakeyama collection and this piece in Cleveland share comparable scale and condition, while another group of smaller vessels of the same date appear less dramatic.[2]

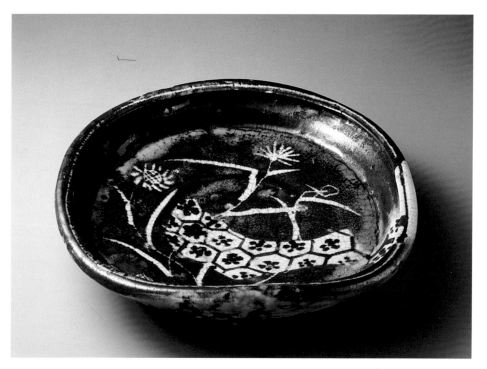

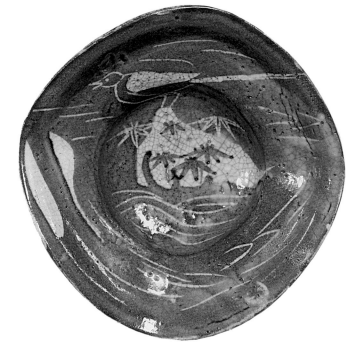

86 Bowl
Shino ware, Nezumi Shino type
Diam. 26.6 cm
Momoyama period, 17th century
Goto Art Museum, Tokyo

Gray Shino (Nezumi Shino) ware is characterized by clear patterns of white inlay on a gray ground. This effect was achieved by first coating the bowl with an iron slip and, after it dried, incising designs onto the slip with a bamboo spatula. A thick, white, feldspathic glaze was then applied. The final result was a white design that stood out against a background of gray.

This bowl is shallow, and the rim of the mouth curves slightly inward. The center of the bowl bears a decorative pattern of asters and tortoise shells created by painting the design in iron brown directly onto the surface areas of the bowl where the iron slip had not taken. Three small feet were subsequently attached to the base. ST

87 Bowl
Shino ware, Nezumi Shino type
Diam. 26.8 cm.
Momoyama period, late 16th-early 17th century
Tokyo National Museum
Important Cultural Property

This large bowl is made from white clay. Its bottom is rounded and its inside wall rises straight up, then gradually flares out to form a large, uneven rim. Somewhat large feet are attached to the base.

An iron slip was casually poured onto the inside from the bottom up to the side, which accidentally left an uncovered area in the middle of the dish. Probably because the potter saw this as a rock jutting out into the water, he scraped designs of a wagtail, flowing water, and bamboo grass into the slip. Indeed, the vividly drawn wagtail thrusts its tail rakishly into the air, with legs bent, as if about to take wing. The bamboo leaves are painted in iron brown. ST

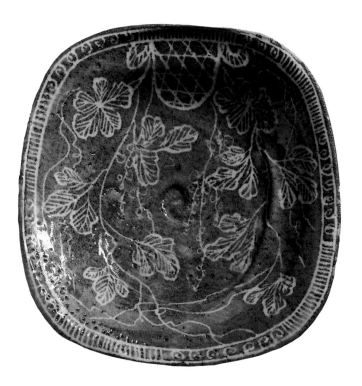

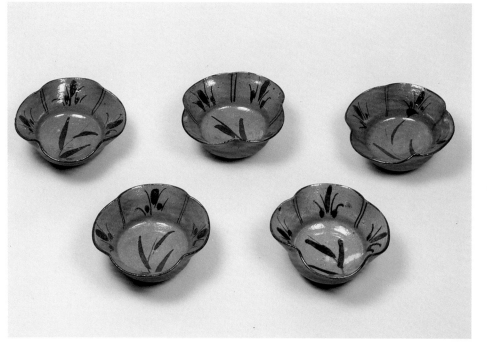

88 Bowl (*hachi*)
Shino ware, Nezumi Shino type
Diam. 28.3 cm
Momoyama period, early 17th century
The Mary and Jackson Burke Foundation,
New York

This large, scooped bowl represents one of the most felicitous meldings of shape and surface decoration in all Shino wares. The design is a fluid rendering of a trellis of grape leaves with a woven basket-like form nestled to one side. This enigmatic feature orients the piece. The design fills the entire surface, unlike most Nezumi Shino. The subject of grapes and gourds (or melons), often including squirrels, occurs frequently in 16th- and 17th-century lacquerware [54] and, later, in ceramics.[1]

Shino ware bowls and dishes, particularly Nezumi Shino bowls (*mukozuke*), usually possess a decorative schema that determines how they are intended to be presented at meals in the course of the tea ceremony. The rim designs on these pieces not only serve to affirm that aspect but also add a formal note to the shape. Consequently, the lack of such a framing element here appears to be a conscious decision by the potter to add to the ebullience apparent in the grape decoration. It has been incised so skillfully into the body as to appear drawn with a brush, rather like the painted grape designs on the pair of sake containers (*heishi*) in the exhibition [60].[2]

This bowl (*hachi*) was thrown on a wheel and then manipulated to its present, generous size. Interior carving marks appear prominently under the gray glaze, which is remarkably warm and porous. Three clay feet balance the form, and four spur marks, as well as finger marks, are visible on the bottom.

89 Set of five bowls (*mukozuke*)
Karatsu ware, *e-garatsu* type
Diam. 12.9 cm
Momoyama period, 17th century
Aichi Prefectural Ceramic Museum, Seto

The Karatsu kilns are located in present-day Saga and Nagasaki Prefectures in Kyushu. Following military campaigns in Korea in the 1590s, Japanese officers brought skilled potters from the Korean peninsula to Japan. The many kilns that were established as a result of this action began mass producing pottery in *noborigama* (climbing kilns). Although the number of kilns making Karatsu ware has decreased since that time, some of the kilns are still producing pottery.

Paralleling Korean pottery of this date, Karatsu kilns used white and yellow feldspathic glazes. This resulted in a dark brown iron glaze, a milky straw-ash glaze, or a green wooden-ash glaze. The style of these bowls—called *e-garatsu*—is characterized by designs painted in iron oxide prior to feldspathic glazing. Such pieces were produced in large quantities.

Utensils for the tea ceremony, such as this set of five *mukozuke*, were the main products of the Karatsu kilns. *Mukozuke*—small, deep bowls used for serving side dishes in a traditional Japanese meal—are noticeably deep, with a hip just above the base. The rims were shaped by hand to form their round four-petaled flower shapes. In the interior of each bowl, the petals are separated by double drawn lines. Between these lines and on the bottom of each bowl is a grass pattern. A foot has been added to each bowl. ST

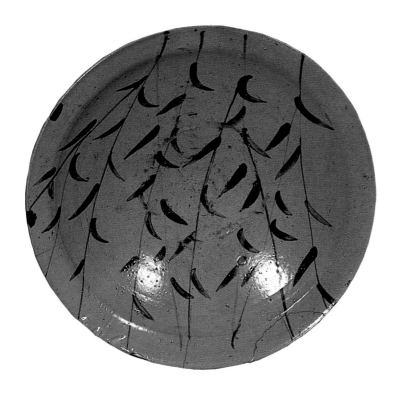

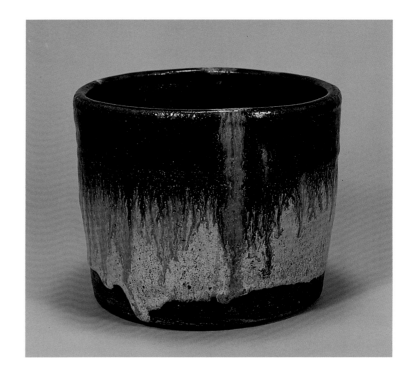

90 Large dish
Karatsu ware, *e-garatsu* type
Diam. 38.7 cm
Momoyama period, 17th century
Umezawa Kinenkan, Tokyo

This type of large dish is a rarity in Karatsu
ware—mainly because the rim has a wide,
flat edge, unlike typical Karatsu pottery with
irregular, pinched rims. A design of elegantly
drooping willows has been painted in light
brushstrokes over the entire surface of the
dish, including the rim.

 Attached to the bottom of the dish is a small
katausu style foot, which has straight outer
sides and slanting inner sides. ST

91 Fresh water jar (*mizusashi*)
Karatsu ware, *Chosen-garatsu* type
H. 14 cm
Momoyama period, 17th century
Private Collection, Kyoto

Chosen-garatsu (Korean Karatsu) is a type of
Karatsu ware that has had both an iron-base
dark brown glaze and a straw-ash milky glaze
applied to it. Many pieces of *Chosen-garatsu*,
especially large jars, were formed using the
"patting method" (*tataki*), a characteristic
technique that is unique to Karatsu ware.

 This fresh water jar was made by this
method. It has a flat base and a cylindrical
body that opens slightly outward. Its single-
edged rim (*hitoe-guchi*) is curved slightly
inward. The upper portion of the body is cov-
ered with a dark brown glaze; the bottom half,
with a milky-white glaze. The entire inside is
covered with a thin, dark brown glaze, and a
milky-white glaze covers part of the side and
the base. Trails of thin, milky-white glaze
were poured from the rim onto both the outer
and inner surfaces to create accents. ST

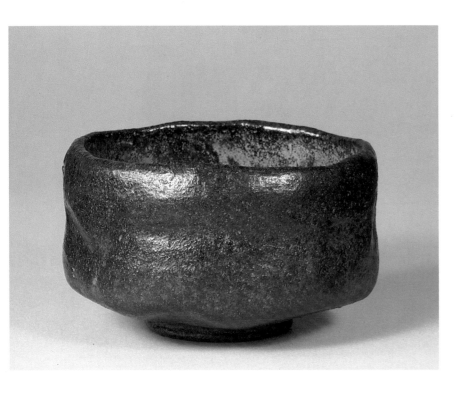

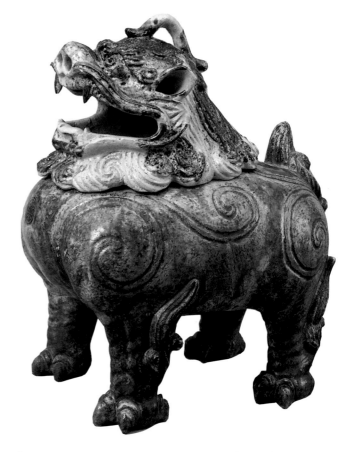

92 Teabowl (called *Kamiya-guro*)
Black Raku ware
H. 7.2 cm
Raku Chojiro (1516-1592)
Momoyama period
Seikado Bunko, Tokyo

Raku ware is believed to have been first produced at the end of the 16th century in Kyoto by Chojiro. He was the first Raku potter, and succeeding generations of the Raku family have continued to produce this pottery.

Although Raku ware is primarily associated with teabowls, vessels such as flower vases or water jars can also be found. Raku ware is always formed by hand, without using a potter's wheel, and is fired at comparatively low temperatures (from 700°C to 1000°C) in a small kiln placed outside the house. There are two types of Raku ware: Red Raku (*Aka-Raku*), which is made by first coating the surface of the pot with a slip containing iron oxide and then applying a transparent glaze over it; and Black Raku (*Kuro-Raku*), which is covered with a black glaze.

This teabowl has identations around the waist and hip. The inward-curving rim displays an uneven edge. Both the inside and outside of this piece are covered in black glaze in the Black Raku style. A low foot is attached to the bottom.

When Toyotomi Hideyoshi was fighting in Kyushu, Kamiya Sotan (1551-1635), a merchant and tea master in Hakata, invited him to a tea ceremony. Sotan had commissioned Chojiro to make this Black Raku teabowl for the occasion—hence its name, *Kamiya-guro*. ST

93 Incense burner
Raku ware
H. 27.3 cm
Tanaka Sokei, active mid- to late 16th century
Momoyama period
Umezawa Kinenkan, Tokyo

This is a rare example of a ceramic bearing the potter's name and the year of production. A signature on the body reads: "at the age of sixty/by Tanaka Tenka-ichi Sokei/Bunroku Era 4, September auspicious day." A handwritten seal-style signature is also included. The Japanese year Bunroku 4 was 1595.

According to the *Sonyu-monjo* (Sonyu document), written in 1668, Tanaka Sokei was the father of the second generation Raku potters Jokei (died 1635) and Somi (died 1619). Unfortunately, we have no further information about him. Although his exact position in the Raku family line is still not clear, Sokei must have worked with the first-generation Raku founder, Chojiro [92].

This incense burner is in the shape of a lion-dog (*shishi*) and is colored with green, light brown, and yellow glazes. The head, which forms the cover of the container, is not original. It was made by the seventh-generation Raku potter Chonyu (died 1770). ST

Catalogue Notes and Figure Captions

1 Sun and Moon Landscape

1. See the citations in the bibliography of *Muromachi Jidai no Byobu-e* (Screen Paintings of the Muromachi Period), exh. cat. (Tokyo: Tokyo National Museum, 1989), pp. 258-59. The writings of Yoshida Tomoyuki provide especially useful information related to these *byobu*.

2. This is illustrated to particular advantage in *Fugetsu Sansui* (Nature in Japanese Art), vol. 12 of *Nihon no Isho* (Japanese Design in Art) (Kyoto: Kyoto Shoin, 1986), pl. 22. The *kirihaku* (cut or torn pieces of gold and silver foil pasted onto the painting surface) in this frontispiece along with the faint wave patterns reveal, in part, the origins of the imagery and materials used in the Kongo-ji screens. This sutra, done in a set of thirty handscrolls, was donated to the shrine in 1164 by the Heike family.

Figure 1. *Mandala of the Sanno Shrine Deities*. Hanging scroll; ink, color, and gold on silk. Muromachi period, 15th century. Nara National Museum.

2 Sun and Moon Landscape

1. "Nichigetsu-zu Byobu-kai" (Explanation of the Sun and Moon Screens), *Kokka* no. 491 (1931): 292ff.

2. See the excellent, lengthy bibliography in the *Muromachi Jidai no Byobu-e* (Screen Paintings of the Muromachi Period), exh. cat. (Tokyo: Tokyo National Museum, 1989), pp. 257-61, which includes the major articles on Sun and Moon screens, with historical references.

3 Hamamatsu Bay

1. Predation as a theme in Japanese art has received scant attention. It appears in the Heian period as part of Buddhist painting (Hell and Judgment scenes), and infrequently in Kamakura *emaki* (illustrated handscrolls). In the 16th century it surfaces undisguised in *suibokuga*. Its appearance in [17] is quite unusual for *yamato-e*.

2. Comparison with the other well-known Hamamatsu *byobu* in the Satomi collection illustrates this aspect of these Tokyo National Museum screens. For an introduction to the Japanese concept of what is called "realism" in the West, see Sherman E. Lee, *Reflections of Reality in Japanese Art*, exh. cat. (Cleveland: Cleveland Museum of Art, 1983). See earlier depictions of Hamamatsu in the 1375 *emaki Ishiyama-dera Engi* (Legend of Ishiyama-dera Temple), the 1351 *Boki-e Ektoba*, and the 1309 *Kasuga Gongen Reigenki* (Records of Kasuga Shrine Festivals).

3. Reproduced with fans in the Tokyo National Museum collection in Bunka-cho, ed., *Kokuho* (National Treasures), vol. 2 (Tokyo: Mainichi Shimbun, 1984), pl. 10-5.

4 Flowers and Birds of Autumn and Winter

1. Takeda Tsuneo, in "Shuto Kacho-zu" (Flowers and Birds of Autumn and Winter), *Kokka* no. 1048 (1982): 24-32, introduces these screens. His references to the fascinating array of birds and trees as well as his association of this *byobu* pair with the Hakutsuru Museum bird-and-flower pair by Motonobu are perceptive. This writer prefers a linkage with the same museum's bird-and-flower pair attributed to Kano Eitoku (1543-1590).

2. See, for example, the range of origin of tea utensils in the exhibition catalogue *Chanoyu: Japanese Tea Ceremony* (New York: Japan House Gallery, 1979).

3. Another pair of screens in the Suntory Museum of Art, *Bird and Flower of the Four Seasons*, falls into this category. It is attributed to Tosa Hirochika (1439-1492) by Tosa Mitsuoki (1617-1691) in an inscription on the *byobu*. More likely, it is a painting whose brush style and attention to spatial depth place it with an artist immersed in the Chinese bird-and-flower painting tradition. The Sesshu School comes to mind, but no known bird-and-flower painting from that school makes a strong correlation except, perhaps, the seated portrait of Sugawara Michizane in the Okayama Prefectural Museum collection. See Nakamura Tanio, *Sesshu*, vol. 4 of *Nihon Bijutsu Kaiga Zenshu* (Collection of Japanese Paintings) (Tokyo: Shueisha, 1976), pl. 18.

4. Other 16th-century depictions of owls occur in individual paintings by Hasegawa Tohaku (1539-1610), and, later, in the early 17th century in Kano Sanraku's *suibokuga* (ink paintings). The subject is an intriguing one, yet to be interpreted by Japanese art historians to the same degree as, for example, hawk paintings. Its presence here lends credibility to dating these *byobu* in the last quarter of the 16th century, when other owl images appear.

5 Sun and Moon with Cranes and Pine

1. See *Muromachi Kinpekiga kara Kinsei-e* (From Muromachi Era Paintings on Gold Backgrounds to Modern Painting), exh. cat. (Tokyo: Mitsui Bunko, 1990), for the introduction of these screens together with related *byobu* and *emaki*. Note especially nos. 6, 9, and 12.

2. All appear conveniently in *Muromachi Jidai no Byobu-e* (Screen Paintings of the Muromachi Period), exh. cat. (Tokyo: Tokyo National Museum, 1989), nos. 10, 11, 37, 38, except for the Cleveland screens [6].

6 Phoenix and Paulownia, Peacock and Bamboo

1. See the fan painting in [37] for phoenixes roosting in paulownia.

2. See Suntory Museum, *Suntory Bijutsukan Hyakusen* (100 Masterpieces from the Collection of the Suntory Museum of Art) (Tokyo: Otsuka Kogeisha, 1981), nos. 14 and 30; and Yoshimura Motoo, *Kodai-ji Maki-e* (Kodai-ji Maki-e Lacquer) (Tokyo: Kodansha, 1981).

3. See the Idemitsu Museum of Art's *Flowers and Trees in Four Seasons* in *Muromachi Jidai no Byobu-e* (Screen Paintings in the Muromachi Period), exh. cat. (Tokyo: Tokyo National Museum, 1989), pl. 10. Another important painting is Kano Motonobu's *Bird and Flowers byobu* in the Hakutsuru Museum, Kobe. Datable to mid-century, Motonobu's paintings vividly portray the Kano School's commingling of Chinese style and subject with *yamato-e* (see Tokyo National Museum, *Kano-ha no Kaiga* [Kano School Painting], exh. cat. [Tokyo, 1979], no. 62).

7 Bamboo in Four Seasons

1. See *Tosa-ha no Kaiga* (Paintings of the Tosa School), exh. cat. (Tokyo: Suntory Museum of Art, 1982), pls. 11-14. See also Yoshida Yuji, *Tosa Mitsunobu*, vol. 5 of *Nihon Bijutsu Kaiga Zenshu* (Survey of Japanese Painting) (Tokyo: Shueisha, 1979), pls. 2, 22, 23, and fig. 6 for bamboo imagery.

2. See, for example, Miyajima Shin'ichi, *Tosa Mitsunobu*, no. 247 of *Nihon no Bijutsu* (Arts of Japan) (Tokyo: Shibundo, 1986), fig. 54.

8 Bamboo in Four Seasons

1. For instance, in *Rimpa* (Korin School Painting), exh. cat. (Tokyo: Tokyo National Museum, 1972).

2. See examples in *Muromachi Jidai no Byobu-e* (Screen Paintings of the Muromachi Period), exh. cat. (Tokyo: Tokyo National Museum, 1989), nos. 87, 92.

3. See Miyajima Shin'ichi, *Tosa Mitsunobu*, no. 247 of *Nihon no Bijutsu* (Arts of Japan) (Tokyo: Shibundo, 1986), fig. 72. A later version in the Tokyo National Museum, possibly by Tosa Mitsumochi, attests to the existence of a sketch scroll for Ashiya kettle designs by Mitsunobu.

Figure 1. Fan with bamboo in snow [37]. After Muneshige Narasaki, "The Album of Fan Paintings in the Sasama Collection," *Kokka* no. 845 (1962), pl. 46.

9 Quail among Autumn Grasses

1. The *akikusa* (autumn grasses) theme finds its earliest visual expression during the later Heian period in ceramics, metalwork, and painting—only a small number of which survive. See *Nihon no Isho: Akikusa* (Japanese Design in Art: Autumn Grasses), vol. 2 (Kyoto: Kyoto Shoin, 1983).

2. Tsuji Nobuo, ed., *Kachoga* (Bird and Flower Painting), vol. 6 of *Nihon Byobu-e Shusei* (Compendium of Japanese Screen Painting) (Tokyo: Kodansha, 1980), pls. 88, 89.

3. Renewed study of these *byobu* may well push them back earlier in the 17th century. For comparison, there are the screens of *Birds among Grasses* in the Tokugawa Art Museum attributed to Oguri Sotan (1413-1481), illustrated in Kanazawa Hiroshi and Kawai Masatomo, eds., *Suiboku no Hana to Tori* (Flower and Bird Ink Paintings) (Tokyo: Gakushu Kenkyusha, 1982), pls. 147, 148.

10 Pampas Grasses

1. Besides the *Kuwanomi-dera Engi* scene in this exhibition [33], there are the *sugido* (sliding wood panel) paintings in the Fogg Art Museum's *Nezumi Zoshi* datable to ca. 1500; the Boston Museum of Fine Arts *Bakemono Monogatari* showing a folding screen; a *byobu* and *fusuma* in a *Kitsune Zoshi* datable to the later 15th century; a *byobu* with moon in the *Ishiyama-dera Engi* of 1497, and others. These *emaki* can be related either to Mitsunobu directly or to his Tosa followers and son, Mitsumochi. It is worth noting that the figural style in these *emaki* is like that in two works in this exhibition—[18, 20]. See Yoshida Yuji, *Tosa Mitsunobu*, vol. 5 of *Nihon Bijutsu Kaiga Zenshu* (Collection of Japanese Painting) (Tokyo: Shueisha, 1979), pls. 23, 25, 31; and Akiyama Terukazu, *Emakimono* (Illustrated Handscrolls), vol. 2 of *Zaigai Nihon no Shiho* (Japanese Art in Western Collections) (Tokyo: Mainichi Shimbun, 1980), pls. 14, 17.

2. See *Autumn Grasses and Water*, exh. cat. (New York: Japan Society, 1983), for a discussion of these themes in paintings, lacquer, textiles, and ceramics. Attention should also be given to the development and transformation of the *akikusa* theme in 16th-century lacquerware design, particulary those associated with Kodai-ji *maki-e*. The Itsuo Museum cosmetic box in this exhibition [47] represents an especially refined example of the *akikusa* subject. For background on poetry contests, see Robert H. Brower and Earl Miner, *Japanese Court Poetry* (Stanford, Calif.: Stanford University Press, 1961), pp. 194-97.

11 Flowers and Birds in Four Seasons

1. For a comprehensive treatment of Sesshu, see Nakamura Tanio, *Sesshu Gagyo Shusei* (Collection of Sesshu's Paintings) (Tokyo: Kodansha, 1984), pls. 39-52 and figs. 7-10, 18-19; also Tsuji Nobuo, ed., *Kachoga-Kaboku Kacho* (Flower and Bird Paintings), vol. 6 of *Nihon Byobu-e Shusei* (Collection of Japanese Screen Paintings) (Tokyo: Kodansha, 1978), pp. 117-26.

2. The history of illustrated narrative handscrolls (*emaki*) in Japan provides a vivid record showing large-scale paintings in both styles existing side by side. See Takeda Tsuneo, "Shusei Shoheiga to Sono Gachuga" (Medieval Wall and Screen Paintings with Depictions of Paintings in Them) in *Chusei Shoheiga*, exh. cat. (Kyoto: Kyoto National Museum, 1969).

12 Landscape in Four Seasons

1. See Michael R. Cunningham, "Painting the Wind: A Mid-Fifteenth Century *Suibokuga*," *The Bulletin of the Cleveland Museum of Art* 72 (November 1985): 363-75.

2. See Matsushita Takaaki, *Josetsu/Shubun*, vol. 2 of *Nihon Bijutsu Kaiga Zenshu* (Collection of Japanese Painting) (Tokyo: Shueisha, 1979), pl. 36, as well as related screens in pls. 35, 37, and 39. Paintings related to Shokei and Gakuo are also found here.

Figure 1. *Winter and Spring Landscape.* Six-fold screen; ink and slight color on paper. Attributed to Shubun, active 1414-1463, Muromachi period. The Cleveland Museum of Art, The Norweb Collection, 58.476

13 Eight Views of Xiao and Xiang Rivers

1. For the Daisen-in whose *fusuma* paintings are thought to have been completed in 1513, see *Nihon no Suibokuga* (Japanese Ink Painting), exh. cat. (Tokyo: Tokyo National Museum, 1989), pl. 51.

2. Watanabe Hiroshi, *Of Water and Ink: Muromachi Period Paintings from Japan 1392-1568*, exh. cat. (Detroit: Detroit Institute of Arts, 1986), no. 63.

3. See, for example, *16 Seiki no Bijutsu* (Sixteenth-Century Art), exh. cat. (Osaka: Osaka City Museum, 1988), pls. 52 and 57, which demonstrate how closely Motonobu studied Ami School painting.

14 Monkeys on Rocks and Trees

1. Among the artists who painted monkey images are Sesshu, Shugetsu (1440?-1529), Sesson, Geiami, Hasegawa Tohaku (1539-1610), and Tosa Mitsunobu. Another tradition of colorful, fine-line monkey paintings on silk were collected in Japan and admired by tea aesthetes, but not nearly to the extent of *suibokuga* images. See Mitsunobu's monkey paintings, done in *suibokuga*, on *fusuma* depicted in the 1487 *Seiko-ji Engi* (Legends of Seiko-ji Temple) in Yoshida Yuji, *Tosa Mitsunobu*, vol. 5 of *Nihon Bijutsu Kaiga Zenshu* (Collection of Japanese Paintings) (Tokyo: Shueisha, 1979), pl. 2 and fig. 26. Clearly Mitsunobu knew Soami's paintings too.

2. For an extensive discussion of Shikibu in relation to regional painting styles, see Yamashita Yuji, "Shikibu Terutada no Kenkyu" (A Study of Shikibu Terutada), *Kokka* no. 1084 (1985): 1-45.

15 Seven Sages in a Bamboo Grove

1. Kameda Tsutomu, *Sesson*, vol. 8 of *Nihon Bijutsu Kaiga Zenshu* (Collection of Japanese Paintings) (Tokyo: Shueisha, 1980), pls. 24, 25. See also Miyeko Murase, *Japanese Art: Selections from the Mary and Jackson Burke Collection*, exh. cat. (New York: Metropolitan Museum of Art, 1975), no. 41, for an early version of this subject.

2. For Mitsuyoshi's extensive *Genji* paintings, see Miyajima Shin'ichi, *Tosa Mitsunobu*, vol. 247 of *Nihon no Bijutsu* (Arts of Japan) (Tokyo: Shibundo, 1986), pls. 15, 16, 69 (for albums) and 13, 62-66 (for *byobu*).

16 Birds and Flowers

1. See fn. 3 in [9].

2. Curiously, these Shoei *byobu* and others by his contemporaries in the Kano atelier have not been studied with any method, except by the late American art historian Carolyn Wheelright in "Kano Shoei" (Ph.D. diss., Princeton University, 1981).

17 Birds, Animals, and Flowers

1. See *Muromachi Bijutsu to Sengoku Gadan* (Art of the Muromachi and Sengoku Periods), exh. cat. (Tokyo: Tokyo Teien Art Museum, 1986), pl. 7, where these screens are given a Mitsunobu attribution.

2. See Kanazawa Hiroshi and Kawai Masatomo, eds., *Suiboku no Hana to Tori* (Flower and Bird Ink Paintings) (Tokyo: Gakushu Kenkyusha, 1982), pls. 39-43. This is the best source for material exploring the relationship between *kanga* and *yamato-e* bird-and-flower painting traditions in 16th-century Japan.

3. See pls. 10, 27, 30, 44, and 59 in fn. 1 citation; the Suntory Museum of Art's Tosa Hirochika *byobu* of birds and flowers should also be considered a part of this group (pl. 4).

4. The Doan version of one of the Virginia panels appears as pl. 68 in the exhibition catalogue cited in fn. 1.

18 Scenes in and around Kyoto (*Rakuchu-Rakugai*)

1. *Koe-zu* (Old Maps), exh. cat. (Kyoto: Kyoto National Museum, 1968).

2. See Kobayashi Tadashi, "Shinshutsu no Shoki Rakuchu Rakugai-zu Byobu ni tsuite" (Recently Discovered Screens of Sights in and around Kyoto), *Kokka* no. 1105 (1987): 19-24, and the succeeding articles in that issue.

3. See the artist's *Picture Map of Shoten-ji Temple* in Sherman E. Lee, *Reflections of Reality in Japanese Art*, exh. cat. (Cleveland: Cleveland Museum of Art, 1983), no. 95. Some of the fans in [37] may be attributable to Shoei.

4. *Tosa no Kaiga* (Paintings of the Tosa School), exh. cat. (Tokyo: Suntory Museum of Art, 1982).

Detail of [18]. After Kobayashi Tadashi, "About the Newly Discovered *Rakachu Rakugai* Screens," *Kokka* no. 1105 (1987), pl. 1.

19 Famous Views of Lake Biwa

1. See *Muromachi Jidai no Byobu-e* (Screen Paintings of the Muromachi Period), exh. cat. (Tokyo: Tokyo National Museum, 1989), pl. 73. It is introduced in *Kokka* no. 1104 (1987) by Miyajima Shin'ichi, who correctly appraised its Muromachi, rather than Edo, date. He has subsequently linked these paintings to the anonymous artist of the famous Uesugi *Rakuchu-Rakugai byobu*.

2. Compare these screens, for example, to the Cleveland Museum *Lake Biwa* paintings in Takeda Tsuneo, ed., *Byobuga* (Screen Painting), vol. 4 of *Zaigai Nihon no Shiho* (Japanese Art in Western Collections) (Tokyo: Mainichi Shimbun, 1980), pls. 98, 99.

Figure 1. *Kumano Mandala: The Three Sacred Shrines* (detail). Hanging scroll; ink and color on silk. Kamakura period, ca. 1300. The Cleveland Museum of Art, John L. Severance Fund, 53.16

Detail of [19]. After Miyajima Shin'ichi, "The Tradition of *Omi Meisho* Paintings," *Kokka* no. 1104 (1987), pl. 2.

20 Scenes of Hie-Sanno and Gion Festivals

1. See the comments of Sakakibara Satoru in *Muromachi Jidai no Byobu-e* (Screen Paintings of the Muromachi Period), exh. cat. (Tokyo: Tokyo National Museum, 1989), pl. 32, and in *Suntory 100-sen* (100 Masterpieces from the Suntory Museum of Art) (Tokyo: Otsuka Kogeisha, 1981), pl. 6.

2. See Kageyama Haruki and Christine Guth Kanda, *Shinto Arts*, exh. cat. (New York: Japan House Gallery, 1976), pp. 95-102.

21 Genre-Scene Fans in a Landscape

1. See Takeda Tsuneo, "Kyoraku Getsuki Fuzoku-zu Senmen-ryu Byobu" (A Screen with Fan Paintings Illustrating the Manners and Customs of Kyoto), *Kokka* no. 889 (1966): 15-20. See also the same author's *Nanzen-ji Senmen Byobu* (The Nanzen-ji Screens of Fan Paintings), vol. 6 of *Bijutsu Senshu* (A Collection of Japanese Art) (Kyoto: Fuji Art, 1973).

2. For instance, nos. 18-20 in *Muromachi Jidai no Byobu-e* (Screen Paintings of the Muromachi Period) exh. cat. (Tokyo: Tokyo National Museum, 1989).

3. See *Rakuchu-Rakugai*, exh. cat. (Kyoto: Kyoto National Museum, 1965), no. 32.

22 Horses and Grooms in the Stable

1. See Tsuji Nobuo, ed., *Fuzokuga: Kobu* (Genre Painting: Warrior Subjects), vol. 12 of *Nihon Byobu-e Shusei* (Collection of Japanese Screen Paintings) (Tokyo: Kodansha, 1980), pls. 36, 37.

2. In *Kano-ha no Kaiga* (Paintings of the Kano School), exh. cat. (Tokyo: Tokyo National Museum, 1981), pl. 62. See also the bird-and-flower painting in *yamato-e* style attributed to Eitoku (1543-1590), pl. 76.

23 Horses and Grooms in the Stable

1. These *byobu* were handed down in one branch of the Tokugawa family and have traditionally been attributed to the Tosa School. See Mitsunobu's rendering of this subject in the 1487 *emaki Seiko-ji Engi* (Legends of Seiko-ji Temple) in Yoshida Yuji, *Tosa Mitsunobu*, vol. 5 of *Nihon Bijutsu Kaiga Zenshu* (Collection of Japanese Painting) (Tokyo: Shueisha, 1979), pls. 2 and 5.

24 Emperor's Visit to Ohara

1. Kitagawa Hiroshi and Bruce T. Tsuchida, trans., *The Tale of the Heike* (Tokyo: Tokyo University Press, 1975), epilogue, 761-82.

2. See Yamane Yuzo, *Jimbutsuga: Yamato-e Jimbutsu* (Figure Painting: Yamato-e Figure Painting), vol. 5 of *Nihon Byobu-e Shusei* (Collection of Japanese Screen Paintings) (Tokyo: Kodansha, 1979), pls. 1-25 for *Genji* examples.

3. See pls. 23 and 24 in *Muromachi Jidai no Byobu-e* (Screen Paintings of the Muromachi Period), exh. cat. (Tokyo: Tokyo National Museum, 1989).

25 Scene from *The Tale of Genji*

1. See Miyajima Shin'ichi, *Tosa Mitsunobu*, vol. 247 of *Nihon no Bijutsu* (Arts of Japan) (Tokyo: Shibundo, 1986), pp. 50-56, 67-69, and fig. 74 (sketch copies of genre paintings, now lost, by Mitsumochi, which confirm his interest in such subjects and with the environs of Lake Biwa).

2. Murasaki Shikibu, *The Tale of Genji*, trans. Edward Seidensticker (New York: Alfred A. Knopf, 1977), pp. 20-48.

26 Horse Race at the Kamo Shrine

1. Other *byobu* of the subject appear in Takeda Tsuneo, ed., *Fuzokuga* (Genre Painting), vol. 13 of *Nihon Byobu-e Shusei* (Collection of Japanese Screen Paintings) (Tokyo: Kodansha 1978), pls. 23-36.

2. See Ivan Morris, *The Nobility of Failure* (New York: Holt, Rinehart and Winston, 1975) for an immensely readable series of essays touching upon this theme. It is of course a principal subject of *The Tale of Genji*.

3. See *Emaki* (Illustrated Narrative Handscrolls), exh. cat. (Tokyo: Tokyo National Museum, 1974), nos. 25-30, 34, 55-57, for a general reference to these subjects.

28 Small Birds and Flowers in Four Seasons

1. See the extensive and intriguing article by Bettina Klein, adapted by Carolyn Wheelwright, "Japanese *Kinbyobu*: The Gold-Leafed Folding Screens of the Muromachi Period (1333-1573)," pt. 1, in *Artibus Asiae* XLV, 1 (1984): 5-33; pts. 2-4, in vol. XLV, 2/3: 101-73. This is currently the most definitive interpretation of these screens and provides the best source for checking documentation of 15th- and 16th-century *yamato-e* in English.

2. Ibid., pts. 2-4, pl. 20, where the *byobu* are called "Studio of Kano Shoei."

Figure 1. *Birds and Flowers in Four Seasons*. Pair of six-fold screens; ink, color, and gold on paper. Kano Motonobu, 1476-1559, Momoyama period. Hakutsuru Museum, Kobe.

29 Hawking scene

1. *Soga Chokuan, Nichokuan no Kaiga* (Paintings of Soga Chokuan and Nichokuan), exh. cat. (Nara: Nara Prefectural Museum, 1989), no. 9.

2. *Echizen Asakura no Eshitachi to Richo Kaigaten* (The Painters of Asakura Echizen and Yi Dynasty Painting), exh. cat. (Fukui: Fukui Prefecture Art Museum, 1990), no. 39.

30 Peonies and Camellias in a Landscape

1. Kawai Masatomo, *Yusho/Togan*, vol. 11 of *Nihon Bijutsu Kaiga Zenshu* (Collection of Japanese Painting) (Tokyo: Shueisha, 1978), pls. 8 and 29.

2. Ibid., pl. 16. See also pl. 18 in *Muromachi Jidai no Byobu-e* (Screen Paintings of the Muromachi Period), exh. cat. (Tokyo: Tokyo National Museum, 1989), which demonstrates Yusho's attention to traditional *yamato-e* themes and format.

31 Bamboo and Morning Glories, Pine and Camellias

1. These screens are introduced and discussed by the author, "A New Discovery: Screens Attributed to Kaiho Yusho," *The Bulletin of The Cleveland Museum of Art* 76 (March 1989): 88-95.

2. Yusho's painting style has typically been linked by Japanese art historians to interpretations of Chinese landscape and figural painting modes. It would be useful to look at his work with an eye towards the Ami School painters, as well as *yamato-e* traditions.

32 Pine Amid Grasses and Flowers

1. For an overview of Chishaku-in, see Mizuo Hiroshi, *Chishaku-in*, vol. 1 of *Shohekiga Zenshu* (Collection of Wall Paintings) (Tokyo: Bijutsu Shuppansha, 1966).

2. The painting cycles at the Myoren-in and Zuigan-ji, among other "anonymous" *yamato-e* paintings, point to the Hasegawa School painters. See Nakajima Junji, *Hasegawa Tohaku*, vol. 10 of *Nihon Bijutsu Kaiga Zenshu* (Collection of Japanese Painting) (Tokyo: Shueisha, 1979), pl. 16, and bibliography p. 146.

33 Kuwanomi-dera Engi

1. Komatsu Shigemi, ed., *Kuwanomi-dera Engi/Dojo-ji Engi*, vol. 13 of *Zoku Nihon Emaki Taisei* (Survey of Japanese Narrative Handscrolls) (Tokyo: Chuokoronsha, 1982).

Detail of [33]. After Komatsu, p. 14.

Figure 1. Section of scroll 2. After Komatsu, pp. 42-44.

34 Festival at Chikubushima Island

1. *Koe-zu* (Old Picture Maps), exh. cat. (Kyoto: Kyoto National Museum, 1968), no. 22.

2. See *Omi Hakkei* (Eight Views of Lake Biwa), exh. cat. (Otsu: Shiga Prefectural Museum of Modern Art, 1988), pls. 12, 13.

3. See Yoshimura Motoo, *Kodai-ji Maki-e* (Tokyo: Kodansha, 1981), pls. 9-14.

35 Mt. Fuji Mandala

1. *Fuji no E* (Pictures of Mt. Fuji), exh. cat. (Nara: Museum Yamato Bunkakan, l980).

2. *Shaji Sankei Mandara* (Pictures of Pilgrimages to Temples and Shrines), exh. cat. (Osaka: Osaka City Art Museum, l987), no. 46.

36 The Pleasures of Food, Sake, and Conversation (*Shuhanrozu*)

1. See, for example, the rice-planting and cherry-blossom-viewing scenes in the Tokyo National Museum *Genre Scenes of the Twelve Months byobu*, perhaps the most famous of such *tsukinami-e* (festivals of the twelve months), in *Muromachi Jidai no Byobu-e* (Screen Paintings of the Muromachi Period), exh. cat. (Tokyo: Tokyo National Museum, 1989), no. 30. See also Suzuki Norio, *Shuki* (Sake Utensils), vol. 266 of *Nihon no Bijutsu* (Arts of Japan) (Tokyo: Shibundo, 1988).

2. Another 16th-century version in one scroll is in the Seikado Bunko. It is reproduced, in part in *Muromachi Kinpekiga kara Kinsei e* (From Muromachi Era Paintings on Gold Backgrounds to Modern Painting), exh. cat. (Tokyo: Mitsui Bunko, 1990), no. 14.

3. Yamaoka Taizo, *Kano Masanobu/Motonobu*, vol. 7 of *Nihon Bijutsu Kaiga Zenshu* (Collection of Japanese Painting) (Tokyo: Shueisha, 1978).

37 Fan Paintings

1. See Takeda Tsuneo, "Nanzen-ji zu Ogimen Haritsuke Byobu ni tsuite" (Concerning the Nanzen-ji Collection of Fan Screens), *Kokka* no. 849 (1962). This album is published in part by Narazaki Muneshige in *Kokka* no. 845 (1962): entire issue. Originally, the fans in this album were attached to a pair of screens with five fan paintings on each panel.

2. See *Muromachi Jidai no Byobu-e* (Screen Paintings of the Muromachi Period), exh. cat. (Tokyo: Tokyo National Museum, 1989), no. 18; nos. 19 and 20 are also examples of fan paintings attached to screens.

38 The Various Professions

1. Ishida Hisatoyo, *Shokuninzu-e* (Painting of the Various Professions), vol. 132 of *Nihon no Bijutsu* (Arts of Japan) (Tokyo: Shibundo, 1977).

2. See *Emaki*, exh. cat. (Tokyo: Tokyo National Museum, 1974), nos. 62-78, 80.

3. These appear in Tsuji Nobuo, *Iwasa Matabei*, vol. 13 of *Nihon Bijutsu Kaiga Zenshu* (Collection of Japanese Paintings) (Tokyo: Shueisha, 1980), pls. 37, 46, 51, 63, and 67).

43 Writing utensil box (*suzuribako*)

1. For Western readers, the best source for appreciating this famous collection of poetry is: Robert H. Brower and Earl Miner, *Japanese Court Poetry* (Stanford, Calif.: Stanford University Press, 1961). The translation here is excerpted from Helen Craig McCullough, *Kokin Wakashu: The First Imperial Anthology of Japanese Poetry, with 'Tosa Nikki' and 'Shinsen Waka'* (Stanford, Calif.: Stanford University Press, 1985), p. 83.

44 Writing utensil box (*suzuribako*)

1. See Robert H. Brower and Earl Miner, *Japanese Court Poetry* (Stanford, Calif.: Stanford University Press, 1961), pp. 235-49.

2. First associated with Chinese Song dynasty (960-1278) painting, this subject was popular among *suibokuga* (ink painting) artists of the 15th and 16th centuries, including the Shikibu *byobu* in this exhibition [14].

46 Incense burner (*akoda koro*)

1. See, for example, the poem by Mibu no Tadamine (a 9th-century poet) in Helen Craig McCullough, *Kokin Wakashu: The First Imperial Anthology of Japanese Poetry*, with 'Tosa Nikki' and 'Shinsen Waka' (Stanford, Calif.: Stanford University Press, 1985), no. 361, p. 87.

2. The *chidori* subject appears often in Japanese poetry in an autumnal setting. See other incense burners in Okada Jo, Matsuda Gonroku, and Arakawa Hirokazu, eds., *Nihon no Shitsugei* (Japanese Lacquer) (Tokyo: Chuokoronsha, 1978-79), vol. 2, nos. 71, 91-93.

48 Cosmetic box

1. The most thorough compilations of Kodai-ji style lacquer can be found in Yoshimura Motoo, *Kodai-ji Maki-e* (Kodai-ji *Maki-e* Lacquer) (Tokyo: Kodansha, 1981), and in the same author's exhibition catalogue, *Kodai-ji Maki-e* (Kyoto: Kyoto National Museum, 1971).

2. This writing box is one of a small but distinguished group of Japanese lacquers at the Detroit Institute of Arts that has yet to be published adequately. Occasional photographs have appeared in the annual reports of the Institute.

49 Cosmetic set

1. Since the next eight objects [50-57] are in the Kodai-ji style of *maki-e*, the reader may wish to refer to the essay on lacquerware in the present publication (pp. 105-108) for a description of this technique. For additional information, see also Yoshimura Motoo, *Kodai-ji Maki-e* (Tokyo: Kodansha, 1981).

55 Reading stand

1. See Yoshimura Motoo, *Kodai-ji Maki-e* (Tokyo: Kodansha, 1981) for the most recent compilation of Kodai-ji style lacquerwares in a discussion of its history and characteristics; the Cleveland stand is pl. 26, the Tokyo National Museum example, pl. 27.

58 Tray

1. See Suzuki Norio, *Shikko: Chusei-hen* (Lacquerwares: Medieval Period) (Tokyo: Shibundo, 1985), pl. 23 and fig. 139.

60 Pair of sake containers (*heishi*)

1. Suzuki Norio, *Shuki* (Sake Utensils), vol. 266 of *Nihon no Bijutsu* (Arts of Japan) (Tokyo: Shibundo, 1988): 86-93.

62 Tea caddy (*chaire*)

1. See Sakai City Art Museum, *Negoro*, exh. cat. (1986), nos. 200-206, for this piece and other related utensils.

2. See Kawada Sadamu, *Negoro* (Kyoto: Shikosha, 1985), pl. 417.

70 Bowl

1. Ito Akira, *Bizen*, vol. 10 of *Nihon Toji Zenshu* (Survey of Japanese Ceramics) (Tokyo: Chuokoronsha, 1977), pls. 67, 68.

77 Set of five bowls (*mukozuke*)

1. For Yellow Seto wares, see Takeuchi Junichi, *Ki-Seto/Seto-guro* (Yellow Seto/Black Seto), vol. 14 of *Nihon Toji Zenshu* (Survey of Japanese Ceramics) (Tokyo: Chuokoronsha, 1977), pls. 57-67.

78 Teabowl

1. See the comments of Rupert Faulkner in *Shino and Oribe Kiln Sites*, exh. cat. (Oxford: Ashmolean Museum, 1981), pp. 52-53. Hayashiya Seizo dicusses this teabowl briefly in *Tojiki* (Ceramics), vol. 9 of *Zaigai Shiho* (Japanese Art in Western Collections) (Tokyo: Mainichi Shimbun, 1981), no. 21.

2. See the variety of teawares unearthed recently in central Kyoto, including black wares, in *Momoyama no Chado* (Tea Ceramics of the Momoyama Period), exh. cat. (Tokyo: Nezu Art Museum, 1989). See also Louise Allison Cort, "Japanese Ceramics and Cuisine," *Asian Art* III, No. 1 (Winter 1990): 9-36, where she discusses many of the fascinating historical issues raised by the discovery of these ceramics.

81 Ewer

1. For an overview of 16th-century ceramics as well as specific comparisons between wares produced at different ceramic centers, see *Nihon no Toji* (Japanese Ceramics), exh. cat. (Tokyo: Tokyo National Museum, 1985), nos. 160-262.

2. See, for example, Tanikawa Setsuzo, ed., *Oribe*, vol. 4 of *Nihon no Toji* (Japanese Ceramics) (Tokyo: Chuokoronsha, 1988), pls. 36, 128-31.

85 Fresh water jar (*mizusashi*)

1. See *Nihon no Toji* (Japanese Ceramics), exh. cat. (Tokyo: Tokyo National Museum, 1985), no. 221.

2. See Hayashiya Seizo, *Shino*, vol. 15 of *Nihon Toji Zenshu* (Survey of Japanese Ceramics) (Tokyo: Chuokoronsha, 1975), pls. 63-76.

88 Bowl (*hachi*)

1. The grape subject actually derives from the Japanese "still-life" depiction that favors vegetative and floral assemblages: melons, vegetables, flowers, and so forth. In the 15th and 16th centuries the grape theme became popular because of its association with several famous Chinese ink paintings that were favored in tea circles. It then became thoroughly transformed into an attractive pictorial statement in the decorative arts. Present at Kodai-ji and in later, related, wares, it reappears in the late 17th century in Japanese porcelains. See Yoshimura Motoo, *Kodai-ji Maki-e* (Tokyo: Kodansha, 1981), as well as two lacquers in the Burke Collection in *Die Kunst des Alten Japan* (The Art of the Old Japan), exh. cat. (Frankfurt: Schirn Kunsthalle, 1990), nos. 110, 113.

2. For related Shino ware designs, see Narasaki Shoichi, *Mino no Koto* (Old Ceramics of Mino Province) (Kyoto: Korinsha, 1976), pls. 21-64, 158-62.

References

The following reference texts and exhibition catalogues were consulted in the preparation of catalogue numbers 27-93 by the authors from the Agency for Cultural Affairs, Tokyo.

Ceramics

Aichi Prefectural Ceramic Museum. *Aichi-ken Toji Shiryokan Shozohin Zuroku* (Collection of the Aichi Prefectural Ceramic Museum). Seto, 1988. [89]

Chaki Zuroku (Catalogue for Tea Utensils). Vol. 3. Tokyo: Seikado Bunko, 1979. [68]

Goto Art Musuem. *Goto Bijutsukan no Meihin* (Selected Works from the Goto Art Museum). Tokyo, 1985. [67, 86]

Goto Art Museum. *Jidai no Bi–Goto Bijutsukan Seika* (The Beauty of the Ages: Brilliant Art of the Goto Art Museum). Tokyo, 1990. [67, 86]

Matsunaga Jian Iaihin Zuroku (Collection of Jian Matsunaga). Tokyo: Matsunaga Kinenkan, 1976. [79, 82]

MOA Art Museum. *Nihon no Toji–Chusei no Koyo no Bi kara Kinsei no Hatten-e* (Ceramics in Japan: Beauty of Old Kilns from the Medieval to Modern Eras). Exh. cat. Atami, 1988. [69, 76, 80]

Nihon Toji Zenshu (Complete Works of Japanese Ceramics). Tokyo: Chuokoronsha, 1977. Vol. 11 [74, 75]; Vol. 12 [73]; Vol. 13 [71, 72]; Vol. 14 [76]; Vol. 15, 1975 [84, 87]; Vol. 16, 1976 [83]; Vol. 17, 1976 [90, 91].

Sekai Toji Zenshu (Complete Works of World Ceramics). Tokyo: Shogakkan, 1977. Vol. 4 [71, 72, 74, 75]; Vol. 5, Chuokoronsha, 1976 [84, 87]; Vol. 15, Chuokoronsha, 1975 [84, 87]; Vol. 20, Chuokoronsha, 1976 [93].

Tokyo National Museum. *Nihon no Toji* (Japanese Ceramics). Exh. cat. Tokyo, 1987. [91]

Lacquer

Akikusa (Autumn Flowers). Vol. 2 of *Nihon no Isho* (Japanese Design in Art). Kyoto: Kyoto Shoin, 1983. [47]

Itsuo Museum of Art. *Itsuo Seisho: Itsuo Bijutsukan Meihin Zuroku* (Selected Works from the Itsuo Museum of Art). Exh. cat. Ikeda, 1986. [57]

Kawada Sadamu. *Negoro* (Negoro Lacquer). Kyoto: Shikosha, 1985. [58, 59, 61]

Kokuho Sanjusangendo-ten (Sanjusangen-do Temple: a National Treasure). Exh. cat. Tokyo: Nihon-Keizai-Shimbunsha, 1972. [49, 50]

Kyoto National Museum. *Kodai-ji Maki-e* (Kodai-ji *Maki-e* Lacquer). Exh. cat. Kyoto, 1971. [44, 51-54, 56]

Kyoto National Museum. *Kogei ni Miru Koten Bungaku Isho* (Illustrated Designs of Classical Literature in the Decorative Arts). Exh. cat. Kyoto, 1980. [43, 44]

Maki-e II. Vol. 2 of *Nihon no Shitsugei* (Japanese Lacquer). Tokyo: Chuokoronsha, 1978, [43, 45] and Vol. 3 [44, 51-54, 56]

Negoro, Urushi-e. Vol. 5 of *Nihon no Shitsugei* (Japanese Lacquer). Tokyo: Chuokoronsha, 1979. [58, 61]

Tokyo National Museum. *Toyo no Shikkogei* (Oriental Lacquer). Exh. cat. Tokyo, 1977. [44, 52, 53, 56, 58]

Paintings

Doi Tsugiyoshi. *Kinsei Nihon Kaiga no Kenkyu* (A Study of Modern Japanese Paintings). Tokyo: Bijutsu Shuppansha, 1972. [27]

Kagawa-ken no Chimei (Place Names in Kagawa Prefecture). Vol. 38 of *Nihon Rekishi Chimei Taikei* (Dictionary of Japanese Place Names in History). Tokyo: Heibonsha, 1987. [41]

Kyoto National Musem. *Nihon no Shozo* (Japanese Portraiture). Exh. cat. Kyoto, 1978. [42]

Yamanashi Prefectural Museum. *Yamanashi no Bungaku to Bijutsu* (Literature and Art in Yamanashi Prefecture). Exh. cat. 1986. [39, 40]

Textiles

Kyoto National Museum. *Nihon no Senshoku-Wazu to Bi* (Japanese Dyeing and Weaving: Beauty and Technique). Exh. cat. Kyoto, 1987. [63, 64]

Nihon no Senshoku (Japanese Dyeing and Weaving). Vol. 3. Tokyo: Chuokoronsha, 1979, [63] and Vol. 5 [66].

Sakai City Museum of Art. *Nui-Kosode o Iro-doru* (Embroidery: *Kosode* Decoration). Exh. cat. Sakai, 1987. [64, 65]

Suggested Reading

Ceramics

Becker, Johanna. *Karatsu Ware: A Tradition of Diversity*. Tokyo: Kodansha, 1986.

Cort, Louise A. *Shigaraki, Potters' Valley*. Tokyo and New York: Kodansha, 1979.

Hayashiya Seizo, ed. *Nihon Toji Zenshu* (Survey of Japanese Ceramics). 30 vols. Tokyo: Chuokoronsha, 1976-79.

Hayashiya Seizo, ed. *Nihon no Toji* (Japanese Ceramics). 14 vols. Tokyo: Chuokoronsha, 1989.

Hayashiya Seizo and Narasaki Shoichi, eds. *Nihon Toji Zenshu* (Survey of Japanese Ceramics). 3 vols. Tokyo: Chuokoronsha, 1975-78.

Jenyns, Soame. *Japanese Pottery*. New York: Praeger, 1971.

Mitsuoka Tadanari, ed. *Sekai Toji Zenshu* (Ceramic Art of the World). Vols. 3-5. Tokyo: Shogakkan, 1977-78.

Seattle Art Museum. *Ceramic Art of Japan: One Hundred Masterpieces from Japanese Collections*. Exh. cat. Seattle, 1972.

Tokyo National Museum. *Nihon no Toji* (Japanese Ceramics). Exh. cat. Tokyo, 1985.

General

Akiyama Terukazu. *Japanese Painting*. Geneva: Skira, 1961.

Colcutt, Martin; Jansen, Marius; and Kumakura Isao; eds. *Cultural Atlas of Japan*. New York: Facts on File Publications, 1988.

Heibonsha Survey of Japanese Art. 31 vols. Tokyo: Weatherhill/Heibonsha, 1972-80.

Japanese Arts Library. 11 vols. Tokyo and New York: Kodansha/Shibundo, 1979.

Kageyama Haruki and Guth Kanda, Christine. *Shinto Arts*. Exh. cat. New York: Japan House Gallery, 1976.

Keene, Donald. *Japanese Literature: An Introduction for Western Readers*. New York: Grove, 1955.

Keene, Donald. *Landscape and Portraits: Appreciations of Japanese Culture*. Tokyo: Kodansha, 1971.

Kidder, J. E. *Ancient Japan*. Oxford: Phaidon, 1977.

Kodansha Encyclopedia of Japan. 9 vols. Tokyo and New York: Kodansha, 1983.

Morris, Ivan. *The Tale of Genji Scroll*. Tokyo and New York: Kodansha, 1971.

Morris, Ivan. *The World of the Shining Prince: Court Life in Ancient Japan*. Oxford: Oxford University Press, 1960.

Pollack, David. *The Fracture of Meaning: Japan's Synthesis of China from the Eighth through Eighteenth Centuries*. Princeton: Princeton University Press, 1986.

Rosenfield, John, and Cranston, Edwin and Fumiko. *The Courtly Tradition in Japanese Art and Literature*. Exh. cat. Cambridge: Fogg Art Museum, 1973.

Rosenfield, John, and Shimada Shujiro. *Traditions of Japanese Art: Selections from the Kimiko and John Powers Collection*. Exh. cat. Cambridge: Fogg Art Museum, 1970.

Sansom, George B. *Japan Culture, A Short History*. Honolulu: University of Hawaii Press, 1984.

Seattle Art Museum. *A Thousand Cranes: Treasures of Japanese Art*. San Francisco: Chronicle Books, 1987.

Seidensticker, Edward G., trans. *The Tale of Genji* (Genji Monogatari). 2 vols. New York: Knopf, 1976.

Shimizu Yoshiaki, ed. *Japan: The Shaping of Daimyo Culture 1185-1868*. Exh. cat. Washington, D.C.: National Gallery of Art, 1988.

Varley, H. P. *Japanese Culture, A Short History*. Honolulu: University of Hawaii Press, 1984.

Lacquer

Arakawa Hirokazu, Okada Jo, and Matsuda Gonroku, eds. *Nihon no Shitsugei* (Japanese Lacquer). 6 vols. Tokyo: Chuokoronsha, 1978-79.

Brommelle, N. S., and Smith, Perry, eds. *Urushi: Proceedings of the Urushi (Lacquer) Study Group*. Tokyo: Dai Nippon, 1988.

Kawada Sadamu. *Negoro*. Kyoto: Shikosha, 1985.

Kyoto National Museum. *Momoyama Jidai no Kogei* (Decorative Arts of the Momoyama Period). Exh. cat. Kyoto, 1977.

Rague, Beatrix von. *A History of Japanese Lacquerwork*. Toronto and Buffalo: University of Toronto Press, 1976.

Sakai City Museum. *Negoro, Sono Yo to Bi* (Red Lacquer: the Utility and Beauty of Negoro). Exh. cat. Sakai, 1986.

Yonemura, Ann. *Japanese Lacquer*. Washington, D.C.: Freer Gallery of Art, 1979.

Paintings

Asia Society Galleries. *Emaki: Narrative Scrolls from Japan.* Exh. cat. New York: Asia Society Galleries, 1983.

Grilli, Elise. *The Art of the Japanese Screen.* Tokyo and New York: Weatherhill, 1970.

Lee, Sherman E., et. al. *Reflections of Reality in Japanese Art.* Exh. cat. Cleveland: Cleveland Museum of Art, 1983.

Meech, Julia. *Momoyama: Japanese Art in the Age of Grandeur.* Exh. cat. New York: Metropolitan Museum of Art, 1975.

Miyajima Shin'ichi and Sato Yasuhiro. *Japanese Ink Paintings.* Exh. cat. Los Angeles: Los Angeles County Museum of Art, 1985.

Murase Miyeko. *Japanese Art: Selections from the Mary and Jackson Burke Collection.* Exh. cat. New York: Metropolitan Museum of Art, 1975.

Murase Miyeko. *Masterpieces of Japanese Screen Painting.* New York: Braziller, 1990.

Shimizu Yoshiaki and Wheelright, Carolyn, eds. *Japanese Ink Paintings from American Collections: the Muromachi Period, an Exhibition in Honor of Shujiro Shimada.* Exh. cat. Princeton: Art Museum, Princeton University, 1976.

Shizuoka Prefectural Art Museum. *Kano-ha no Kyojintachi* (Great Masters of the Kano School). Exh. cat. Shizuoka, 1989.

Takeda Tsuneo. *Nihon Byobu-e Shusei* (Collection of Japanese Screen Paintings). 18 vols. Tokyo: Kodansha, 1977-81.

Tanaka Ichimatsu. *Nihon Bijutsu Kaiga Zenshu,* (Collection of Japanese Painting). 25 vols. Tokyo: Shueisha, 1978-81.

Tanaka Ichimatsu. *Suiboku Bijutsu Taikei* (Compendium of Ink Paintings). 17 vols. Tokyo: Kodansha, 1975-77.

Tanaka Ichimatsu, ed. *Emakimono Zenshu* (Collection of Narrative Handscroll Painting). Tokyo: Kadokawa, 1958-67.

Watanabe Akiyoshi. *Of Water and Ink: Muromachi Period Paintings from Japan 1392-1568.* Exh. cat. Detroit: Detroit Institute of Arts, 1986.

Sixteenth-Century History

Arnesen, Peter. *The Medieval Japanese Daimyo.* New Haven: Yale University Press, 1979.

Berry, Mary E. *Hideyoshi.* Cambridge: Harvard University Press, 1982.

Colcutt, Martin. *Five Mountains, the Rinzai Zen Monastic Institution in Medieval Japan.* Cambridge: Harvard University Press, 1981.

Duus, Peter. *Japanese Feudalism.* New York: Knopf, 1969.

Ellison, George, and Smith, Bardwell L., eds. *Warlords, Artists, and Commoners: Japan in the Sixteenth Century.* Honolulu: University of Hawaii Press, 1981.

Hall, John W., and Toyoda Takashi, eds. *Japan in the Muromachi Age.* Berkeley: University of California Press, 1977.

Textiles

Hayao Ishimura, and Maruyama Nobuhiko, eds. *Robes of Elegance: Japanese Kimonos of the 16th-20th Centuries.* Exh. cat. Raleigh: North Carolina Museum of Art, 1988.

Ito Toshiko. *Tsujigahana: The Flower of Japanese Textile Art.* New York and Tokyo: Kodansha, 1981.

Japan House Gallery. *Kosode: 16th-19th Century Textiles from the Nomura Collection.* Exh. cat. New York, 1984.

Kyoto National Museum. *Nihon no Senshoku: Waza to Bi* (Japanese Textiles: Beauty and Skill). Exh. cat. Kyoto, 1985.

Noma Seiroku. *Japanese Costume and Textile Arts.* Tokyo: Weatherhill, 1974.

Tokugawa Yoshinobu and Okochi Sadao. *The Tokugawa Collection: No Robes and Masks.* Exh. cat. Washington, D.C.: National Gallery of Art, 1977.

Glossary

akikusa (autumn grasses)
A traditional Japanese literary theme, well represented in the visual arts.

bugaku
A dance form introduced from the Asian continent, which became closely associated with the Nara period court and Shinto shrines.

byobu (folding screen)
Folding panels, initially containing designs on cloth, separately mounted, but joined by metal hinges. Developed in Japan into continuous compositions, usually on paper, mounted as a six-panel unit.

chidori (plover)
Sea or beach plover; a bird favored in Heian literature and visual imagery and often incorporated into lacquer designs.

chinkin (inlaid gold or sunken gold)
Japanese name for *qiangjin*, a lacquer technique originating in China, in which the linear decoration is incised into the lacquer surface and filled with gold or silver leaf.

choshitsu (carved lacquer)
A decorative technique in which the surface design is carved into the layers of lacquer. If there is more than one lacquer color, the carving will reveal this, thereby enhancing the linear and sculptural effects of the surface.

damon
The "crackle" pattern that forms naturally on lacquer surfaces over time.

ema
Painted votive plaques or tablets donated to shrines and temples.

emaki (illustrated narrative handscrolls)
Long, narrow picture scrolls that are drawn on joined sheets of paper; they usually consist of illustrations and calligraphy, and are read from right to left.

fukinuki-yatai (roofless house)
A compositional device in which roofs and ceilings of houses and rooms are removed in order to show interior scenes in a bird's-eye view.

fusuma (sliding doors)
Partitions covered with paper on both sides, whose surfaces usually bear paintings in ink or color.

fuzokuga (genre painting)
Subjects depicting annual events, customs, and everyday life.

go/shogi
Board games of strategy.

heishi
Bottles with narrow stems and flaring shoulders for holding sake; made in ceramic or lacquer.

hera-me
Spatula patterns on the surface of earthenware.

hidasuki (fire-mark decoration)
Reddish brown cord-like decorations on the unglazed surface of ceramic ware from Bizen.

hiramaki-e (flat *maki-e*)
A technique in which gold or silver powder is sprinkled over patterns already delineated in lacquer. After drying, the decorated areas are coated with *suri-urushi* lacquer and subsequently polished.

hirameji
A technique applied to the lacquer background of an object in which filed and pressed coarse flakes of gold or silver are sprinkled over the half-dry lacquered surface. After hardening, and coating with *roiro urushi* lacquer, the metalflake decoration is polished.

ikakeji
A technique in which gold or silver powder is sprinkled densely over all or parts of the lacquered ground.

kanga
Term used to designate Chinese-style painting of the 14th-16th centuries; it is distinguished from *kara-e* in its reference to brush and ink style rather than subject matter.

kara-e (Chinese painting)
In the Heian period, the term *kara-e* referred to paintings imported from China (or Korea). From the Kamakura period (14th century), both paintings imported from the Continent and later Japanese paintings influenced by them were called *kara-e*.

kasen-e (portraits of poetic immortals)
Paintings portraying master poets that include an inscription and one of the master's poems.

katami-gawari (differing halves)
A type of costume design in which the right and left halves are made from different patterns or colors; the concept was also used in lacquer designs.

kinpaku (gold leaf)
A sheet of gold beaten with a wooden mallet into a paper-thin leaf; used for surface decoration on Buddhist images, and wall and screen paintings.

kirihaku
Thin strips of silver or gold foil, frequently twisted, that are applied to painting surfaces. A technique originating in the Heian period.

machi-eshi (townsmen artists)
Painters not belonging to the court, feudal, or Buddhist temple cultural systems, who earn their livelihood by selling their paintings; a phenomenon of the 16th century.

maki-e (sprinkled lacquer decoration)
A decorative techinque in which metal powder is sprinkled over patterns delineated on a damp lacquer surface. *Maki-e* technique is usually divided into three types: (1) *togidashi maki-e*, (2) *hiramaki-e*, and (3) *takamaki-e*.

meishozu-e (pictures of celebrated places)
In *yamato-e* of the Heian period many of these were produced with the specialized *tsukinami-e* (paintings illustrating the characteristics of the months) and *shiki-e* (paintings of the four seasons).

mikoshi
A portable shrine for a Shinto deity (*kami*).

mizusashi (water jar)
A ceramic vessel, usually with a lid, that holds fresh water to be heated for use in the tea ceremony.

mukozuke
A small, deep bowl used for serving side dishes in a traditional Japanese meal.

nashiji (pearskin-ground lacquer)
In this technique, course metal flakes of silver or gold are sprinkled over the wet lacquered base; after hardening, reddish, amber or transparent lacquer is applied over the surface and later polished. When used within a pictorial design outlined in *hiramaki-e* (flat sprinkled design), it is called *e-nashiji*.

Negoro lacquerware
A type of lacquer technique (named after the Negoro temple) in which several final layers of red lacquer are applied over a black lacquer undercoating.

noborigama (climbing kiln)
A type of kiln that has several continuous kiln chambers built on a slope, with a fire mouth at the bottom and a chimney at the top; as heat rises, the next chamber becomes heated at the same time.

roiro-nuri
The dark black lacquer tone achieved by adding an iron-based pigment to lacquer.

shikishi (poem-papers)
A traditional Heian format of thick paper squares used for poetic calligraphy painting.

suibokuga (ink painting)
Pictures with dark and light ink tones, drawn only in carbon ink (*sumi*); based on the idea that all colors are contained in black. It originated during the Tang dynasty in China.

sunago
Fine, sand-like particles of gold or silver affixed to surfaces of a *byobu* to enhance decorative and textural effects.

surihaku (impressed metal foils)
A technique of decorating cloth, in which rice paste is applied through a stencil; then gold or silver foil is impressed on the pasted pattern; after drying, the unpasted foil is swept out with a brush, and the pasted gold or silver foil forms the design on the cloth.

suri-urushi
Lacquer that has been thinned, usually for use in *hiramaki-e*.

suzuki (pampas grass)

suzuribako
A writing utensil box containing an inkstone, water-dropper, inkstick, and trays for brushes; lacquer designs are usually found on the interior and exterior of the box.

takamaki-e (raised or relief *maki-e*)
A decorative technique in which motifs are built up with a mixture of lacquer and metal powder.

tanetsubo
Storage jar for seeds.

togidashi maki-e
A decorative technique in which the low-relief design (*hiramaki-e*) is covered with additional layers of lacquer. Once hardened, the lacquer is polished down to reveal the underlying design.

uchikake
An outer garment worn by women over the *kosode* (short-sleeved kimono); it was not tied at the waist with a sash.

urushi-e (lacquer painting)
A pictorial design executed with colored lacquer, namely, a mixture of *urushi* (lacquer) and various kinds of pigments.

yamato-e (Japanese-style painting)
A painting style featuring Japanese subjects or themes and using strong color rather than ink.

yuto (hot water vessel)
A container, usually made of lacquer, used in the tea ceremony.

Photograph Credits

(According to catalogue numbers)

Courtesy of the Agency for Cultural Affairs
1-5, 8, 9, 11, 12, 14-16, 18-22, 24-30, 32-45,
47, 49-54, 56-59, 61, 63-69, 71-76, 79-80,
82-84, 86, 87, 89-93

The Metropolitan Museum of Art, 7

Virginia Museum of Fine Arts, 17

The Detroit Institute of Arts, 48

Copyright Schecter Lee 1991, 77, 78

Sheldon Comfort Collins, 88